SOFA CHICAGO

SCULPTURE OBJECTS FUNCTIONAL ART

NOVEMBER 5 – 7 1999

NAVY PIER

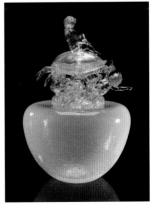

front cover detail:
Dale Chihuly,
*Putti Lounging on Crab
Resting on Madder
Orange Vessel*
Represented by
Habatat Galleries

A project of Expressions of Culture, Inc.

Printed in Hong Kong

EXPRESSIONS OF CULTURE, INC.

225 West Huron, #216
Chicago, IL 60610
Tel: 312.654.0870
Fax: 312.654.0872

Mark Lyman, President
Anne Meszko
Julie Oimoen
Kate Jordan
Jennifer Haybach
Sara Braun
Lynne Melcher
Graphic Design by
 William Seabright & Associates

SCULPTURE OBJECTS FUNCTIONAL ART

TABLE OF CONTENTS

RICHARD M. DALEY

MAYOR

November 1, 1999

Greetings

As Mayor and on behalf of the City of Chicago, I extend my warmest
greetings to all those participating in the SOFA CHICAGO 1999,
the 6th Annual International Exposition of Sculpture, Objects and
Functional Art.

SOFA is the world's largest marketplace for contemporary sculpture,
art objects and art furnishings. Presenting works from a wide range
of countries, styles and traditions, this year's SOFA showcases nearly
1,000 artists and 80 galleries. I am delighted to have them represented
here in Chicago. Like the many public exhibits located throughout
our city this summer, SOFA's exciting International Exposition helps
make Chicago a world-class center for design, sculpture, and other
three-dimensional art.

My best wishes to each of you for an enjoyable and memorable event.

Sincerely,

Mayor

CHICAGO ART DEALERS ASSOCIATION

730 North Franklin
Suite 308
Chicago, Illinois
60610

Phone
312.649.0065

Fax
312.649.0255

August 3, 1999

Mark Lyman
Executive Director
Expressions of Culture / SOFA
225 W. Huron
Chicago, IL 60610

Dear Mark:

On behalf of the Board of Directors and membership of the Chicago Art
Dealers Association, I want to congratulate you and the staff of SOFA CHICAGO
1999 on the sixth annual exposition of sculpture, objects and functional art.

As we approach the millenium, the interest in contemporary craft continues to
grow. This year, more than 100 galleries will be participating in what has
become the most significant venue for contemporary craft. Your efforts have
created a richly visual and educational experience for the growing craft audience.

Our thanks and appreciation for another exciting exhibition.

Sincerely,

Frank Paluch
President, Chicago Art Dealers Association

WELCOME

Welcome to the sixth annual International Exposition of Sculpture, Objects and Functional Art: SOFA CHCIAGO 1999. This year's gathering of galleries and art dealers will present the finest selection of work by highly acclaimed artists as well as newly emerging talent in the field.

1999 is a very special year because of the number of art organizations that have become partners in our programming. Of particular note is the new group, Collectors of Wood Art, guided in part by Robyn Horn and Jane and Arthur Mason. In September of 1998 I attended their second annual conference in San Francisco, with my wife and business partner, Anne Meszko. We were swept away by the quality of the art we discovered, and the passion radiated by those in attendance. We invited the CWA to organize their 1999 conference in conjunction with SOFA CHICAGO 1999, an offer which resulted in the special exhibit "Collectors' Choice" and accompanying panels and presentations by artists, critics and museum curators, all intensely involved in the medium of wood. Most happily, it resulted in the gathering of many dedicated connoisseurs!

We wish to thank the organizations that are an integral part of this year's show :

- Friends of Fiber Art International and Camille Cook, who organized an insightful panel of five contemporary fiber artists, and will make their annual grant awards at SOFA

- Pilchuck Glass School, sponsor of "Frequently Asked Questions About Collecting Glass," moderated by the inimitable Marge Levy

- Rhode Island School of Design and Sheridan School of Craft and Design, each presenting a special exhibit of alumni work, corresponding panel discussion and catalog essay

- UrbanGlass of Brooklyn, in the exposition for the first time as a gallery that will present the work of emerging artists

- Art Alliance of Contemporary Glass and Leatrice Minzter, who will present an annual achievement award to this year's recipient, The Corning Museum of Glass, during their Saturday panel

- The Society of North American Goldsmiths and Art Jewelry Forum, who tackled the mission of visibility for jewelry and metalsmiths by sponsoring a total of five presentations

- From Toronto, Canada—The George R. Gardiner Museum of Ceramic Art, and Curator Susan Jefferies, who put together a lecture and the special exhibit "Canada—Clay Today/Céramiques d'Aujourd'hui"

- The Textile Arts Centre of Chicago and Karen Carlson, who again make their expertise accessible to the public by offering a guided tour of fine fiber works at SOFA

- Craft Australia, the national craft organization in Australia that has consistently supported Australian galleries participating in SOFA

- The American Craft Council and Jeffrey Larris, sponsor of the artist's discussion, "Ideas as Objects" and host of a festive reception for exhibitors

- The Surface Design Association and Nancy Jones Wetmore, sponsor and co-presenter of SOFA's first-ever worldview of contemporary textiles and fiber art

- The Mint Museum of Craft + Design, whose Director Mark Leach and Curator Mary Douglas are making presentations

- The James Renwick Alliance of the Smithsonian Institution, Washington, DC, and David Montague, host of a national reception for members

- The Illinois Art Education Association, which again made SOFA CHICAGO part of its annual meeting program

- The many museums, universities and schools who bring groups to visit

We again thank the AIDS Foundation of Chicago for their creativity in organizing the 1999 benefit gala. Co-chairs Aldo Castillo and Ruth Sklar have pulled together a hard working committee from a broad cross section of the Chicago community. SOFA CHICAGO is proud to help the AFC in their mission to provide AIDS care and prevention programs in the Midwest.

I thank the team at Expression of Culture, Inc. whose talents, hard work and caring are the foundation of the successful production and promotion of the exposition; and GES, for their expert work. Lastly, thanks to all at the galleries for the incomparable exhibits and to the artists whose passion is at the core of the whole experience.

Mark Lyman

Mark Lyman

President

Expressions of Culture, Inc.

Expressions of Culture, Inc. would like to thank the following individuals for their time, efforts and understanding as this year's exposition evolved

Participating artists,
 galleries & speakers
AIDS Foundation of Chicago
AVHQ Sound & Stage Craft
American Airlines
Art Source
Sandra Berlin
Kathy Berner
Lincoln Boehm
Kate Bonansinga
Braun Creative Group
Sara Braun
Catherine Brillson
Fran Capua
Cardinal Colorprint
Chicago Art Dealers Association
Chicago Tribune
Dale Chihuly
Claridge Hotel
Diana Cobb
Kelly Colgan
Jay Coogan
Liz Cosgrove
Craft Australia
Daniel Crichton
DAX Transport
Floyd Dillman
Dobias Safe Service
Hugh Donlan
Anne Dowhie
Lenny Dowhie
David Drury
Jan Estep
Fast Signs
Lori Gray Faversham

Ellen Ferar
Fine Art Risk Management
Focus One
Don Friedlich
Robert Friedman
Fred Gnadt
GES Exposition Service
George R. Gardiner Museum
 of Ceramic Art
Jennifer Haybach
Josephine Heitter
The Henderson Company
Andre Herzog
Scott Hodes
Holiday Inn Chicago
 City Centre
Robyn Horn
Leonard Hull
Scott Jacobson
Sue Jefferies
Kate Jordan
John Keane
Deryk Langlais
David Li
Frances Lui
Marge Levy
Ellie Lyman
Nate Lyman
Jeanne Malkin
Arthur & Jane Mason

Anne McGahn
Lynne Melcher
Anne Meszko
Robert Meszko
Metropolitan Pier &
 Exposition Authority
Kate Mobley
David Montague
Susan Murphy
Louis Mueller
Ann Nathan
Oceanic Graphic Printing
Wells Offutt
Julie Oimoen
Molly Otting
Paul Pajor
Josh Phillips
Bruce Robbins
The Rylander Company
Terri Schafer
William & Jean Seabright
Sheraton Chicago Hotel & Towers
Deanna Shoss

Mary Beth Sova
Sterling Publishing
Swissotel
Trade Shoe Electric
VU Case Rentals
Natalie van Straaten
Israel Vines
WGN Flag
WXRT
William Seabright & Associates
William Warmus
Danny Warner
Michael Wathan
Greg Worthington
Nancy Wryobek
Don Zanone

AIDS Foundation
OF CHICAGO

411 South Wells Street
Suite 300
Chicago, IL 60607

Tel (312) 922-2322
Fax (312) 922-2916
TDD (312) 922-2917

Welcome to the opening night of SOFA CHICAGO 1999.

The AIDS Foundation of Chicago is very honored to be the beneficiary of the SOFA Opening Night Benefit presented by Dupont Pharmaceuticals. The monies raised through this event will help continue funding projects that educate and assist thousands of men, women, and young people throughout the Chicago metropolitan area impacted by HIV/AIDS.

Ten years ago, only a handful of Chicago-area organizations were involved in AIDS care and prevention programs. Responding to the spread of the epidemic, the AIDS Foundation of Chicago's grantmaking program has distributed over $8.5 million helping start dozens of new programs for people living with HIV/AIDS and enabling established groups to expand and improve their services to meet increased, and increasingly complex, demand.

We could not have come this far without the support and commitment of so many: our presenting sponsor, Dupont Pharmaceuticals; our devoted volunteers; the hard working AFC staff and so many others whose dedication to supporting those people living with HIV/AIDS and the people who help them has given us the strength to continue this critical work.

We are also thankful to SOFA CHICAGO 99, its producer Expressions of Culture, Inc. and Mark Lyman, whose vision, creativity, and philanthrophy gave us this opportunity and to our wonderful benefit committee and sponsors who have helped us create this extraordinary evening.

So many people whose lives have been affected by the AIDS epidemic have significantly touched so many in the arts community. Tonight, through SOFA CHICAGO 99 and this benefit,
the arts community will positively touch those people whose lives have been affected by HIV/AIDS.

Thank you for your understanding and for joining us this evening. Your contribution is very much appreciated, and will be put to good use.

Aldo Castillo
Co-Chair
SOFA Opening Night Benefit

Ruth Sklar
Co-Chair
SOFA Opening Night Benefit

AIDS FOUNDATION OF CHICAGO

The AIDS Foundation of Chicago was organized in 1985 by health professionals and civic leaders to coordinate local response to the AIDS epidemic. Today, there are nearly 34,000 HIV/AIDS cases in metropolitan Chicago, and more than 130 local organizations offering care.

At the same time that powerful new drugs are helping people infected with HIV live longer, the number of people newly infected with HIV continues to rise— with AIDS spreading rapidly among women, young people, minority populations and IV drug users.

As the AIDS epidemic continues to move through its second decade, the need for local leadership and coordination to address these new challenges has never been greater. Effective public education, advocacy for sound public policies and increased funding, and coordination of programs serving different populations are vitally important.

The AIDS Foundation is the largest source of private philanthropic support for AIDS care and prevention programs in the Midwest - supporting a wide range of organizations in our community that provide education, prevention, direct medical care, hospital care, and food and nutrition services among other services. With the support of generous people like you, AFC is able to continue to assist so many worthwhile programs.

For more information, write, call or fax the AIDS Foundation of Chicago at 411 South Wells Street, Suite 300, Chicago, Illinois 60607, phone: 312/922-2322, fax: 312/922-2916.

The AIDS Foundation of Chicago is deeply grateful to the following people for their donations of services, talents, guidance, and funds to the AIDS Foundation of Chicago. This benefit is a success because of their continued support, dedication, and understanding.

BENEFIT CO-CHAIRS

Aldo Castillo
Ruth Sklar

SOFA OPENING NIGHT BENEFIT COMMITTEE

(as of July 23, 1999)

Joanne Armenio
Richard L. Asch
Demetrius Barbee
Anthony Bruck
Tom Buchanan
Steve Buck
Carol & Doug Cohen
Gary S. Cohen
Leslie Cole-Morgan
Isiaah Crawford, II
Dirk S. Denison
Linda Eisenberg
Thomas J. Feie
Eudice & Robert L. Fogel
Martin D. Gapshis
Larry Giddings
Martha Goldberg
Valerie Hoffman
Ralph Hughes
Mr. & Mrs. Martin M. Israel
Leslie Jones
Lori & Stephen Kaufman
John Leonard
Stephen C. Mack
Kimberly A. Madigan
Martin N. Matthews
Gary Metzner
Brandon Neese
Richard L. Nelson
Ruth K. Nelson

Gerard Notario
Sarah Esler Pearsall
Ellen B. Pritzker
Donald H. Ratner
Bruce Robbins
Julio Rodriguez
Mary Lu Roffe
Marcia Sabesin
Judy A. Saslow Gallery
Judy A. Saslow
Rebecca Sive & Steve Tomashesfsky
Valerie Hoffman
Michael L. Sklar
Jeanne M. Sparrow
Joseph Powell Stokes
Frederick Thomas
Anthony Vaccaro
Barbara Van Dorf
John Viera
Cleo F. Wilson
Stephen L. Wood
Barbara Zoub & Bud Traub

FRIDAY, NOVEMBER 5

10 – 11 AM RM. 301 WOOD TURNING: PROCESS AND EVOLUTION
Philip Moulthrop discusses his process of making turned wood bowls and how it has evolved with the development of his work, from beginning to the present.

10 – 11 AM RM. 309 CHRISTINA Y. SMITH A discussion of the way in which politics, both national and personal, inspire the stories depicted in her brooch, container and teapot forms. Her most recent work includes sterling teapots and tea services. Sponsored by the Society of North American Goldsmiths (SNAG)

11 AM – 12 RM. 301 TWO LOOKS TO HOME In the playful style that characterizes his life and art, renowned artist **Tommy Simpson** takes a look at his youth in a small Midwestern town and its influence on his colorful and high-spirited art.

11 AM – 12 RM. 309 OBJECT LESSONS: COLLECTING, SORTING AND VISUAL DISPLAY, AND THE RELATIONSHIP TO MAKING ART Kathleen Browne, head of Jewelry/Metals/Enameling department at Kent State University, explores the relationship between what artists collect and the work they produce. Sponsored by the Society of North American Goldsmiths (SNAG)

12 – 1:30 PM RM. 301 FAQ: COLLECTING GLASS A panel of major American glass collectors and specialists tell you the questions they are most frequently asked, then answer them. Includes **Aviva Robinson, Dennis DuBois, Franklin Silverstone, Richard Basch** and **Lillian Zonars,** moderated by **Marge Levy,** Executive Director of Pilchuck Glass School, who will reserve time for YOU to ask YOUR questions. Sponsored by Pilchuck Glass School

12 – 1 PM RM. 309 CHALLENGING BOUNDARIES: CONTEMPORARY WOOD
A lecture focusing on the rich sculptural heritage and dynamic approaches of the leading artists working in turned wood. Presented by **John Brunetti,** Chicago-based art critic and the Illinois editor of dialogue. Sponsored by the Collectors of Wood Art.

1 – 2 PM RM. 309 FUTURAMA: FROM THIS POINT FORWARD
Mark Burns discusses his studio career in relationship to the millennial generation of American ceramic artists, looking ahead to the next era of ceramic innovation and those who will produce it. Burns is an associate professor and head of the ceramic department at the University of Nevada in Las Vegas.

1:30 – 2:30 PM RM. 301 LINEAGE: DRAWING FROM WESTERN ART HISTORY A look at aristocratic portraiture from the 16th Century, its relevance and how it translates into Rath's current work. **Tina Rath** is an MFA candidate at Sandberg Institute in Amsterdam. Sponsored by Art Jewelry Forum

2 – 3 PM RM. 309 VIRTUOSITY REVEALS THE MYSTERIES OF NATURE
"You have to be searching for the mysteries in nature to discover something new and beautiful. Through my work in glass I uncover meaning in things I wasn't previously aware of," says **Paul Stankard.**

2 – 4 PM RM. 305 SLIDES AND SLIDES OR WHAT'S HAPPENING IN WOOD TODAY Exciting slideshow and discussion by 24 wood artists, sponsored and selected by vote of the Collectors of Wood Art. An instant view of the best of what's happening in wood.

3 – 4:30 PM RM. 301 FIVE VOICES FROM THE FIBER WORLD Five artists who weave, stitch, knot, dye, pleat and quilt: **Michael James, Barbara Lee Smith, Candace Kling, Kate Anderson** and **Jon Eric Riis.** 1999 grants will be awarded by **Camille J. Cook.** Sponsored by the Friends of Fiber Art International

3 – 4:30 PM RM. 309 HOWARD, HOWEIRD! Howard Kottler— teacher, scholar, collector, philanthropist and artist—was a true Renaissance voice in contemporary American ceramic art. His career, work and influence will be illuminated by two people who knew him as a student, colleague, artist and friend: **Judith Schwartz,** New York University and **Mark Burns,** University of Nevada, Las Vegas

4:30 – 5:30 PM RM. 309 FOREST GIANTS EXPOSE MONUMENTAL DREAMINGS Marcus Tatton will introduce his large carved wooden urns by tracing influences and discoveries throughout their 15 year evolution.

4:30 – 6 PM RM. 301 GIVING THOUGHT FORM A profile of the work and philosophy of Rhode Island School of Design's glass and jewelry departments, discussing their educational roles in the context of American work in their fields. Presented by **Susan Holland,** Glass MFA '94 and faculty member **Barbara Seidenath,** Jewelry Department

6 PM RM. 301 CHIHULY IN THE LIGHT OF JERUSALEM 2000
To celebrate the millennium, **Dale Chihuly** revitalized the ancient city of Jerusalem with the vibrancy of glass. He will discuss the creation and significance of his 15 distinct installations set within the archeological ruins of the Tower of David Museum.

10 – 11 AM RM. 301 GEMSTONE CARVING A discussion of the arduous process of releasing forms from gemstones, a very unforgiving medium. Includes a depiction of mastery of Faberge methods as well as the breakthrough innovative techniques developed by **Andreas von Zadora-Gerlof,** whose work is inspired by nature.

10 – 11 AM RM. 309 ART JEWELRY: DIMENSIONS OF INTIMACY
The variety of ways that contemporary artists exploit jewelry's intimacy with the body – from sensual statement to visions of the "functional body." **Tacey Rosolowski** has lectured and published on the arts and art jewelry. Sponsored by the Society of North American Goldsmiths (SNAG)

11 AM – 12 RM. 309 VESSEL AS ICON AND OTHER STORIES
Sidney Hutter discusses his work over the past twenty years, including the unique Ultraviolet laminating and cold sculpted glassworking techniques that he uses in his glass sculpture.

11 AM – 12 RM. 301 SOUTHERN ARTISTS—VOICES OF A NEW GENERATION A look at some artists working in the southern states today, with an emphasis on those in the Mint's collection, whose practice will be contextualized with older generations and traditional craft of the region. **Mary Douglas,** curator, Mint Museum of Craft + Design, Charlotte, NC

12 – 1 PM RM. 309 BEYOND KNOWN FRONTIERS: THE KILN-CAST SCULPTURES OF IVAN MARES An independent studio artist living and working in the Czech Republic, **Ivan Mares'** massive glass sculptures embody a marriage of art and technology, while his conceptual concerns challenge the technological limits of the material.

12 – 1 PM RM. 301 CANADA – CLAY TODAY Canadian ceramic artists have made a significant contribution to the international ceramic scene, providing a lively discussion of aesthetics, usage (traditional/functional) and clay as metaphor. **Susan Jefferies,** curator of contemporary ceramics, The George R. Gardiner Museum of Ceramic Art, Toronto, Canada

1 – 2 PM THE WAY WE WORK: ROUGH CUT BURL TO FINISHED FORM
Functional furniture, wood turning and carving: a presentation of a variety of works in progress by **Michelle** and **David Holzapfel.** Includes furniture and vessel forms and a discussion of the materials, techniques and design processes that shape them. Sponsored by Collectors of Wood Art

1 – 2 PM RM. 301 ADVOCATE FOR ARTISTS: THE STUDIO OF THE CORNING MUSEUM OF GLASS Each year the Art Alliance for Contemporary Glass (AACG) honors one outstanding institution with a grant – this year it is the Glass Studio at the Corning Museum in Corning, New York. **Amy Schwartz,** the Head of "The Studio," will present the program. Sponsored by AACG

2 – 3:30 PM RM. 301 CONTEMPORARY WOODTURNING IN AMERICA
The emergence of the field of wood, including wood turning, sculpture, and furniture: **Bonita Fike,** associate curator, Detroit Institute of Art; **Glenn Adamson,** curator & researcher, Yale University; **Mark Leach,** director, Mint Museum of Craft + Design and **Jo Lauria,** assistant curator of decorative arts, Los Angeles County Museum of Art. Sponsored by the Collectors of Wood Art

2:30 – 3:30 PM RM. 309 IDEAS AS OBJECTS: PIKE POWERS
Trained as a sculptor, painter and glassblower, **Pike Powers** will talk about her use of both glass and painting as vehicles, which transform her ideas into tangible objects. Powers is Artistic Program Director at Pilchuck Glass School. Sponsored by American Craft Council

3:30 – 4:30 PM RM. 309 A CABINET OF EVIDENCE Patrick Hall looks at his recent work, examining the expression of the personal through the stored object, and the notion of cabinets as receptacles of individual histories and narratives.

3:30 – 5 PM RM. 301 GLASS @ SHERIDAN: A NORTHERN PERSPECTIVE
Canadian glass designer **Jeff Goodman,** teacher and sculptor **Kevin Lockau** and glass artist **Susan Rankin** discuss their educational and studio experience, preceded by a brief overview of each artist's work. Introduced by **Daniel Crichton,** Professor and Glass Studio Head, Sheridan College, Oakville, Ontario.

4:30 – 5:30 PM ROOM 309 COOL STUFF AND OTHER VISUALS
Renown glass artist **Ginny Ruffner** talks about her work and influences

5 – 6:30 PM RM. 301 DYNAMIC SURFACE SURFACE: a worldview of contemporary textiles and fiber art, featuring images of the latest works by the most innovative artists working in fiber today; utilizing the newest tools and techniques available. **Michele Fricke,** associate professor of Art History, (contemporary textiles), Kansas City Art Institute; and **Nancy Jones Wetmore,** Executive Director of the Surface Design Association. Sponsored by Surface Design Association

5:30 – 6:30 PM RM. 309 BILLIE JEAN THIEDE: FROM JEWELRY TO HOLLOWARE TO TEAPOTS A discussion of the influences and experiences that have led to her recent metalwork. Thiede is a Professor of Art and Chair of the Metal Program at the University of IL at Urbana –Champaign. Sponsored by the Society of North American Goldsmiths (SNAG)

RESURGENCE OF THE BAROQUE IN CONTEMPORARY ART

BY KATE BONANSINGA

Dale Chihuly, *Floats*

In the autumn of 1996 Dale Chihuly's blown glass installations punctuated the aged architectural landscape of Venice, Italy. Purple ellipses of luminous glass hung together like clusters of over-sized grapes, waiting to be harvested. Canary-and apple-colored teardrop-shaped cells floated along the canals amongst the gondolas, contemporary accents in a city defined by an aesthetic of a bygone era. Chihuly's opulent sculptures seemed at home in Italy, birthplace of the Baroque, 1600-1750. Though Baroque was initially a derogatory label coined by 19th-century art critics, who respected the timelessness and order of the art of the Renaissance, it is currently experiencing a healthy resurgence. Today the term is used most frequently as an adjective.

Gianlorenzo Bernini (1598-1680) is possibly the best remembered Italian Baroque artist. He was a sculptor, an architect and the interior designer for St. Peter's in Rome, where he orchestrated complex visual relationships between constructions made of bronze, marble, gilded wood, stucco and colored glass. The cathedral is a splendid realm with filtered sunlight illuminating the artist's orgiastic display of figurative sculptures and decorative architectural elements. His cast bronze baldacchino, over 100 feet tall, is a canopy for the altar beneath the cathedral's great dome and a focal point for the interior.

Some may think it's a stretch to compare Bernini to Chihuly, but their art is parallel in several respects. Both excel in the creation of grand-scaled pieces that command their surrounding space. They share a fondness for extravagant and mesmerizing displays. Like Bernini, Chihuly orchestrates teams of artists. Though one can only imagine the atmosphere of the Baroque artist's studio, Chihuly's work place can easily be likened to the set of a Fellini film, frenetic with activity. His postmodern embrace of team effort in the creation of visual objects draws upon pre-Modern practices.

Both the Baroque and Postmodern eras are marked by significant advances pertaining to communication and travel. Seminal figures include Newton, Galileo, Jobs and Gates. During

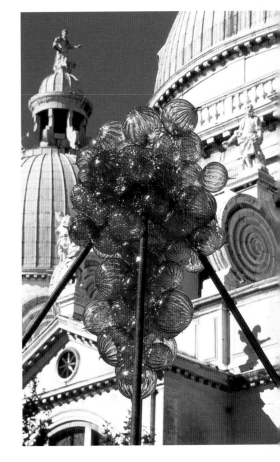

ABOVE: Dale Chihuly, *Chandelier*
Chihuly Over Venice

LEFT: Ginny Ruffner
Beauty of Perception

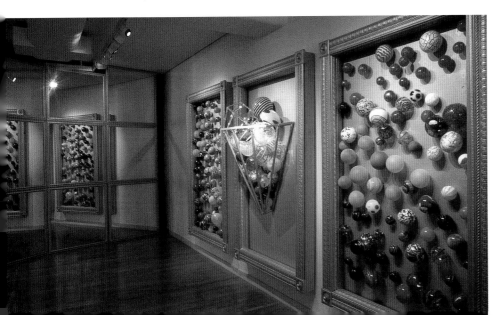

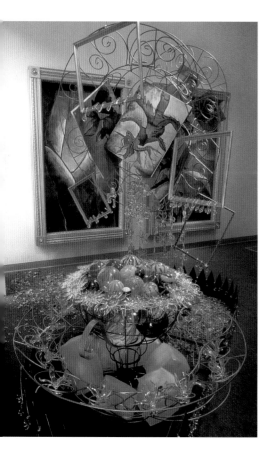

Ginny Ruffner
Large Conceptual Narratives:
Concocting a New Beauty

both eras humankind gained an expanded perception of the near and the far, the small and the large, and the relationships between them. Bernini set the artistic standard during the Baroque. Conversely, Chihuly is only one among a multitude of contemporary artistic voices. But both Bernini and Chihuly react to times of great change with an aesthetic of abundance.

If Chihuly nods to Bernini in his creation of architectural-scale sculptures that elicit a visceral response, Ginny Ruffner takes her cue from the Baroque master's interest in illusion. One of Bernini's best known works is the *Ecstasy of St. Teresa* in the Cornaro Chapel, also in Rome. At center stage, like-sized marble figures portray a divine moment; an angle pierces St. Teresa's bosom with the fiery dart of Divine love, as the nun swoons with anguished pleasure. Gilt streams of light shine down on the scene, seemingly emitted from an extraterrestrial space behind the pediment, carved with putti and florid plant life. On the periphery, marble renditions of the members of the Cornaro family witness Teresa's transverberation. Faces wrinkle and torsos twist with awe as they watch from their balcony-like "corretti." Bernini's chapel becomes a stage populated by the artist's contemporaries and by spirits from the past. Earth and heaven, ephemera and matter converge by Bernini's hand. The presence of modern-day visitors further compresses time and space.

In a similar spirit, Ruffner explores the transformative potential of illusion. In the recent installation *The Perception of Beauty/The Beauty of Perception,* a pair of framed mirrors straddles a corner where two walls meet. Adjacent to the right mirror is a massive gilded frame articulating a series of colorful glass spheres. These frames are deliriously ornate. As the viewer approaches, he or she is reflected in a series of virtual images. The viewer becomes a formal element, much like the viewer becomes an actor on Bernini's stage.

Another of Ruffner's installations, *Conceptual Narratives,* toys with viewers' expectations. Empty frames hang from the ceiling and act as borders surrounding the mixed-media, abstract sculptures placed on the floor behind them. By framing the three dimensional Ruffner confounds the Renaissance desire to recreate a three-dimensional world on a two-dimensional surface. Her individual sculptures writhe,

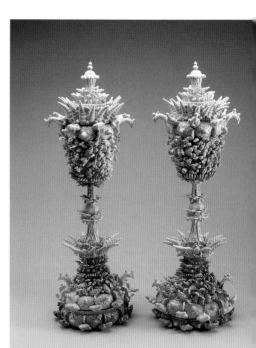

Susan Beiner
Mantle Jars

compilations of twisted glass vines pulsing with Baroque drama.

Ceramist Susan Beiner uses the historical format of decorative arts for her extravagant sculptural expressions. She creates plaster molds from construction materials, such as rebar and fasteners. These applied forms are literally crammed together onto a base vessel. They project a visual weight akin to Bernini's baldacchino at St. Peter's, though on a much smaller scale. Luster applied over manganese provides a satin sheen. Though industrial materials are Beiner's baseline, her final works emanate the organic. She thus refers to the tension between the manufactured and the natural. The artist currently resides in Detroit and was born in Elizabeth, New Jersey, and is consequently familiar with manufacturing environments and their unexpected beauty.

Beiner's sculptures reside in the space between polarities, just as Baroque churches and

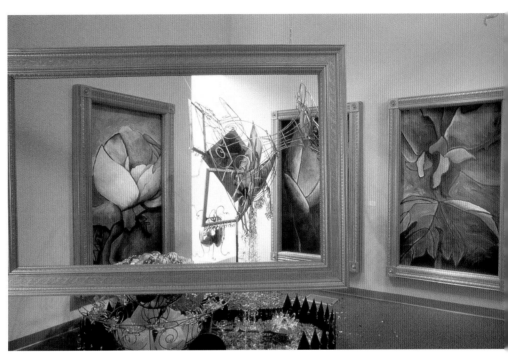

Ginny Ruffner
Large Conceptual Narratives: Concocting a New Beauty

their related arts were a crossroads for the worldly and the other worldly. The Baroque and the contemporary are but two of the many eras that have been marked by evolutions in our understanding of time and space. However, many visual artists of today, including Dale Chihuly, Ginny Ruffner and Susan Beiner nod to their Baroque predecessors in their adoption of high drama, illusion and a grotesque floridity.

Kate Bonansinga is an art historian and critic

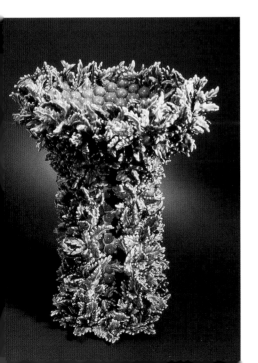

Susan Beiner
Bird Bath

19

GIVING THOUGHT FORM:

THE RISD EXPERIENCE

BY JAY COOGAN

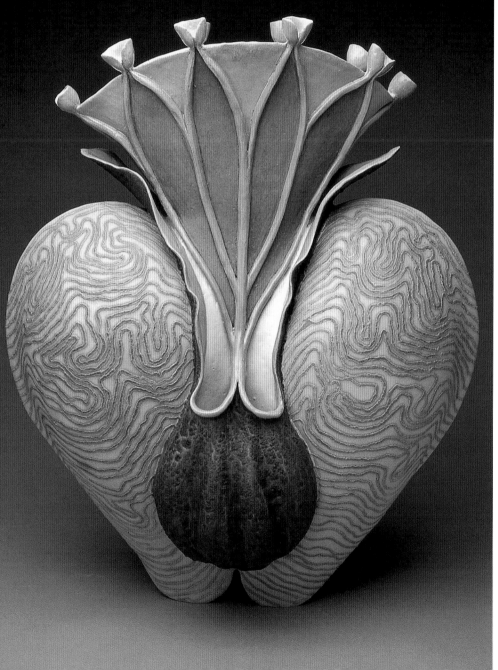

You will see an extraordinary number of alumni and faculty throughout the SOFA exhibition. The alumni who are represented at RISD's special exhibit at SOFA CHICAGO 1999 are all recent graduates chosen for the quality of their work. They are Nermin Kura, Ceramics MFA '97; Emi Ozawa, Furniture MFA '92; Susan Holland, Glass MFA '94; Seung Hea Lee, Jewelry MFA '98; Efharis Alepedis, Jewelry MFA '95; and Liz Collins, Textiles MFA, '99.

The Rhode Island School of Design (RISD) Departments of Ceramics, Furniture, Glass, Jewelry and Textiles, are represented at SOFA CHICAGO 1999 by six recent alumnae of these programs. The work of these artists embodies the hallmark of a RISD education, which places a high value on the powerful balance between

Nermin Kura
Untitled

Emi Ozawa
Pendulum Box

retained their traditional roots while incorporating the latest content and issues into their teaching. The strong emphasis on developing technical mastery across a range of skills and materials is evident in the goal of giving form to thought. The fundamentals of drawing and process, of researching and synthesizing from unique sources whether conceptual, historical or formal provide the foundation for the rich range of aesthetic development of our students. As you will see in the work that represents RISD at SOFA the influences of nature, geometry, memory and perception and the psychology of the body provide underlying themes for these artists.

I invite you to savor their work when you visit the RISD booth.

Jay Coogan is the Dean of Fine Arts at Rhode Island School of Design

Efharis Alepedis
Ring-Speciman From Nature

developing the hand and the mind. Through a well-defined curriculum these programs integrate design, craft and fine arts issues.

The philosophy of these programs is to provide a specialist's proficiency with humanistic values and broad artistic exploration. The studio experience at RISD revolves around the dynamics of inquiry, execution and critique set against the backdrop of pertinent history, theory and critical issues. The educational experience focuses on individuals and their practical and intellectual development as artists and designers. RISD's faculty work with students to stimulate analytical thinking that will help them develop a distinctly personal aesthetic.

While many schools have dissolved the boundaries between disciplines these areas have

Susan Bane Holland
Parabolic Bowl

Liz Collins
*knitted, felted wool
and elastic*

CANADA-CLAY
TODAY
CÉRAMIQUES
D' AUJOURD'HUI

BY SUSAN JEFFERIES

Bruce Cochrane, *Untitled*

Steve Heineman, *Untitled*

It is a great pleasure for the Gardiner Museum to present this exhibition of 20 pieces of contemporary ceramics from across Canada. This work illustrates the diversity of approaches to clay by Canadian artists and demonstrates their important contribution to the international ceramic scene.

Ceramics have changed dramatically in the last 50 years and the late 20th century opens an exciting new chapter in the story.

At this moment in ceramic history, interests are varied and eclectic. Painting, sculpture, the decorative arts, as well as political, social, moral and intellectual issues influence today's artist working in clay. These ideas, translated into a ceramic vocabulary, provoke a lively discussion of aesthetics, usage (traditional/functional) and clay as metaphor (conceptual work). As well, the ceramic materials themselves lead some artists to an intense study of the natural world.

What is startling, perhaps, at the start of a new millennium, is how strong the links are to our ceramic past, and how the study of important ceramic cultures by today's artists, has influenced contemporary work. This does not mean that the work produced is in any way derivative; in fact, resulting pieces are highly original, profound and often humorous. They tell us as much about our own age as the past.

Thus it is entirely fitting that museums such as the Gardiner, with its strong historical collections, should exhibit and acquire contemporary work. Both historical and contemporary work are enhanced by the wider public appreciation and discussion of the aesthetic and cultural role of clay.

Susan Jefferies is the Assistant Curator
of Contemporary Ceramics and Joint-Head
of Education and Programs at The George R.
Gardiner Museum of Ceramic Art, Toronto
and Curator of Canada-Clay Today
Céramiques d'Aujourd'hui

GLASS@SHERIDAN: PERSONAL REFLECTIONS
AFTER TWENTY YEARS OF TEACHING

BY DAN CRICHTON

Untitled, Jeff Goodman

Daniel Crichton is Professor and Glass Studio Head at Sheridan College, Oakville Ontario. He is also curator of the special exhibit Glass @ Sheridan: an alumni and faculty invitational exhibition, on view at SOFA CHICAGO 1999

In John Ralston Saul's reflections on Canada at the end of the twentieth century, he argues passionately that "Canada is above all an idea of what a country could be, a place of imagination. In spite of a recurring desire to find outside inspirations, it is very much its own invention." This experiment in nation building has been remarkably original in accommodating the three historic cultures, Aboriginal, English and French. In its unique northern context, pragmatically rooted in community-driven values, Canada has managed to avoid resorting to a centralized, dominant mythology. In its place there has evolved a vibrant multi-cultural ethos that is founded on an inherent respect and acceptance of its geographic and cultural complexity.

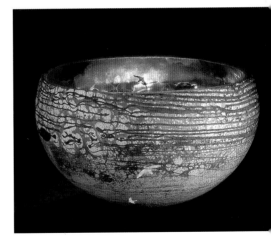

This radical experiment, inclusive and open-ended by nature, has been an inspiration to many Canadian artists. The same spirit of reconciliation and tolerance described by Saul pervades many of our cultural institutions, including the Glass Studio at Sheridan College. Over the past three decades it has offered scores of Canadians and international students access to the material by offering a comprehensive glass curriculum and program that encourages strong craft values, independent artistic research and thoughtful expression. Sheridan's glass studio is Canada's first and largest educational glass facility, with 8 faculty and staff and over 100 students and 50 majors enrolled in its course offerings. Since 1975 its graduates have been establishing studios and educational facilities across Canada.

The success of Sheridan's glass program can be attributed to these artists who have had the courage to follow through on a career that requires so much hard work and personal commitment. Over the years they have founded studios and evolved areas of expertise from glass casting and blowing to multi-media sculpture, and they are now passing on this experience to the next generation of students. It is the Dedication of artists/mentors like Susan Edgerley, Laura Donefer, Jeff Goodman, Kevin Lockau and Donald Robertson that forms the core of this wonderful spirit of trust and sharing that makes me very optimistic about the future of the glass arts in Canada.

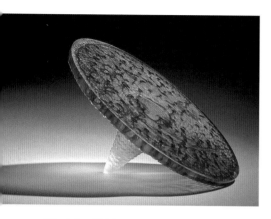

Whorl, Donald Robertson

Mayan Witch Pot, Laura Donefer

In the latter part of my career as an artist and mentor, I fully understand how enormously helpful it is to live and work in an educational space where each individual's experience, whatever its metamorphosis, has ample room to breathe and be transformed by this chameleon-like material. In essence, the constant challenge is embedded in the endless search for equilibrium between this environment of free discourse and expression and the extraordinary discipline demanded by the medium of glass and its rich history.

In approaching Susan Edgerley's mixed-media work you will see paper that looks like glass, glass that resembles ice or stone and metal that could be either. It is often the best artists, however, who are able to draw simplicity out of complexity. Susan's balanced use of these materials invariably results in her pieces resonating with one clear voice, offering an intimate connection with the imagination and lived experience of the artist and the viewer. In her words, "Sometimes beauty is not found in what is evident, but what is hidden underneath. When people talk to me about my work they always mention how it reminds them of something they have felt, experienced, or even imagined. I like when this happens because, at the edge of every association, it is confirmed that there is an element of truth in my reason for making what I make. And now we have been able to share something which is important to us both."

Laura Donefer takes a provocative and often emotive perspective in her work, challenging the stereotypical perceptions of both a woman's body and spiritual inner life. Laura's color treatment is often dramatic and expressive, the work being grounded in primitive and personal archeology that comes from the wild and vital roots of basic instincts. "My work concerns the unification of the earth-spirit with the human inner core, the marriage of molten glass interiors cooled to take on the vibrant colors of the life force. The search is for the primal voice that begs to tear itself out of the body and howl."

In his sculptural work, Jeff Goodman typically incorporates massive translucent sandcast glass with rugged industrial steel, concrete and stone. In contrasting these urban elements with the natural fluidity of the cast glass, Jeff's sculptures make reference to an archaic architecture, permeated by primitive icons and symbols. These robust objects often reach full human scale, serving as functional cabinets, tables and vessels. "At the outset, it was the effects of time on primitive objects that fascinated me. But I realized that my work had to reflect aspects of my own world, my

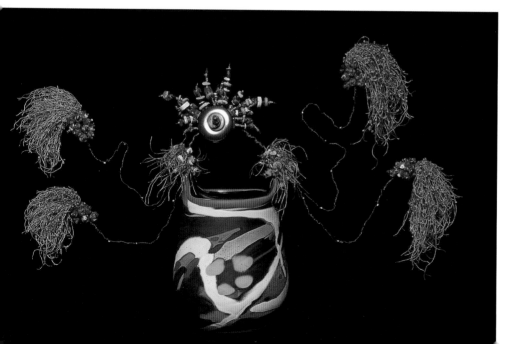

own society, i.e., the cracking of asphalt, the peeling layers of paint built up over decades, the erosion of our urban concrete environment."

Kevin Lockau's sculptures are thought of by many to be archetypically Canadian. Certainly the materials he incorporates in to his glasswork represent the untamed northern environment; beaver-chewed wood, fur and stone. But it is the underlying universal theme that captivates the viewer, especially his interest in reconciling the experience of a life lived in both the urban industrial environment with the indigenous natural world. Here glass becomes a metaphorical substance, the fluid solid, a poetic host for Kevin's vision of our animal spirit. "My work mirrors my life, my concerns, my relationship with others. It evolves as I change, adapt and move foreword in life. I carry my background in animal science, another season living in the bush and another year of rephrasing the question of how we are reconciled with nature."

A sculptor with a broad understanding of the material technology of glass, as well as a wide range of other metals, Donald Robertson is Canada's most celebrated virtuoso in the art of lost-wax kilncasting. Don's ability to understand the way the viscous glass moves in a mold at elevated temperatures has made it possible for him to experiment adventurously with three-dimensional form while evolving his alchemical aesthetic. "As an artist, my interest lies in revealing the links between the universe of ideas and their visible manifestations, transitional moments of balance of energy and matter, thought and action."

Territory, Kevin Lockau

Bench Mark,
Brad Copping

CHIHULY
THE
EXPLORER

BY WILLIAM WARMUS

He transforms glass into art, adults into children, children into artists. Dale Chihuly, the Tiffany for the new millennium, fuses performance art, environments and sculpture, creating luminous worlds that are never murky or cynical, always inspiring, but with the edginess that only brittle glass born from fiery hot furnaces can arouse.

Among the only living artists who can mount a blockbuster museum exhibition, the eminent critic Donald Kuspit has described Chihuly as "a legend in his own time." Collectors who have followed Chihuly's work for a long time know him as a maker of fabulous *Cylinders, Baskets, Seaforms, Venetians and Persians*. Increasingly, the world knows him as an artist-explorer who spends most of his time on the road, traveling with a team of as many as 30 people to install his art in spectacular settings including Jerusalem, Niijima island off the coast of Japan, and Venice.

Chihuly with *Yellow Spears* and *Blue Tower*, Jerusalem

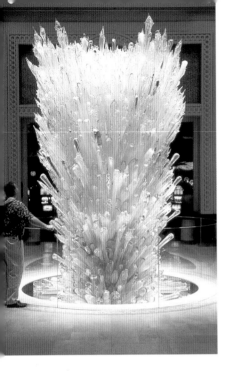

Crystal Gate (Atlantis)

It was the explorer in the artist that prompted Henry Geldzahler to remark that "Chihuly's work is American in its apparent vulgarity, its brazenness, and its fearlessness to move farther out west even if there is no further west to move to. There's a kind of pioneering spirit to it."

Chihuly is an incredibly inquisitive artist: spend even a few minutes with him and you may be asked your opinion about his most recent project, or to compare the day's headlines in the *New York Times* with those in *USA Today,* or for the best place nearby to find old Frisbees for his collection. Striking in appearance—he wears a black patch to cover an eye damaged in an automobile accident, and his paint-splattered, custom shoes are famous in the artworld-he "looks like a pirate and sometimes acts like a pirate," (Geldzahler's words) leading the life of a nomad, traveling widely to orchestrate installations, museum shows, glassblowing sessions.

And like a pirate, he has a crew. The injury to his eye combined with a bodysurfing accident in 1979 to lead Chihuly to refine a team system for creating art. Working within a group brings many benefits, including an energy and comradery that help to disperse Chihuly's depressive states, and the flavor of performance art permeates the blowing sessions, which have attracted a following among collectors and students. The unscripted character and high energy level of Chihuly-style glassmaking means that anything might happen, fast. Audiences are mesmerized by the elements of danger: blasting-hot furnaces, molten glass hanging off the ends of spear-shaped metal rods, the team members moving like gladiators as they struggle to control the process. From time to time, a fabulous piece that has taken hours to make explodes as it crashes to the ground.

At the same time the process is somehow comforting. The audience begins to recognize that the furnace around which it gathers (or

Jerusalem Cylinder—clear

witnesses on television) is like the hearth or campfire; the seeming chaos of the hot shop soon reveals a logic of its own, all carefully orchestrated as the team takes its cues from the maestro, the gaffer, the artist. It is all incredibly hot, and incredibly cool.

Sea Form Lap Pool
with swimmer

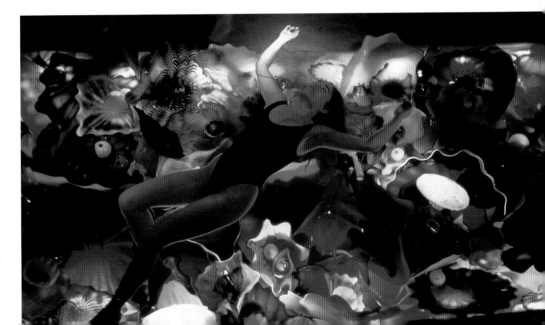

Best of all, unlike theater performances, where the ending can sometimes be a letdown, the end of the blowing session results in a solid object: an artwork. Chihuly seems to be practicing alchemy or magic, but the results are tangible!

Given his extreme curiosity and love of travel,

it was inevitable that Chihuly would become a pioneer explorer in and out of the artworld. The heroic age of exploration ended with Shackleton's famous Antarctic Expedition in 1915, replaced by the age of scientific exploration that peaked with the moon landings and robotic planetary probes in the late sixties and early seventies, and followed by the age of extreme exploration culminating in the never-ending ascents of Mount Everest. Chihuly suggests another way to explore the world: with art, with an eye for beauty. He has made a radical extension of art by taking it out of the museum and into the world, challenging it under the most dramatic and demanding circumstances, only to bring the art back into the museum or private collection, freshly energized and with an aura of triumphant return.

There are almost three decades of these explorations, including **20,000 Pounds of Ice and Neon,** created in 1971 with Jamie Carpenter; **Chihuly Over Venice** in 1996; and **Chihuly: In the Light of Jerusalem 2000.** Of the earliest, Kuspit commented: "Chihuly and Carpenter brought together primal elements-fire and ice-in a high-tech way, in effect raising the question of Robert Frost's poem: How will the world end? Will it freeze in ice or sizzle like neon?" For Venice, Chihuly re-wrote the ending, suggesting that it might be possible to complete the world with an amplification of beauty, brazenly daring to enhance the Venetian canals with glass ornaments in a city where glass is king, but curiously almost never displayed out of doors.

Jerusalem 2000 is perhaps the artist's most ambitious project. Installed in June, 1999 at The Tower of David Museum, it will remain into the

year 2000. There is a *Crystal Mountain*, 44 feet tall and consisting of tons of steel and…plastic! It gleams and thrusts, harsh as the Jerusalem sun, benign as the promise of paradise. And an even taller *Blue Tower*, composed of 2000 incredibly fragile glass arms, extends some 20 feet underground, probing the archaeological depths of the fortress, while in its airy heights birds have taken to nesting. In Crusader Hall, a vaulted room deep within the castle, a retrospective of Chihuly's signature blown-glass forms begins with the latest *Jerusalem Cylinders*, extraordinary collisions between the breath of the glassblower and massive chunked glass. Like the *Macchias*, which were dubbed the "uglies" when they first made an

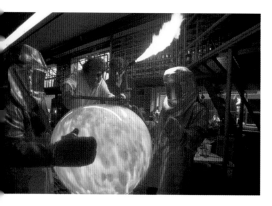

ABOVE: Chihuly studio

RIGHT: *Doge's Chandelier, Chihuly Over Venice*

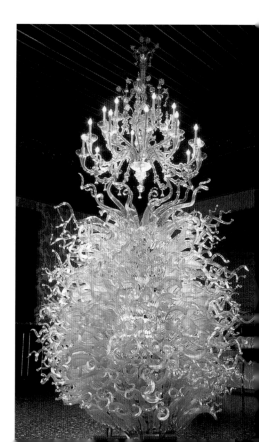

appearance, this new series seems too unripe, too pungent for most Chihuly traditionalists.

But that is Chihuly. Approaching 60, never satisfied, he cruises towards some distant unknown, never afraid to take chances, whether with plastics, or an exotic city, or a new "ugly." When the team had finished the installations in Jerusalem, and the audience arrived for opening night (they had expected 1500 but 2500 arrived), I realized that what Chihuly had sought to create within the sheltered walls was a kind of privileged domain. The three great religions represented in Jerusalem all make reference to such an ideal place, a spiritual garden or paradise: *Paridaida* (Old Persian), *paradeisos* (Greek), *prds* (Biblical Hebrew)-evolving into *Gan Eden,* later the Garden of Eden. These ideal gardens are always enclosed spots, suitable for walking and contemplation; sometimes paradise is located on a mountain top; sometimes it only appears after the world has been purified by fire. The startling colors of the glass (one piece titled Green Grass was greener than any grass I ever saw), the way the *Red Spears* led the eye to the *Crystal Mountain,* the looking-glass qualities of the *Niijima Floats*: all combined to transform the Chihuly installation at The Tower of David Museum into a garden of mythical proportions. Just as in the museum there is an elaborate nineteenth-century scale model of Jerusalem, so in a way Chihuly has built a model of paradise in the courtyard of the Citadel. An artist's paradise. The only place anywhere where you can see grass so green or spears so red, grass and spears purified by the fire of the furnace. If Chihuly ever "relents," as his friend Italo Scanga has urged, if he ever mellows and seeks safe harbor, it will have to be in such a haven.

William Warmus is a writer and former Curator of the Corning Museum

Copyright 1999 William Warmus

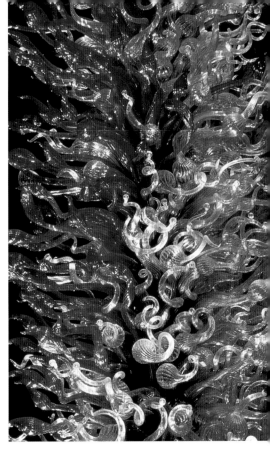

Blue Tower, Jerusalem, detail

LEFT: *Crystal Mountain,* Jerusalem

BELOW: *Crystal Mountain,* inside detail, Jerusalem

Aaron Faber Gallery
666 Fifth Avenue
New York, NY 10103
212.586.8411
fax 212.582.0205
info@aaronfaber.com

Adamar Fine Arts/
Modus Vivendi Galeries d'Art
177 NE 39th Street
Miami, FL 33137
305.576.1355
fax 305.576.0551
adamargal@aol.com

23-28 Place des Vosges
Paris 75003
France
33.1.4278.1010
fax 33.1.4278.1400
modus@galerie-modus.com

Aldo Castillo Gallery
233 West Huron
Chicago, IL 60610
312.337.2536
fax 312.337.3627
info@artaldo.com
www.artaldo.com

Ann Nathan Gallery
218 West Superior
Chicago, IL 60610
312.664.6622
fax 312.664.9392
nathangall@aol.com

Aron Packer
Guest Curator at Yello Gallery
1630 North Milwaukee Avenue
Chicago, IL 60647
773.235.9731
or 773.743.2825

ARTEFACT International
Suite 103, Level 1
129 Fitzroy Street
St. Kilda, Melbourne, Victoria 3182
Australia
61.3.9534.4443
fax 61.3.9534.4449
artefact@webtime.com.au

Beaver Galleries
Beaver Galleries
81 Denison Street
Deakin, Canberra, ACT 2600
Australia
61.2.6282.5294
fax 61.2.6281.1315
beaver@interact.net.au

Belloc Lowndes
Fine Art Gallery, Inc.
300 West Superior, Suite 203
Chicago, IL 60610
312.573.1157
fax 312.573.1159
belloclowndes@bigplanet.com

Blue Spiral 1
38 Biltmore Avenue
Asheville, NC 28801
828.251.0202
fax 828.251.0884
bluspiral1@aol.com

The Bullseye Connection
300 NW Thirteenth Avenue
Portland, OR 97209
503.227.2797
fax 503.227.2993
gallery@bullseye-glass.com

Chappell Gallery
14 Newbury Street
Boston, MA 02116
617.236.2255
fax 617.236.5522
amchappell@aol.com

Charon Kransen
357 West 19th Street
New York, NY 10011
212.627.5073
fax 212.633.9026
chakran@earthlink.net

Chinalai Tribal Antiques, Ltd.
52 Woodville Road
P.O. Box 815
Shoreham, NY 11786
516.821.4272
fax 516.821.4272
cta@unix.asb.com

Compositions Gallery
317 Sutter Street
San Francisco, CA 94108
415.693.9111
fax 415.693.9344
info@compositionsgallery.com

Coplan Gallery
608 Banyan Trail
Boca Raton, FL 33431
561.994.9151
fax 561.994.5864
netters@flinet.com

Cylindra Gallery
Tusvik
N-6222 Ikornnes
Norway
47.7025.0033
fax 47.7025.0014
cylindra-objects@cylindra.no

del Mano Gallery
11981 San Vicente Boulevard
Los Angeles, CA 90049
310.476.8508
fax 310.471.0897
delmano@aol.com

Despard Gallery
15 Castray Esplanade
Hobart, Tasmania 7000
Australia
61.3.6223.8266
fax 61.3.6223.6496
eajoyce@trump.net.au
www.despard-gallery.com.au

Donald Ellis Gallery
RR #3
Dundas, Ontario L9H 5E3
Canada
905.648.1837
fax 905.648.8711
ellisgal@interlynx.net

Douglas Dawson
222 West Huron Street
Chicago, IL 60610
312.751.1961
fax 312.751.1962
ddgallery@aol.com

Elliott Brown Gallery
619 North 35th Street, #101
Seattle, WA 98103
206.547.9740
fax 206.547.9742
kate@elliottbrowngallery.com

Ferrin Gallery
179 Main Street
Northampton, MA 01060
413.586.4509
fax 413.586.4512
laferrin@ix.netcom.com
www.ferringallery.com

Finer Things Gallery
1898 Nolensville Road
Nashville, TN 37210
615.244.3003
fax 615.254.1833
www.finerthingsgallery.com

Gail Severn Gallery
620 Sun Valley Road
Ketchum, ID 83340
208.726.5079
fax 208.726.5092
gseverngallery@svidaho.net

**Galerie des Métiers
d'Art du Québec**
350 Saint-Paul East, Suite 400
Montreal, Quebec H2Y 1H2
Canada
514.861.2787
fax 514.861.9191
cmaq@metiers-d-art.qc.ca

Galerie Elena Lee Verre d'Art
1428 Sherbrooke West
Montreal, Quebec H3G 1K4
Canada
514.844.6009
fax 514.844.1335
glasart@cam.org

Galerie Na Jànském Vršku
Jànský Vršek 15
Prague 11800
Czech Republic
4202.57531546
fax 4202.24255694
jitka.pokorna@telecom.cz

Galerie Rob van den Doel
Anna Paulownastraat 105
The Hague 2518 BD
The Netherlands
31.70.364.6239
31.65.389.0581
fax 31.70.361.7612
info@galerierobvandendoel.com

Gallery 500
Church and Old York Roads
Elkins Park, PA 19027
215.572.1203
fax 215.572.7609

Gia Designer Jewelry
64 East Walton Street
Chicago, IL 60611
312.944.5263
fax 312.944.6873
www.giajewelry.com

Glass Artists' Gallery
70 Glebe Point Road
Glebe, Sydney, NSW 2037
Australia
61.2.9552.1552
fax 61.2.9552.1552
glassartistsgallery@bigpond.com

The Glass Gallery
4720 Hampden Lane
Bethesda, MD 20814
301.657.3478
fax 301.657.3478
salgall@worldnet.att.net

Habatat Galleries
7 North Saginaw Street
Pontiac, MI 48342
248.333.2060
fax 248.333.2717

222 West Superior
Chicago, IL 60610
312.440.0288
fax 312.440.0207

608 Banyan Trail
Boca Raton, FL 33431
561.241.4544
fax 561.241.5793

117 State Road 7
Great Barrington, MA 01230
413.528.9123

Heller Gallery
420 West 14th Street
New York, NY 10014
212.414.4014
fax 212.414.2636
info@hellergallery.com

Heltzer
Suite 1800
Merchandise Mart
Chicago, IL 60654
312.527.3010
fax 312.527.3176

Holsten Galleries
Elm Street
Stockbridge, MA 01262
413.298.3044
fax 413.298.3275
artglass@holstengalleries.com

J. Cacciola Galleries
501 West 23rd Street
New York, NY 10011
212.462.4646
fax 212.462.4556
jcacciola@aol.com

Jean Albano Gallery
215 West Superior
Chicago, IL 60610
312.440.0770
fax 312.440.3103

Jewelers' Werk Galerie
2000 Pennsylvania Avenue NW
Washington, DC 20006
202.293.0249
fax 202.659.4149

Joan Guaita-Art
Verí, 10
Palma de Mallorca
Baleares 07001
Spain
34.971.715989
fax 34.971.715898

John Elder Gallery
529 West 20th Street, 7th floor
New York, NY 10011
212.462.2600
fax 212.462.2510
mail@johnelder.com
www.johnelder.com

John Natsoulas Gallery
140 F Street
Davis, CA 95616
530.756.3938
fax 530.756.3961
art@natsoulas.com

Katie Gingrass Gallery
241 North Broadway
Milwaukee, WI 53202
414.289.0855
fax 414.289.9255
katieg@execpc.com

L.H. Selman Ltd.
123 Locust Street
Santa Cruz, CA 95060
831.427.1177
fax 831.427.0111
selman@paperweight.com

Leo Kaplan Modern
41 East 57th Street, 7th floor
New York, NY 10022
212.872.1616
fax 212.872.1617
lkm@lkmodern.com

Lyons Wier Gallery, Inc.
300 West Superior
Chicago, IL 60610
312.654.0600
fax 312.654.8171
chgoartdlr@aol.com

Mariposa Gallery
113 Romero NW Old Town
Albuquerque, NM 87104
505.842.9097
fax 505.842.9658
fay@mariposa-gallery.com

3011 Monte Vista NE
Albuquerque, NM 87106
505.265.7966
fax 505.266.0005

Maruku Arts & Crafts
CMA Ininti Store
Ayers Rock, NT 0872
Australia
61.8.8956.2153
fax 61.8.8956.2410
maruku@bigpond.com

Marx-Saunders Gallery, Ltd.
230 West Superior
Chicago, IL 60610
312.573.1400
fax 312.573.0575
marxsaunders@earthlink.net

Maurine Littleton Gallery
1667 Wisconsin Avenue NW
Washington, DC 20007
202.333.9307
fax 202.342.2004
mlittle972@aol.com

Miller Gallery
560 Broadway
New York, NY 10012
212.226.0702
fax 212.334.9391
info@millergallery.com
www.millergallery.com

Mobilia Gallery
358 Huron Avenue
Cambridge, MA 02138
617.876.2109
fax 617.876.2110
mobiliaart@aol.com

Mostly Glass Gallery
3 East Palisade Avenue
Englewood, NJ 07632
201.816.1222
fax 201.816.9582
info@mostly-glass.com
www.mostly-glass.com

Narek Galleries
292 Wanna Wanna Road
via Queanbeyan, NSW 2620
Australia
61.2.6299.2731
fax 61.2.6299.2731

Niemi Fine Art Gallery
39370 North Route 59, Unit B
Lake Villa, IL 60046
847.265.2343
fax 847.356.6908
gallery@bruceniemi.com

The O. Group
152 Franklin Street
New York, NY 10013
212.431.5973
fax 212.431.0259

Option Art
4216 de Maisonneuve Blvd. W., #302
Montreal, Quebec H3Z 1K4
Canada
514.932.3987
fax 514.938.3171

Perimeter Gallery, Inc.
210 West Superior Street
Chicago, IL 60610
312.266.9473
fax 312.266.7984
artchicago@aol.com

Portals Ltd.
742 North Wells
Chicago, IL 60610
312.642.1066
fax 312.642.2991
artisnow@aol.com

Portia Gallery
207 West Superior
Chicago, IL 60610
312.932.9500
fax 312.932.9501
portia1@interaccess.com

Prime Gallery
52 McCaul Street
Toronto, Ontario M5T 1V9
Canada
416.593.5750
fax 416.593.0942
prime@ican.ca

R. Duane Reed Gallery
1 North Taylor
St. Louis, MO 63108
314.361.8872
fax 314.361.1788
reedart@primary.net

215 West Huron
Chicago, IL 60610
312.932.9828
fax 312.932.9753

Raglan Gallery
5-7 Raglan Street
Manly, NSW 2095
Australia
612.99770906
fax 612.99770906

REVOLUTION
23257 Woodward Avenue
Ferndale, MI 48220
248.541.3444
fax 248.541.1914
gallery@revolutn.com

525 West 22nd Street, #4D
New York, NY 10011
212.463.8037
fax 212.242.1439
revolutnny@aol.com

Riley Hawk Galleries
16 Central Way
Kirkland, WA 98033
425.576.0762
fax 425.576.0772
seattleinfo@rileyhawk.com

2026 Murray Hill Road
Cleveland, OH 44106
216.421.1445
fax 216.421.1435
cheri@rileyhawk.com

642 North High Street
Columbus, OH 43215
614.228.6554
fax 614.228.6550
sherrie@rileyhawk.com

Sandy Carson Gallery
125 West Twelth Avenue
Denver, CO 80204
303.573.8585
fax 303.573.8587
scarson@ecentral.com

NEW LOCATION
760 Santa Fe Drive
Denver, CO 80204
303.573.8585
fax 303.573.8587
scarson@ecentral.com

**Serge Lechaczynski/
Galerie Internationale du Verre**
à la Verrerie de Biot
Chemin des Combes
Biot 06410
France
33.49.365.0300
fax 33.49.365.0056
verrerie@biotverre.fr

Sherry Leedy Contemporary Art
2004 Baltimore Avenue
Kansas City, MO 64108
816.221.2626
fax 816.221.8689
leedyart@gvi.net

Snyderman/Works Galleries
303 Cherry Street
Philadelphia, PA 19106
Snyderman: 215.238.9576
Works: 215.922.7775
fax 215.238.9351

Steuben
717 Fifth Avenue
New York, NY 10022
212.752.1441
fax 212.832.4944
kedelson@corning.com

Susan Cummins Gallery
12 Miller Avenue
Mill Valley, CA 94941
415.383.1512
fax 415.383.0244
scumminsg@aol.com

Susan Whitney Gallery
2220 Lorne Street
Regina, Saskatchewan S4P 2M7
Canada
306.569.9279
fax 306.352.2453
swgallery@hotmail.com

Tai Gallery/Textile Arts, Inc.
1571 Canyon Road
Santa Fe, NM 87501
505.983.9780
fax 505.989.7770
gallery@textilearts.com

Tercera Gallery
534 Ramona Street
Palo Alto, CA 94301
650.322.5324
fax 650.322.5639

24 North Santa Cruz Avenue
Los Gatos, CA 95030
408.354.9484
fax 408.354.0965

550 Sutter Street
San Francisco, CA 94102
415.773.0303
fax 415.773.0306

Thomas Mann Gallery
1804 Magazine Street
New Orleans, LA 70130
504.581.2113
or 800.923.2284
fax 504.568.1416
tmd@thomasmann.com

UrbanGlass
647 Fulton Street
Brooklyn, NY 11217
718.625.3685
fax 718.625.3889
www.urbanglass.com

William Zimmer Gallery
Box 263
Mendocino, CA 95460
707.937.5121
fax 707.937.2405

Yaw Gallery
550 North Old Woodward
Birmingham, MI 48009
248.647.5470
fax 248.647.3715

A

Abe, Motoshi
Tai Gallery/Textile Arts, Inc.

Abrams, Whitney
Charon Kransen

Adam, Jane
Jewelers' Werk Galerie

Adams, Dan
Mobilia Gallery

Adams, Hank Murta
Elliott Brown Gallery

Adams, Renie Breskin
Mobilia Gallery

Ahlgren, Jeanette
Katie Gingrass Gallery
Mobilia Gallery

Akagi, Chieko
Yaw Gallery

Akers, Adela
Snyderman/Works Galleries

Aldridge, Peter
Steuben

Allen, Ray
del Mano Gallery

Amigo, Frank
del Mano Gallery

Anderson, Dan
Gail Severn Gallery
Snyderman/Works Galleries

Anderson, Kate
Mobilia Gallery
R. Duane Reed Gallery

Anderson, Ken
R. Duane Reed Gallery

Andersson, Jonathan
Mostly Glass Gallery

Andres, Julia
Portals Ltd.

Angelino, Gianfranco
del Mano Gallery

Annear, Paul
Charon Kransen

Appel, Cricket
Ferrin Gallery

Appel, Nicolai
Charon Kransen

Arbuckle, Linda
Mobilia Gallery

Arentzen, Glenda
Aaron Faber Gallery

Argueyrolles, Jean-Jacques
Adamar Fine Arts/
 Modus Vivendi Galeries d'Art

Arleo, Adrian
Snyderman/Works Galleries

Arner, Franz
William Zimmer Gallery

Arneson, Robert
John Natsoulas Gallery

Arnold, Anna
Mobilia Gallery

Avaalaaqiaq, Irene
Susan Whitney Gallery

Aydlett, Chuck
Ferrin Gallery

Ayotte, Rick
L.H. Selman Ltd.

B

Baba, Junichiro
Chappell Gallery

Babetto, Giampaolo
Jewelers' Werk Galerie

Bach, Carolyn Morris
William Zimmer Gallery

Bachorik, Vladimir
Compositions Gallery

Bahlmann, Alexandra
Charon Kransen

Bailey, Clayton
John Natsoulas Gallery

Bakker, Ralph
Charon Kransen

Balasov, Andrei
Charon Kransen

Baldwin, Philip
Portia Gallery

Balgavy, Milos
Galerie Rob van den Doel

Bally, Boris
Thomas Mann Gallery

Banner, Michael
Yaw Gallery

Barnaby, Margaret
Susan Cummins Gallery

Bauer, Jim
John Natsoulas Gallery

Baum, Jan
Mobilia Gallery

Bean, Bennett
Susan Cummins Gallery

Beard, Peter
William Zimmer Gallery

Beck, Rick
Heller Gallery

Becker, Michael
Charon Kransen

Beecham, Gary
Maurine Littleton Gallery

Behar, Linda
Mobilia Gallery

Ben Haim, Patricia
Galerie des Métiers
 d'Art du Quebec

Bencomo, Derek
del Mano Gallery

Benes, Janet
Heltzer

Bennett, Garry Knox
Leo Kaplan Modern

Bennett, Jamie
Susan Cummins Gallery

Berlet, Marc
Adamar Fine Arts/
 Modus Vivendi Galeries d'Art

Berman, Harriete Estel
Charon Kransen
Mobilia Gallery

Berringer, Mary
Mobilia Gallery

Bettison, Giles
The Bullseye Connection

Bigger, Michael D.
Niemi Fine Art Gallery

Biggs, Lorraine
Despard Gallery

Bikakis & Johns
Yaw Gallery

Bilek, Ilja
Galerie Na Jánském Vršku

Bishop, Mark
Despard Gallery

Blavarp, Liv
Charon Kransen

Blazina, Jennifer
The Glass Gallery

Blomdahl, Sonja
R. Duane Reed Gallery

Bloomfield, Greg
Leo Kaplan Modern

Bodemer, Iris
Jewelers' Werk Galerie

Bohls, Margaret
Mobilia Gallery

Bohus, Zoltan
Galerie Rob van den Doel

Bokesch-Parsons, Mark
Miller Gallery

Book, Flora
Mobilia Gallery

Borella, Claudia
The Bullseye Connection

Borst, Andrea
Charon Kransen

Boselli, Jean Pierre
Option Art

Bottomley, Stephen
Jewelers' Werk Galerie

Bourgeois, Louise
Joan Guaita-Art

Boyadjiev, Latchezar
Compositions Gallery

Boyd, Michael
Mariposa Gallery
Mobilia Gallery

Brady, Robert
John Elder Gallery

Braham, Frederic
Jewelers' Werk Galerie

Braunstein, Stuart
Miller Gallery

Brekke, John
Leo Kaplan Modern

Bremers, Peter
Miller Gallery

Brink, Joan
Katie Gingrass Gallery

Brinkmann, Esther
Charon Kransen

Broullard, William
Mobilia Gallery

Brown, Charlotte
Portals Ltd.

Browne, Kathleen
Susan Cummins Gallery

Bryant, Anthony
del Mano Gallery

Brychtová, Jaroslava
Galerie Na Jánském Vršku
Galerie Rob van den Doel

Buck, Andy
John Elder Gallery

Buck, Kim
Charon Kransen

Buddle, Roger
ARTEFACT International

Burchard, Christian
del Mano Gallery

Burger, Falk
Yaw Gallery

Burleson, Mark
Blue Spiral 1
Mobilia Gallery

Burns, Mark
Ferrin Gallery

Bulter, Mr.
Maruku Arts & Crafts

Butt, Harlan W.
Yaw Gallery

Buzzini, Chris
L.H. Selman Ltd.
Riley Hawk Galleries

Byers, John Eric
John Elder Gallery
Tercera Gallery

C

Caldwell, Dorothy
Prime Gallery

Calkins, Larry
Gallery 500

Calyer, Sean
John Elder Gallery

Carignan, Danielle
Option Art

Carlson, William
Marx-Saunders Gallery, Ltd.

Carr, Tanija & Graham
Beaver Galleries

Carrigy, Peter
Narek Galleries

Carter, James
Thomas Mann Gallery

Cash, Sydney
Chappell Gallery

Castle, Wendell
Leo Kaplan Modern

Cecchetto, Giorgio
Jewelers' Werk Galerie

Cepka, Anton
Charon Kransen

Chandler, Gordon
Ann Nathan Gallery

Chang, Kim
UrbanGlass

Chapman, David
REVOLUTION

Charbonnet, Suzanne
UrbanGlass

Charbonnet, Thais
Thomas Mann Gallery

Chardiet, José
Leo Kaplan Modern
Marx-Saunders Gallery, Ltd.

Chatterley, Mark
Gallery 500

Chavent, Françoise & Claude
Aaron Faber Gallery

Chihuly, Dale
Habatat Galleries
Holsten Galleries

Chotard, Cathy
Charon Kransen

Christensen, Cherie
William Zimmer Gallery

Christensen, Kip
del Mano Gallery

Chu, Shao-Pin
Charon Kransen

Cicansky, Victor
Susan Whitney Gallery

Cigler, Vaclav
Galerie Na Jánském Vršku
Galerie Rob van den Doel

Cinnamon, Olga Dvigoubsky
Snyderman/Works Galleries

Clague, Lisa
John Elder Gallery
John Natsoulas Gallery

Clarke, Glen
Despard Gallery

Class, Petra
Susan Cummins Gallery

Clayman, Daniel
Habatat Galleries

Clements, Stephen
Miller Gallery

Cliffel, Kristen
Mobilia Gallery

Cocks, Deb
Glass Artists' Gallery

Coddington-Rast, Ann
Lyons Wier Gallery, Inc.

Cohen, Mardi Jo
Snyderman/Works Galleries

Colette
Aaron Faber Gallery

Collett, Susan
Mobilia Gallery

Colombino, Carlos
Aldo Castillo Gallery

Contractor, Donna
Mariposa Gallery

Cook, Lia
Maurine Littleton Gallery
Perimeter Gallery, Inc.

Cooley, Billy
Maruku Arts & Crafts

Cooper, Diane
Jean Albano Gallery

Cooperman, Andrew
Susan Cummins Gallery

Cope, Mitsura
Galerie des Métiers
 d'Art du Quebec

Copping, Brad
Galerie Elena Lee
 Verre d'Art

Coren, Buzz
Blue Spiral 1

Cormier, Scott
Jewelers' Werk Galerie

Corney, Mike
Mobilia Gallery

Corvaja, Giovanni
Charon Kransen

Côté, Marie-Andrée
Galerie des Métiers
 d'Art du Quebec

Coulson, Valerie Jo
Mobilia Gallery

Crawford, David
William Zimmer Gallery

Cribbs, Kéké
Marx-Saunders Gallery, Ltd.

Crichton, Daniel
Galerie Elena Lee
 Verre d'Art

Crow, Nancy
Snyderman/Works Galleries

Cullen, Michael
Tercera Gallery

Culler, Rene
The Glass Gallery

Curtis, Matthew
Glass Artists' Gallery

Cutler, Robert J.
del Mano Gallery

Cylinder, Scott & Lisa
Snyderman/Works Galleries

D

Da Silva, Jack
Yaw Gallery

Da Silva, Marilyn
Mobilia Gallery

Dailey, Dan
Leo Kaplan Modern

del, Damiani
Gia Designer Jewelry

Damkoehler, David
Charon Kransen

Dawson, Knuckle
Maruku Arts & Crafts

Davis, Derek
Sandy Carson Gallery

de Amaral, Olga
Perimeter Gallery, Inc.

De Marchi, Livio
Mostly Glass

de Santillana, Laura
Elliott Brown Gallery

de Villier, David
Gail Severn Gallery

de Wit, Peter
Charon Kransen

Degener, Patricia
R. Duane Reed Gallery

Denzel, Henrich
Gia Designer Jewelry

Denali Crystal
L.H. Selman Ltd.

Diaz de Santillana, Alessandro
R. Duane Reed Gallery

Dickinson, John
Finer Things Gallery

Dilworth, Steve
Belloc Lowndes
 Fine Art Gallery, Inc.

Dittlmann, Bettina
Jewelers' Werk Galerie

Dodd, John
William Zimmer Gallery

Dokoupil, Giri Georg
Joan Guaita-Art

Dolack, Linda
Lyons Wier Gallery, Inc.

Dominguez, Eddie
Mariposa Gallery
Mobilia Gallery

Donefer, Laura
The Glass Gallery

Dotson, Virginia
del Mano Gallery

Dowler, David
Steuben

Dreisbach, Fritz
Maurine Littleton Gallery

Duchamp, Frank
J. Cacciola Galleries

Dudley, Peter
The O. Group

Dvorak, Petr
Charon Kransen

E

Earl, Jack
Ferrin Gallery
Perimeter Gallery, Inc.

Eberle, Edward
Perimeter Gallery, Inc.

Eckert, Carol
Snyderman/Works Galleries

Edgerley, Susan
Galerie Elena Lee
 Verre d'Art

Edols, Ben
The Bullseye Connection

Eliaś, Bohumil
Galerie Na Jánském Vršku

Elliott, Dennis
del Mano Gallery

Elliott, Kathy
The Bullseye Connection

Ellis-Smith, Wendy
Portals Ltd.

Ellison, Robert
William Zimmer Gallery

Ellsworth, David
del Mano Gallery

Elyashiv, Noam
Jewelers' Werk Galerie

English, Joseph
Aaron Faber Gallery

Enterline, Sandra
Susan Cummins Gallery

Epp, Sophia
Jewelers' Werk Galerie

Esguerra, Patricia
Aldo Castillo Gallery

Ewert, Gretchen
Mariposa Gallery

F

Fafard, Joe
Susan Whitney Gallery

Falkesgaard, Lina
Charon Kransen

Farri, Diogenes
Raglan Gallery

Fawkes, Judith Poxsom
Sandy Carson Gallery

Federighi, Christine
R. Duane Reed Gallery

Feller, Lucy
Katie Gingrass Gallery

Fennell, J. Paul
del Mano Gallery

Fero, Shane
Sandy Carson Gallery

Ferre, Fanny
Mostly Glass

Fidler, Lisa
Thomas Mann Gallery

Fifield, Linda
Katie Gingrass Gallery

Firmager, Melvyn
del Mano Gallery

Fisch, Arline
Mobilia Gallery

Fleishman, Gregg
Gallery 500

Flynn, Pat
Susan Cummins Gallery

Foley, Marcus
ARTEFACT International

Ford, Richard
Leo Kaplan Modern

Foster, Clay
del Mano Gallery

Foulem, Léopold L.
Prime Gallery

Fowler, Mark
The Glass Gallery

Frahm, Andrea
Charon Kransen
Jewelers' Werk Galerie

Frank, Egon
Gia Designer Jewelry

Freeman, Warwick
Jewelers' Werk Galerie

French, David
Gail Severn Gallery

Friedlich, Donald
Charon Kransen

Frith, Donald E.
del Mano Gallery

Fritsch, Karl
Jewelers' Werk Galerie

Frolic, Irene
Riley Hawk Galleries

Früh, Bernhard
Charon Kransen

Fujinuma, Noboru
Tai Gallery/Textile Arts, Inc.

Fujita, Kyohei
Maurine Littleton Gallery
Portia Gallery
Riley Hawk Galleries

Furman, David
John Natsoulas Gallery

G

Galloway, Julia
Mobilia Gallery

Garcia, Fabiane
Leo Kaplan Modern
Tercera Gallery

Gardner, Robert
Blue Spiral 1

Garrett, John
Mobilia Gallery
R. Duane Reed Gallery

Gavan, Jane
Glass Artists' Gallery

Geldersma, John
Jean Albano Gallery

Giffin, Chris
Snyderman/Works Galleries

Gilbert, Karen
Susan Cummins Gallery

Giles, Mary
R. Duane Reed Gallery

Gilhooly, David
John Natsoulas Gallery

Gill, John
REVOLUTION

Gilormo, Bob
Jean Albano Gallery

Gilson, Giles
del Mano Gallery

Glovsky, Alan
Chappell Gallery

Godbout, Rosie
Galerie des Metiers
 d'Art du Quebec

Gompf, Floyd
Aron Packer

Gonzalez, Arthur
John Elder Gallery

Good, Michael
Gia Designer Jewelry

Goodman, Jeff
Galerie Elena Lee
 Verre d'Art

Gordon, Anna
Charon Kransen

Gottlieb, Dale
Gallery 500

Gralnick, Lisa
Jewelers' Werk Galerie
Susan Cummins Gallery

Gray, Katherine
Elliott Brown Gallery

Gray, Myra Mimlitsch
Susan Cummins Gallery

Greenberg, Holly
Lyons Wier Gallery, Inc.

Griffin, Gary
Yaw Gallery

Griffith, Bill
Mobilia Gallery

Groover, Deborah Kate
Ferrin Gallery

Gross, Michael
Ann Nathan Gallery

Groth, David
Heller Gallery

Growinska, Goska
ARTEFACT International

Grubb, Randall
L.H. Selman Ltd.

Guarisco, Brent
Thomas Mann Gallery

Guggisberg, Monica
Portia Gallery

Gustin, Chris
John Elder Gallery
Mobilia Gallery

GutierrezBecker, Sonia
Gallery 500

H

Hackner, Elke
Jewelers' Werk Galerie

Hackney, Katy
Charon Kransen

Haley, Hoss
Blue Spiral 1

Hall, Patrick
Despard Gallery

Hall, Susan
Lyons Wier Gallery, Inc.

Halsey, Jeanne
Mariposa Gallery

Hammer, Susanne
Charon Kransen
Jewelers' Werk Galerie

Hanagarth, Sophie
Charon Kransen

Hardenberg, Torben
Charon Kransen

Harney, Rick
John Natsoulas Gallery

Harrison, Peter
Finer Things Gallery

Harvey, Julianne
Mariposa Gallery

Hayes, Peter
William Zimmer Gallery

Healey, John
Compositions Gallery

Heaney, Colin
Raglan Gallery

Heffernon, Gerald
John Natsoulas Gallery

Hefner, Don
Susan Whitney Gallery

Heindl, Anna
Charon Kransen

Heinrich, Barbara
Susan Cummins Gallery

Hejný, Michal
Jewelers' Werk Galerie

Held, Archie
William Zimmer Gallery

Heltzer, Michael
Heltzer

Hepburn, Tony
REVOLUTION

Hibbert, Louise
del Mano Gallery

Hickman, Bill
Finer Things Gallery

Hickman, Pat
Snyderman/Works Galleries

Higashi, Takesonosai
Tai Gallery/Textile Arts, Inc.

Higuchi, Kimiake
Habatat Galleries

Higuchi, Shinichi
Habatat Galleries

Hilbert, Therese
Jewelers' Werk Galerie

Hill, Chris
Ann Nathan Gallery

Hilton, Eric
Steuben

Hiramatsu, Kozo
Charon Kransen

Hiramatsu, Yasuki
Charon Kransen

Hirst, Brian
Miller Gallery

Hlava, Pavel
Habatat Galleries

Hloska, Pavol
Galerie Rob van den Doel

Hogan, Richard
Mariposa Gallery

Hogbin, Stephen
del Mano Gallery

Hoge, Susan
Yaw Gallery

Holzapfel, Michelle
del Mano Gallery

Hong, Soyeon
Charon Kransen

Hopkins, Jan
Mobilia Gallery

Hora, Petr
Heller Gallery

Horn, Robyn
del Mano Gallery

Horrell, Deborah
Elliott Brown Gallery

Hosaluk, Michael
del Mano Gallery
Tercera Gallery

Houserova, Ivana
Galerie Na Jánském Vršku

Howard, Robert
Narek Galleries

Hoyer, Todd
del Mano Gallery

Hoyt, Judith
Snyderman/Works Galleries

Huang, Arlan
UrbanGlass

Hübel, Angela
Jewelers' Werk Galerie

Huchthausen, David
Leo Kaplan Modern

Hucker, Thomas
John Elder Gallery
The O. Group

Hughes, Manuel
Coplan Gallery

Hughes, Patrick
Belloc Lowndes
 Fine Art Gallery, Inc.

Hughes, Stephen
del Mano Gallery

Hunter, Lissa
R. Duane Reed Gallery

Hunter, William
del Mano Gallery

Hurwitz, Michael
John Elder Gallery

Hutter, Sidney
Marx-Saunders Gallery, Ltd.

Huycke, David
Charon Kransen

I

Ibe, Kyoko
Heltzer

Idsardi, Froukje
Charon Kransen

Iezumi, Toshio
Chappell Gallery

Ikeda, Yoshiro
Tercera Gallery

Inbar, Tolla
Adamar Fine Arts/
 Modus Vivendi Galeries d'Art

Inkatji, Ivy
Maruku Arts & Crafts

Isaacs, Ron
Tai Gallery/Textile Arts, Inc.

Ippu, Torii
Galerie Na Jánském Vršku

Isupov, Sergei
Ferrin Gallery

Ito, Makoto
The Glass Gallery

Iwata, Kiyomi
Perimeter Gallery, Inc.

J

Jackson, Mr.
Maruku Arts & Crafts

Jacobs, Ferne
Snyderman/Works Galleries

Jacquard, Nicole
Yaw Gallery

Jakab, Andrej
Galerie Rob van den Doel

James, Michael
Snyderman/Works Galleries

Janich, Hilde
Charon Kransen

Jank, Michal
Jewelers' Werk Galerie

Jensen, Dave
Ann Nathan Gallery

Jernegan, Jeremy
Sandy Carson Gallery

Jocz, Dan
Mobilia Gallery

Johanson, Olle
Yaw Gallery

Johnson, Gary
del Mano Gallery

Jolley, Richard
Leo Kaplan Modern
Maurine Littleton Gallery

Jones, Arthur
del Mano Gallery

Jones, Dave
Snyderman/Works Galleries

Jones, Ray
del Mano Gallery

Jordan, John
William Zimmer Gallery

Juenger, Ike
Charon Kransen

Jung, Bongrey
Charon Kransen

Jünger, Hermann
Jewelers' Werk Galerie

Jurs, Nancy
John Elder Gallery

K

Kalinowski, Viktor
ARTEFACT International

Kallenberger, Kreg
Leo Kaplan Modern

Kaminski, Vered
Charon Kransen

Kanda, Mary
Thomas Mann Gallery

Kaneko, Jun
Sherry Leedy Contemporary Art

Kao, Joana
Susan Cummins Gallery

Katsushiro, Sono
Tai Gallery/Textile Arts, Inc.

Kawanabe, Yuri
Charon Kransen

Kelly, Juan
William Zimmer Gallery

Kelly, Pamela Earnshaw
John Elder Gallery

Kent, Ron
del Mano Gallery

Kerman, Janis
Option Art

Key, Ray
del Mano Gallery

Kibe, Seiho
Tai Gallery/Textile Arts, Inc.

Kim, Jae Youn
Charon Kransen

Kim, Seung-Hee
Charon Kransen

Kim, Susan
Jewelers' Werk Galerie

King, Gerry
Glass Artists' Gallery

King, Kathy
Mobilia Gallery

Knauss, Lewis
Snyderman/Works Galleries

Knobel, Esther
Snyderman/Works Galleries

Knoblauch, Paul
John Elder Gallery

Knowles, Sabrina
R. Duane Reed Gallery

Koehler, James
Mariposa Gallery

Koidl, Gerd
ARTEFACT International

Koopman, Rena
Mobilia Gallery

Kopecky, Vladimir
Galerie Na Jánském Vršku

Kopf, Silas
Leo Kaplan Modern

Kouts, Ulle
Charon Kransen

Kottler, Howard, the Estate of
REVOLUTION

Kovacsy, Peter
Narek Galleries

Krafft, Charles
Ferrin Gallery

Kramer, Linda
Jean Albano Gallery

Kranitzky/Overstreet
Susan Cummins Gallery

Krasnican, Susie
Maurine Littleton Gallery

Kratz, Mayme
Elliott Brown Gallery

Kretchmer, Steven
Gia Designer Jewelry

Kroiz, Shana
Mobilia Gallery

Krueger, Winfried
Charon Kransen

Kruger, Daniel
Jewelers' Werk Galerie

Kuhn, Jon
Marx-Saunders Gallery, Ltd.

Kuramoto, Yoko
Chappell Gallery
The Glass Gallery

Kusumoto, Mariko
Susan Cummins Gallery

Kutschera, Gabriela
Charon Kransen

Kwong, Eva
Mobilia Gallery

L

Ladd, Tracey
Miller Gallery

Lamar, Stoney
Blue Spiral 1

Langer, Claudia
Jewelers' Werk Galerie

Langley, Cam
Finer Things Gallery

Lantz, Gunilla
Charon Kransen

Lapka, Eva and Milan
Galerie des Metiers
 d'Art du Quebec

Laskin, Rebekah
Aaron Faber Gallery

Latven, Bud
del Mano Gallery

Launders, Guntis
Charon Kransen

Lawrence, Les
Ferrin Gallery

Le Cavelier, Nada
Mostly Glass Gallery

Lechman, Patti
Snyderman/Works Galleries

Lee, Ed Bing
Snyderman/Works Galleries

Lee, Jae Won
REVOLUTION

Lee, Michael
del Mano Gallery

Lee, Soon Bong
Ann Nathan Gallery

Lemieux-Bérubé, Louise
Option Art

Lent, Anthony
Yaw Gallery

Leong, Po Shun
del Mano Gallery

Leperlier, Antoine
Serge Lechaczynski/
 Galerie Internationale du Verre

Leuthold, Marc
R. Duane Reed Gallery

Levenson, Silvia
The Bullseye Connection

Levi, David
Portia Gallery

Levin, Bradley
Jean Albano Gallery

Levine, Marilyn
John Natsoulas Gallery

Lewis, John
Leo Kaplan Modern

Lewis, Keith
Susan Cummins Gallery

Lewis, Niningka
Maruku Arts & Crafts

Lezama, Claudia
Mostly Glass Gallery

Libenský, Stanislav
Galerie Na Jánském Vršku
Galerie Rob van den Doel

Lillie, Jacqueline
Susan Cummins Gallery

Lindquist, Mark
del Mano Gallery
Gail Severn Gallery

Lindquist, Melvin
del Mano Gallery
Gail Severn Gallery

Lindsay, Susan
Mobilia Gallery

Linssen, Nel
Charon Kransen

Lipofsky, Marvin
R. Duane Reed Gallery

Lippe, Micki
Charon Kransen

Little, Jefferson
Susan Whitney Gallery

Littleton, Harvey
Maurine Littleton Gallery

Littleton, John
Maurine Littleton Gallery

Litzenberger, Joe
Heltzer

Lloyd, Simon
ARTEFACT International

Lo, Beth
Mobilia Gallery

Loar, Steve
del Mano Gallery

Lockhart, Lisa
Susan Cummins Gallery

Loeber, Ken
Perimeter Gallery, Inc.

Logan, Terri
Thomas Mann Gallery

Lomné, Alicia
The Bullseye Connection

Look, Dona
Perimeter Gallery, Inc.

Lossing, Craig
del Mano Gallery

Loughlin, Jessica
The Bullseye Connection

Lovera, James
Tercera Gallery

Lugossy, Maria
Galerie Rob van den Doel

Lukacsi, Laszlo
Portia Gallery

Lynch, Sydney
William Zimmer Gallery

Lyon, Lucy
Miller Gallery

M

Maberley, Simon
Glass Artists' Gallery

MacGowan, Steve
Lyons Wier Gallery, Inc.

MacNeil, Linda
Leo Kaplan Modern

Madsen, Steve
Mariposa Gallery

Magni, Vincent
Adamar Fine Arts/
Modus Vivendi Galeries d'Art

Magnus, Kirk
Mobilia Gallery

Main, Terrence
The O. Group

Maloof, Sam
del Mano Gallery

Maman, Niso
Adamar Fine Arts/
Modus Vivendi Galeries d'Art

Mamet, David
Coplan Gallery

Mann, Thomas
Thomas Mann Gallery

Mar, Stanley
Miller Gallery

Marchetti, Stefano
Charon Kransen

Mares, Ivan
Heller Gallery

Marioni, Dante
Riley Hawk Galleries

Marquis, Richard
Elliott Brown Gallery

Marsh, Bert
del Mano Gallery

Martin, Terry
del Mano Gallery

Martucci, Rene
John Natsoulas Gallery

Maruyama, Wendy
John Elder Gallery

Mason, John
Perimeter Gallery, Inc.

Mason, Phill
Despard Gallery

Matos, Sandor
ARTEFACT International

Mayer, Kerstin
Charon Kransen

Mayeri, Beverly
Perimeter Gallery, Inc.

McBride, Elaine
Mobilia Gallery

McCauley, Robert
Gail Severn Gallery

McClellan, Duncan
Riley Hawk Galleries

McClure, Mavis
Sandy Carson Gallery

McKay, Hugh
del Mano Gallery

McQueen, John
Elliott Brown Gallery
Perimeter Gallery, Inc.

Medel, Rebecca
R. Duane Reed Gallery

Megroz, Rene
John Natsoulas Gallery

Mejer, Hermann
Mostly Glass Gallery

Melchert, Jim
REVOLUTION

Melnick, Myron
Sandy Carson Gallery

Mendive, Manuel
Joan Guaita-Art

Merritt, Rachel
ARTEFACT International

Merz, Michaela
Yaw Gallery

Metcalf, Bruce
Perimeter Gallery, Inc.
Susan Cummins Gallery

Meyer, Dan
Coplan Gallery

Meyer, John Dodge
del Mano Gallery

Michaelides, Dimitri
John Elder Gallery

Michaels, Guy
William Zimmer Gallery

Michel, C.A.
Snyderman/Works Galleries

Michelsen, Johannes
del Mano Gallery

Mickelsen, Robert
Miller Gallery

Midgett, Steve
Aaron Faber Gallery

Mighyda
Adamar Fine Arts/
Modus Vivendi Galeries d'Art

Mihalisin, Julie
The Bullseye Connection
R. Duane Reed Gallery

Miho, Saito
Charon Kransen

Milder, John
ARTEFACT International

Milette, Richard
Prime Gallery

Miltenberger, Janis
Gallery 500

Minegishi, Yutaca
Jewelers' Werk Galerie

Minkowitz, Norma
Snyderman/Works Galleries

Minoura, Chikuho
Tai Gallery/Textile Arts, Inc.

Miro, Darcy
Jewelers' Werk Galerie

Mississippi, Connie
del Mano Gallery

Mitchell, Bruce
del Mano Gallery

Mitchell, Valerie
Jewelers' Werk Galerie

Mitsushima, Kazuko
Charon Kransen

Mizuno, Keisuke
Ferrin Gallery

Mode, Michael
del Mano Gallery

Monden, Kogyoku
Tai Gallery/Textile Arts, Inc.

Mongrain, Jeffrey
John Elder Gallery

Montgomerie, Gael
del Mano Gallery

Moon, Chang Sik
Ann Nathan Gallery

Moonelis, Judy
John Elder Gallery

Moore, William
del Mano Gallery

Moosman, Kerry
Gail Severn Gallery

Morel, Sonia
Charon Kransen

Moretti, Norberto
Mostly Glass Gallery

Morris, Darrel
Lyons Wier Gallery, Inc.

Morris, William
Riley Hawk Galleries

Morrison, Merrill
Mobilia Gallery

Moser, Kenna
Gail Severn Gallery

Moty, Eleanor
Perimeter Gallery, Inc.

Moulthrop, Philip
Heller Gallery

Mount, Nick
Riley Hawk Galleries

Muerrle, Norbert
Gia Designer Jewelry

Munro, Rolly
del Mano Gallery

Munsteiner, Bernd
Aaron Faber Gallery

Musler, Jay
Marx-Saunders Gallery, Ltd.

Myers, Forrest
The O. Group

Myers, Joel
Marx-Saunders Gallery, Ltd.

Myers, Marcia
Gail Severn Gallery

N

Nachtigall, Jeff
Susan Whitney Gallery

Nagakura, Kenichi
Tai Gallery/Textile Arts, Inc.

Nahser, Heidi
Susan Cummins Gallery

Nemec-Kessel, Charlene
Lyons Wier Gallery, Inc.

Namingha, Dan
J. Cacciola Galleries

Neff, Stacey
R. Duane Reed Gallery

Negreanu, Mateï
Serge Lechaczynski/
 Galerie Internationale du Verre

Nelson, Paul
Portia Gallery

Newport, Mark
Lyons Wier Gallery, Inc.

Nicholson, Laura Foster
Katie Gingrass Gallery

Niemi, Bruce A.
Niemi Fine Art Gallery

Niessing
Gia Designer Jewelry

Nishibayashi, Kazuko
Charon Kransen

Nolen, Matt
Ferrin Gallery

Noten, Ted
Charon Kransen

Novák, Brètislav
Galerie Na Jánském Vršku
Portia Gallery

Novak, Justin
John Elder Gallery

Nowak, James
Mostly Glass Gallery

O

O'Connor, Harold
Mobilia Gallery

Ofiesh, Gabriel
Thomas Mann Gallery

Okun, Barbara-Rose
R. Duane Reed Gallery

Olsen, Fritz
Niemi Fine Art Gallery

Onofrio, Judy
Sherry Leedy Contemporary Art

Opdahl, Martha D.
Snyderman/Works Galleries

Opočenský, Pavel
Jewelers' Werk Galerie

Opsvik, Peter
Cylindra Gallery

Orchard, Jenny
Despard Gallery

Orlandini, Orlando
Gia Designer Jewelry

Osborn-Smith, Jane
Ferrin Gallery

Osolnik, Rude
del Mano Gallery

Ossipov, Nikolai
del Mano Gallery

Ostermann, Matthias
Prime Gallery

Outlaw, Adrienne
Finer Things Gallery

P

Paganin, Barbara
Charon Kransen

Paley, Albert
Leo Kaplan Modern

Palmer, Kelly
Mobilia Gallery

Palová, Zora
Galerie Na Jánském Vršku

Pankowski, Gina
Aaron Faber Gallery

Pappas, Marilyn
Snyderman/Works Galleries

Parcher, Joan
Mobilia Gallery

Pardon, Earl
Aaron Faber Gallery

Pardon, Tod
Aaron Faber Gallery

Parriott, Charles
Elliott Brown Gallery

Pascal, Marc
ARTEFACT International

Pate, Jane
Mariposa Gallery

Paulsen, Stephen
del Mano Gallery
William Zimmer Gallery

Pauly & Co
The O. Group

Paust, Karen
Mobilia Gallery

Payce, Greg
Prime Gallery

Peebles, Bruce
Finer Things Gallery

Peiser, Mark
Marx-Saunders Gallery, Ltd.

Pelikan, Gaia
Aaron Faber Gallery

Perkins, Danny
R. Duane Reed Gallery

Perkins, Flo
Elliott Brown Gallery
John Elder Gallery

Pesce, Gaetano
The O. Group

Peters, Daniel
Mobilia Gallery

Peters, Ruudt
Jewelers' Werk Galerie

Peterson, Michael
del Mano Gallery

Petrovic, Marc
Riley Hawk Galleries

Philbrick, Timothy
John Elder Gallery

Phillips, Maria
Susan Cummins Gallery

Phillips, Peter
Joan Guaita-Art

Picasso, Pablo
Aldo Castillo Gallery

Pierobon, Peter
John Elder Gallery

Pijanowski, Hiroko Sato
Aaron Faber Gallery

Pilon, Alet
Charon Kransen

Pitts, Greg
Mobilia Gallery

Plessi, Fabrizio
Joan Guaita-Art

Pohlman, Jenny
R. Duane Reed Gallery

Pompili, Lucian
John Natsoulas Gallery

Pontoppidan, Karen
Jewelers' Werk Galerie

Potocnik, Andrew
del Mano Gallery

Powell, Stephen
Marx-Saunders Gallery, Ltd.

Powers, Pike
Elliott Brown Gallery

Pozzesi, Gene
del Mano Gallery

Prasil, Peter
Despard Gallery

Precht, Susanne
Compositions Gallery

Putnam, Toni
Portals Ltd.

Q

Quackenbush, Liz
Mobilia Gallery

Quigley, Robin
Jewelers' Werk Galerie

R

Radeschi, George
Gallery 500

Radtke, Charles
Katie Gingrass Gallery

Raffan, Richard
del Mano Gallery

Rahn, Catherine
Riley Hawk Galleries

Raible, Kent
Susan Cummins Gallery

Randal, Seth
Leo Kaplan Modern

Randall, Jim
Glass Artists' Gallery

Rath, Tina
Susan Cummins Gallery

Rauschke, Tom
Katie Gingrass Gallery

Rawdin, Kim
Mobilia Gallery

Reekie, David
Miller Gallery

Regenboog, Roos
Charon Kransen

Reiber, Paul
William Zimmer Gallery

Reid, Colin
Serge Lechaczynski/Galerie
 Internationale du Verre

Reitz, Don
Maurine Littleton Gallery

Rezac, Suzan
Mobilia Gallery

Ribeiro, Andre
Gia Designer Jewelry

Ries, Christopher
Coplan Gallery

Riley, Cheryl
The O. Group

Rippon, Tom
John Natsoulas Gallery
Mobilia Gallery

Rivers, Lucy Ruth Wright
Aron Packer

Robb, Kevin
Niemi Fine Art Gallery

Roberson, Sang
William Zimmer Gallery

Roberts, Constance
Portals Ltd.

Roberts, Greg
Mobilia Gallery

Robertson, Donald
Galerie des Métiers
 d'Art du Quebec

Robinson, Ann
Elliott Brown Gallery
John Elder Gallery

Roethel, Cornelia
Yaw Gallery

Roig, Bernardi
Joan Guaita-Art

Roiseland, Alida
Charon Kransen

Rose, Jim
Ann Nathan Gallery

Rosen, Annabeth
Ann Nathan Gallery

Rosol, Martin
Chappell Gallery
Miller Gallery

Ross, D.X.
Susan Cummins Gallery

Rudavsky, Ondrej
Jewelers' Werk Galerie

Rude, Brad
Gail Severn Gallery

Ruffner, Ginny
R. Duane Reed Gallery

Rush, Tommie
Maurine Littleton Gallery

Russell-Pool, Kari
Riley Hawk Galleries

Russmeyer, Axel
Susan Cummins Gallery

Ruzsa, Alison
Mostly Glass Gallery

Ryan, Jacky
Charon Kransen

Ryder, Sophie
Belloc Lowndes
 Fine Art Gallery, Inc.

Rydmark, Cheryl
Susan Cummins Gallery
Yaw Gallery

S

Saabye, Mette
Charon Kransen

Sainz, Paco
Aldo Castillo Gallery

Salvadore, Davide
Mostly Glass Gallery

Sand, Rudi
Jewelers' Werk Galerie

Sanders, Gary
del Mano Gallery

Sandstrom, Margareth
Charon Kransen

Santillana, Alessandro Diaz de
R. Duane Reed Gallery

Santini, Emilio
Mostly Glass Gallery

Sartorius, Norm
del Mano Gallery

Sato Pijanowski, Hiroko
Aaron Faber Gallery

Sauer, Jane
R. Duane Reed Gallery

Sauer, Jon
del Mano Gallery

Saylan, Merryll
Tercera Gallery

Scarpino, Betty
del Mano Gallery

Schick, Marjorie
Mobilia Gallery

Schippell, Dorothea
Jewelers' Werk Galerie

Schira, Cynthia
Snyderman/Works Galleries

Schmuck, Johnathon
The Bullseye Connection

Schobinger, Bernard
Charon Kransen

Scholz, Renate
Charon Kransen

Schriber, James
John Elder Gallery

Schuler, Melvin
William Zimmer Gallery

Schutz, Biba
Charon Kransen
Thomas Mann Gallery

Schwieder, Paul
Riley Hawk Galleries

Scoon, Thomas
Marx-Saunders Gallery, Ltd.

Scott, Joyce
Susan Cummins Gallery

Scott, Mike
del Mano Gallery

Secrest, David
Gail Severn Gallery

Seide, Paul
Leo Kaplan Modern

Seidenath, Barbara
Charon Kransen
Jewelers' Werk Galerie

Sekimachi, Kay
del Mano Gallery

Selvin, Nancy
Ferrin Gallery

Sengel, David
del Mano Gallery

Seyffert, Stephan
Charon Kransen

Sfirri, Mark
del Mano Gallery

Shahbazian, Eileen
Niemi Fine Art Gallery

Shaw, James
L.H. Selman Ltd.

Shaw, Richard
Ferrin Gallery
Mobilia Gallery

Shaw, Sam
Susan Cummins Gallery

Shawah, Henry
Mostly Glass Gallery

Shepherd, Sara
Susan Cummins Gallery

Sherman, Sondra
Jewelers' Werk Galerie
Susan Cummins Gallery

Sherrill, Michael
Blue Spiral 1
Ferrin Gallery

Shimazu, Esther
John Natsoulas Gallery

Shimizu, Yuko
Tercera Gallery

Shioya, Naomi
Chappell Gallery

Shirley, Adam
Thomas Mann Gallery

Shokosai IV, Hayakawa
Tai Gallery/Textile Arts, Inc.

Shrosbree, James
REVOLUTION

Shull, Randy
John Elder Gallery

Šibor, Jiří
Jewelers' Werk Galerie

Sieber Fuchs, Verena
Charon Kransen

Signoretto, Pino
Portia Gallery

Sills, Leslie
Mobilia Gallery

Simon, Marjorie
Jewelers' Werk Galerie

Simpson, Tommy
Leo Kaplan Modern

Sisson, Karyl
Elliott Brown Gallery

Skau, John
Katie Gingrass Gallery

Skibska, Anna
The Bullseye Connection
R. Duane Reed Gallery

Skidmore, Brent
Blue Spiral 1

Skogberg, Asa
Charon Kransen

Slemmons, Kiff
Susan Cummins Gallery

Slentz, Jack
del Mano Gallery

Slivinski, Lucy
Aron Packer

Smith, Christina
Mobilia Gallery

Smith, Derek
Raglan Gallery

Smith, Hayley
del Mano Gallery

Smith, Jen
Snyderman/Works Galleries

Smith, John
Despard Gallery

Smith, Sherri
Sandy Carson Gallery

Solomon, Judith
Mobilia Gallery

Sommer, Winfried
Jewelers' Werk Galerie

Spencer, Jeffrey
Miller Gallery

Speidel, Julie
Gail Severn Gallery

Spiros, Lisa
Jewelers' Werk Galerie

Spreng, Georg
Gia Designer Jewelry

Spring, Barbara
John Natsoulas Gallery

Stanger, Jay
Leo Kaplan Modern

Stankard, Paul
Marx-Saunders Gallery, Ltd.

Statom, Therman
Marx-Saunders Gallery, Ltd.
Maurine Littleton Gallery

Stasz, Mark
Gail Severn Gallery

Stender, Thomas
Sandy Carson Gallery

Stephens, Margo
Raglan Gallery

Sterling, Lisabeth
Riley Hawk Galleries

Stevens, Magan
Gallery 500

Stewart, Bill
John Elder Gallery

Stirt, Alan
del Mano Gallery

Stockhausen, Dore
ARTEFACT International

Stocksdale, Bob
del Mano Gallery

Stoliar, Lee
John Elder Gallery

Streep, Caroline
Gallery 500

Striffler, Dorothee
Charon Kransen

Stronach, Patrick
Despard Gallery

Stuckenbruck, Corky
Snyderman/Works Galleries

Stutman, Barbara
Charon Kransen

Sudduth, Billie Ruth
Katie Gingrass Gallery

Sudol, Frank
del Mano Gallery

Sultan, Donald
Coplan Gallery

Suntum, Per
Charon Kransen

Suttman, John
Mariposa Gallery

Syvanoja, Janna
Charon Kransen

T

Tachibana, Seiko
Tercera Gallery

Tagliapietra, Lino
Riley Hawk Galleries

Takaezu, Toshiko
Perimeter Gallery, Inc.

Takahashi, Yoshihiko
Chappell Gallery

Takenouchi, Naoko
Galerie Elena Lee Verre d'Art

Tanner, James
Maurine Littleton Gallery

Tatton, Marcus
Despard Gallery

Tawney, Lenore
Perimeter Gallery, Inc.

Taylor, Yoshio
John Natsoulas Gallery

Telesco, Pat
Susan Cummins Gallery

Teschmacher, Winnie
Galerie Rob van den Doel

Tesser, Julie
Mobilia Gallery

Thayer, Susan
Ferrin Gallery

Thayer, Tom
Aron Packer

Thierry, Madonna
Mostly Glass Gallery

Thiewes, Rachelle
Jewelers' Werk Galerie

Thompson, Cappy
Leo Kaplan Modern

Thorne, Charlie B.
Belloc Lowndes
 Fine Art Gallery, Inc.

Threadgill, Linda
Mobilia Gallery

Tiozzo, Claudio
Mostly Glass Gallery

Tjulyata, Topsy
Maruku Arts & Crafts

Tobin, Steve
Belloc Lowndes
 Fine Art Gallery, Inc.

Toffolo, Cesare
Mostly Glass Gallery

Toops, Cynthia
Mobilia Gallery

Toso, Gianni
Leo Kaplan Modern

Tóth, Margit
Compositions Gallery

Trabucco, Victor
L.H. Selman Ltd.

Trask, Jennifer
Mobilia Gallery

Trinkley, Karla
Elliott Brown Gallery

Truman, Catherine
Charon Kransen

Trupperbaumer, Ben
del Mano Gallery

Turner, Robert
REVOLUTION

Tyler, John
William Zimmer Gallery

U

Uravitch, Andrea
Mobilia Gallery

Urruty, Joël
Finer Things Gallery

V

van Aswegen, Johan
Charon Kransen

Van Cline, Mary
Leo Kaplan Modern
Maurine Littleton Gallery

Van Earl, Delos
Tercera Gallery

VandenBerge, Peter
John Natsoulas Gallery

Vanderstukken, Koen
Galerie Elena Lee
 Verre d'Art

Verdegaal, Truike
Charon Kransen

Verlarde, Kukuli
John Elder Gallery

Vesery, Jacques
del Mano Gallery

Vizner, František
Galerie Na Jánském Vršku
Galerie Rob van den Doel

Vogel, Kate
Maurine Littleton Gallery

von Zadora-Gerlof, Andreas
Riley Hawk Galleries

Vostell, Wolf
Joan Guaita-Art

Voulkos, Peter
Perimeter Gallery, Inc.

Voulkos, Pier
Mobilia Gallery

W

Wachs, Gretchen
Gallery 500
Mariposa Gallery

Walburg, Gerald
William Zimmer Gallery

Walch, Anuschka
Charon Kransen
Jewelers' Werk Galerie

Walentynowicz, Janusz
Riley Hawk Galleries

Wallace, Gerry
Ferrin Gallery

Walling, Philip
The Bullseye Connection
R. Duane Reed Gallery

Walter, Barbara
Mobilia Gallery

Wara, Billy
Maruku Arts & Crafts

Ward, Esther
Charon Kransen

Ward, Fred
Maruku Arts & Crafts

Warner, Deborah
Snyderman/Works Galleries

Warren, Raymond
Option Art

Wasicek, Ales
Serge Lechaczynski/Galerie
 Internationale du Verre

Wax, Jack
Elliott Brown Gallery

Webster, Maryann
Ferrin Gallery

Weinberg, Steven
Marx-Saunders Gallery, Ltd.

Weiser, Kurt
Ferrin Gallery

Weissflog, Hans
del Mano Gallery

Wells, C.W.
Snyderman/Works Galleries

Whitaker, Jeff
Gail Severn Gallery

White, Heather
Susan Cummins Gallery

White, Kathy Anne
Finer Things Gallery

White, Mary
Portia Gallery

Whitehouse, C.T.
Niemi Fine Art Gallery

Whiteley, Richard
The Bullseye Connection

Whitney, Ginny
Charon Kransen

Whittlesey, Stephen
John Elder Gallery

Wickman, Dick
Perimeter Gallery, Inc.

Wieske, Ellen
Mobilia Gallery

Wiken, Kaaren
Katie Gingrass Gallery

Wilbur, Roger
Mariposa Gallery

Wilkins, Mark
Gallery 500

Willenbrink, Karen
R. Duane Reed Gallery

Williamson, Dave
Snyderman/Works Galleries

Williamson, Roberta
Susan Cummins Gallery
Snyderman/Works Galleries

Wilson, Anne
REVOLUTION

Wingfield, Leah
Miller Gallery

Wippermann, Andrea
Charon Kransen

Wise, Jeff & Susan
Aaron Faber Gallery

Wolfe, Jon
Marx-Saunders Gallery, Ltd.

Wolfe, Rusty
Finer Things Gallery

Wood, Joe
Mobilia Gallery

Wood, Vic
del Mano Gallery

Woods, Troy
J. Cacciola Galleries

Wynne, Robert
Raglan Gallery

Y

Yako, Hodo
Tai Gallery/Textile Arts, Inc.

Yamada, Tetsuya
John Elder Gallery

Yamaguchi, Rynn
Tai Gallery/Textile Arts, Inc.

Young, Brent Kee
The Glass Gallery

Young, Cybéle
Prime Gallery

Z

Zanella, Annamaria
Charon Kransen

Zaytceva, Irina
Ferrin Gallery

Zbynovsky, Vladimir
Galerie Rob van den Doel

Zeisel, Eva
The O. Group

Zeitler, Irmgard
Yaw Gallery

Zimmerman, Arnold
John Elder Gallery

Zobel, Michael
Gia Designer Jewelry

Zolinsky, Daniel
Mariposa Gallery

Zoritchak, Yan
Miller Gallery

Zuber, Czeslaw
Compositions Gallery

Zucca, Ed
Leo Kaplan Modern

Zulalian, Lia
Ferrin Gallery

Zynsky, Toots
Elliott Brown Gallery

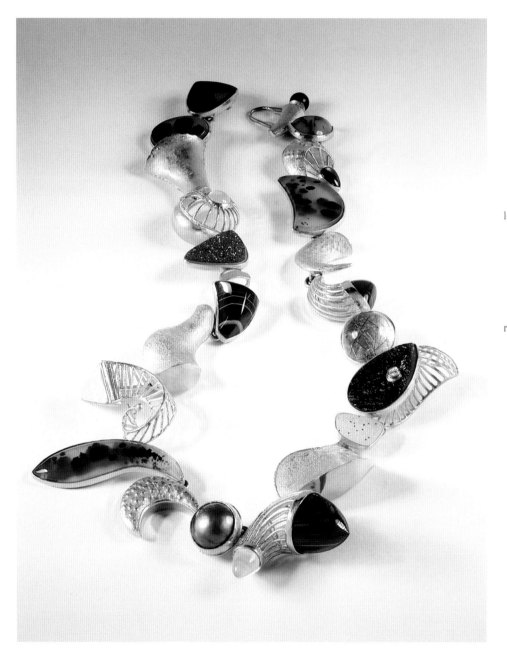

left: Jeff and Susan Wise
 Necklace
 18k gold, black jade, drusy
 quartz, moonstone, agate,
 black star sapphire, diamonds

right: Patek Philippe
 Officer's Campaign
 wristwatch, ca. 1989; Pocket
 watch, made for Baley Banks
 & Biddle, ca. 1910; Cartier
 automatic wristwatch

Aaron Faber Gallery

666 Fifth Avenue
New York, NY 10103
212.586.8411
Fax 212.582.0205
info@aaronfaber.com

Twentieth-century jewelry design

Staff: Patricia Kiley Faber; Edward Faber; Felice Salmon, manager;
Heather Hughes, gallery director; Jackie Wax

Exhibiting Artists

Glenda Arentzen
Françoise and
 Claude Chavent
Colette
Joseph English
Rebekah Laskin
Steve Midgett
Bernd Munsteiner
Gina Pankowski
Earl Pardon
Tod Pardon
Gaia Pelikan
Hiroko Sato Pijanowski
Jeff and Susan Wise

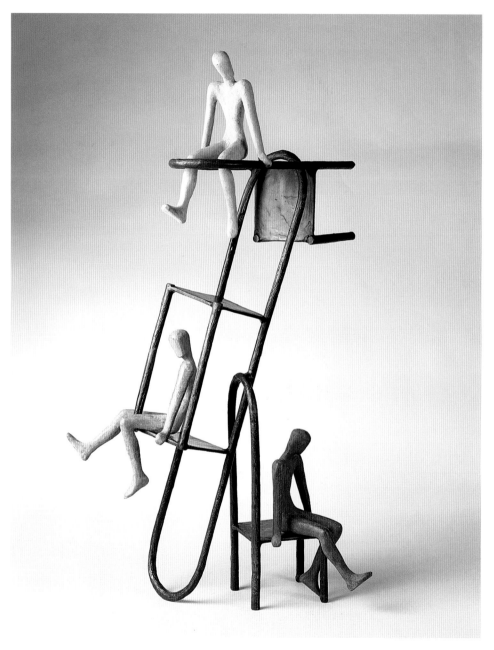

left: Tolla Inbar
 Enjoying a Chair, 1999
 Bronze
 84 x 30 x 30

right: Niso Maman
 Blue Goddess, 1999
 Automotive paint,
 fabricated steel
 33 x 15 x 13

Adamar Fine Arts/Modus Vivendi Galeries d'Art

23-28 Place des Vosges
Paris, 75003
France
33.1.4278.1010
Fax 33.1.4278.1400
modus@galerie-modus.com

177 NE 39th Street
Miami, FL 33137
305.576.1355
Fax 305.576.0551
adamargal@aol.com

American, European and Latin American contemporary sculpture, painting and glass

Staff: Tamar Erdberg, Adam Erdberg, Mark Hachem, owners;
Luis Yllanes, Karl Yeya, Richard Elmir, gallery associates

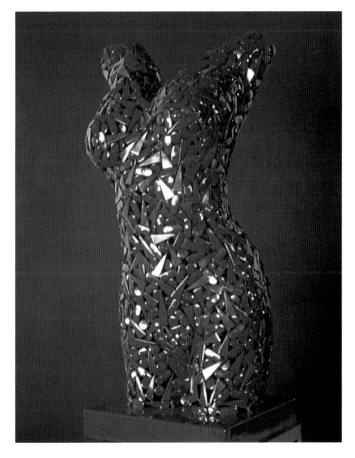

Exhibiting Artists

Jean-Jacques Argueyrolles
Marc Berlet
Tolla Inbar
Vincent Magni
Niso Maman
Mighyda

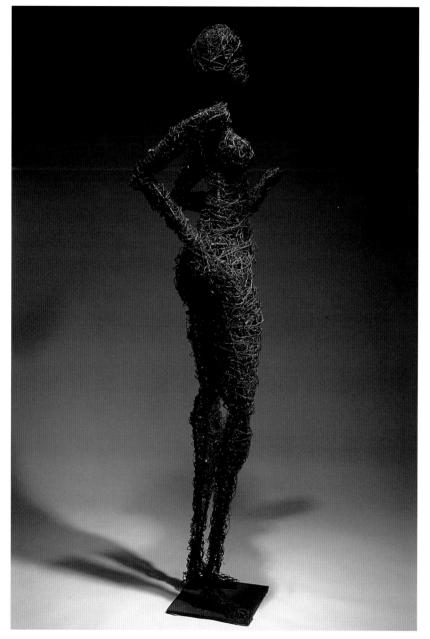

left: Vincent Magni
 La Pose, 1997
 Steel wire
 62 x 16 x 20

right: Jean-Jacques Argueyrolles
 Console, 1999
 Bronze, steel
 30 x 24 x 8

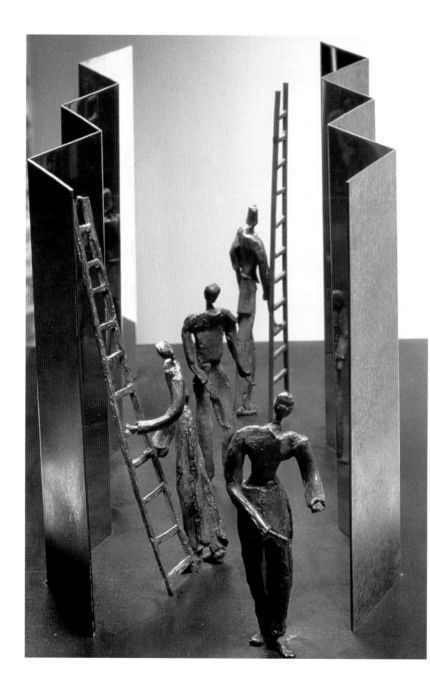

left: Patricia Esguerra
 Labertino (Labyrinth), 1998
 Bronze (edition of 8)
 14.5 x 16 x 29.5
 photo by Aldo Castillo Gallery

right: Paco Sainz
 Power Sharing, 1995
 Stone, fossilized marble
 20 x 12 x 12

Aldo Castillo Gallery

233 West Huron
Chicago, IL 60610
312.337.2536
Fax 312.337.3627
info@artaldo.com
www.artaldo.com

International fine arts — specializing in Latin American art

Staff: Aldo Castillo, director; Richard Richards, president

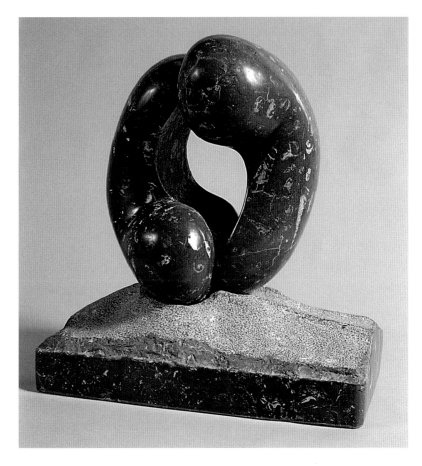

Exhibiting Artists

Carlos Colombino
Patricia Esguerra
Pablo Picasso
Paco Sainz

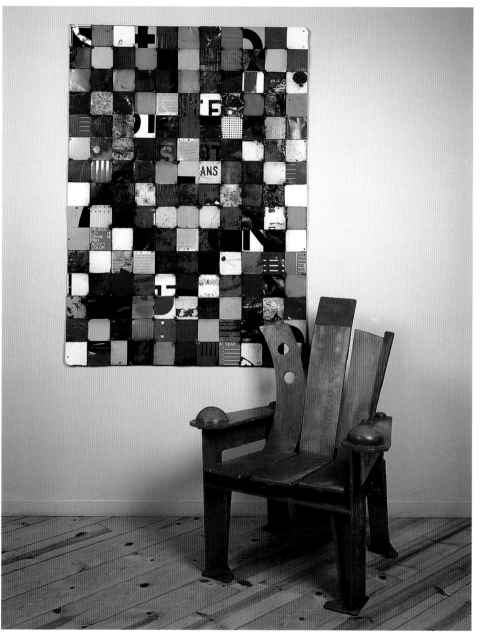

left: Gordon Chandler
Red Chair and *Quilt*, 1999
Found steel parts,
original paint
49 x 40 x 32 and
75 x 55
photo by Tom Van Eynde

right: Chris Hill
English Composition, 1999
Welded steel, acrylic paint
over NASDAQ sheet
57 x 48 x 10
photo by Tom Van Eynde

Ann Nathan Gallery

218 West Superior
Chicago, IL 60610
312.664.6622
Fax 312.664.9392
nathangall@aol.com

A compelling range of artist-designed furniture and unique objects; also painting and sculpture by prominent and emerging artists

Staff: Ann Nathan, director; Victor Armendariz, assistant director

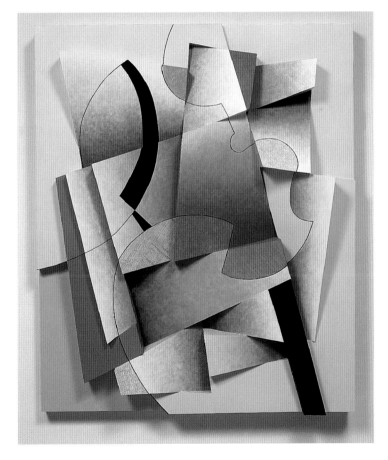

Exhibiting Artists

Gordon Chandler
Michael Gross
Chris Hill
Dave Jensen
Soon Bong Lee
Chang Sik Moon
Jim Rose
Annabeth Rosen

left: Floyd Gompf
 Red Wheel, 1999
 Found materials
 39 x 46 x 19
 photo by Richard Hellyer

right: Lucy Slivinski
 A Gift, 1999
 Steel wire, cast concrete
 31 x 36 x 53
 photo by Eileen Ryan

Aron Packer

Guest Curator at Yello Gallery
1630 North Milwaukee Avenue
Chicago, IL 60647
773.235.9731
or 773.743.2825

Unusual contemporary art in all media — also Folk and Outsider art

Staff: Justine Jentes; Cindy Loehr

Exhibiting Artists

Floyd Gompf
Lucy Ruth Wright Rivers
Lucy Slivinski
Tom Thayer

left: Roger Buddle
Italowie Creek Bed 2, 1999
Multi-layered, multi-fired,
kiln-formed glass
2 x 16
photo by Grant Hancock

right: Dore Stockhausen
Pendant, 1998
925 silver, 500 palladium,
750 gold, enamel, garnets,
steel, magnet
1.5 x 6 x 3.25
photo by Philip Smith

ARTEFACT International

Suite 103, Level 1
129 Fitzroy Street
St. Kilda, Melbourne, Victoria 3182
Australia
61.3.9534.4443
Fax 61.3.9534.4449
artefact@webtime.com.au

Contemporary Australian art and fine craft featuring excellence in technique, design and media treatment

Staff: Anita Traverso, director/curator; Ron Riddle, manager/assistant curator;
Rachel Appleton, assistant manager

Exhibiting Artists

Roger Buddle
Marcus Foley
Goska Growinska
Viktor Kalinowski
Gerd Koidl
Simon Lloyd
Sandor Matos
Rachel Merritt
John Milder
Marc Pascal
Dore Stockhausen

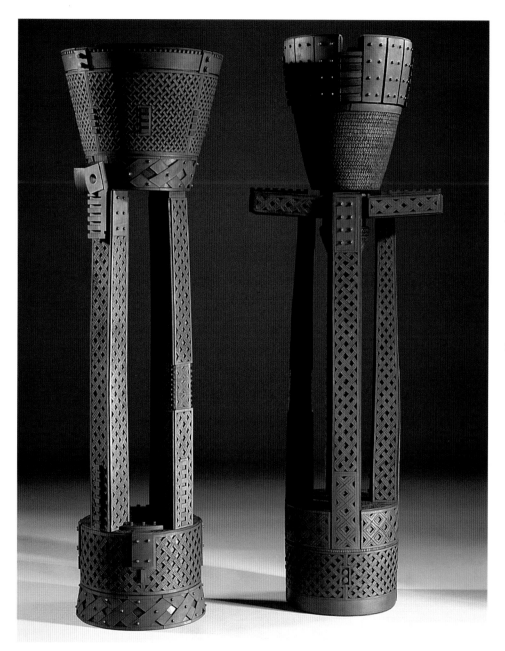

left: Tanija and Graham Carr
Untitled, 1999
Wet-formed, dyed and incised
leather, acrylic paint
50 x 15 x 16.5 and
50.5 x 15.5 x 17
photo by Victor France

right: Tanija and Graham Carr
Untitled, 1999
Wet-formed, dyed and incised
leather, acrylic paint
15 x 31.5 x 15
photo by Victor France

Beaver Galleries

81 Denison Street
Deakin, Canberra, ACT 2600
Australia
61.2.6282.5294
Fax 61.2.6281.1315
beaver@interact.net.au

Contemporary Australian craft and fine art

Staff: Martin Beaver, director

Exhibiting Artists

Tanija and Graham Carr

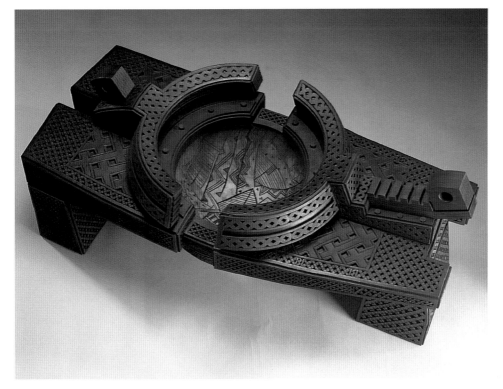

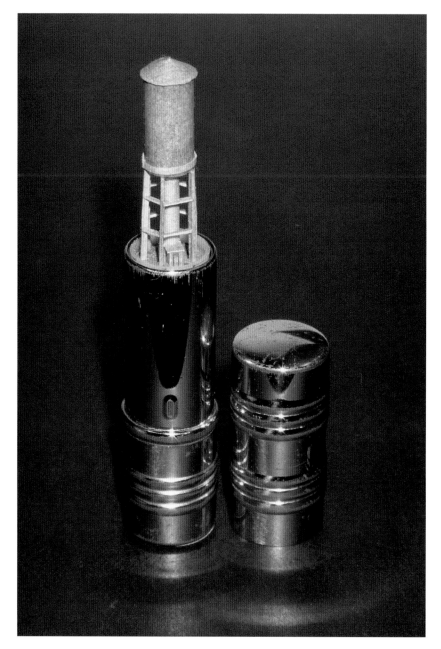

left: Charlie B. Thorne
Water Tower, 1999
Constructed relief
drawing contained
within lipstick case
3.875h

right: Sophie Ryder
Horse with Tulip, 1996
Bronze
9h

Belloc Lowndes Fine Art Gallery, Inc.

300 West Superior, Suite 203
Chicago, IL 60610
312.573.1157
Fax 312.573.1159
belloclowndes@bigplanet.com

20th-century modern and contemporary British and American art in all media

Staff: Charles Belloc Lowndes; Algernon Williams

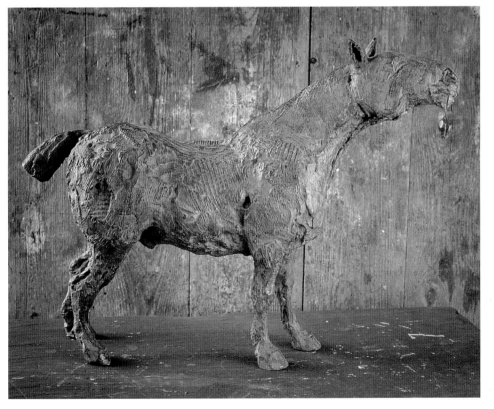

Exhibiting Artists

Steve Dilworth
Patrick Hughes
Sophie Ryder
Charlie B. Thorne
Steve Tobin

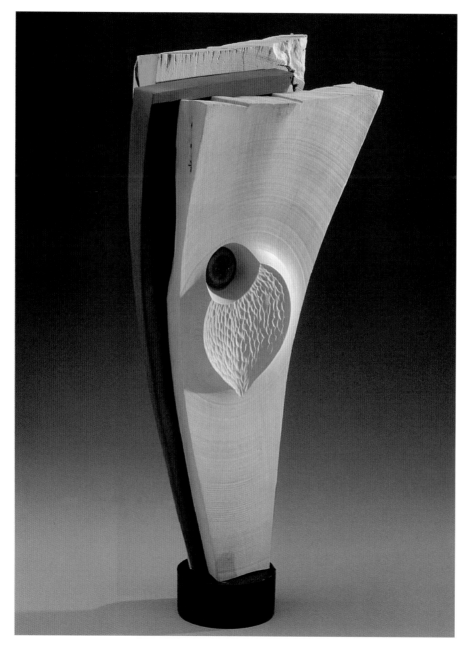

left: Stoney Lamar
 Trio, 1999
 Dogwood, steel
 28 x 12 x 7
 photo by Tim Barnwell

right: Michael Sherrill
 Fishtail Poplar Descent
 (detail), 1999
 Ceramic
 48 x 16 x 14
 photo by Tim Barnwell

Blue Spiral 1

38 Biltmore Avenue
Asheville, NC 28801
828.251.0202
Fax 828.251.0884
bluspiral1@aol.com

Exceptional Southeastern fine art and craft

Staff: John E. Cram, director; Carol Carr; Matt Chambers; Marthe Le Van; Michael D. Zullo

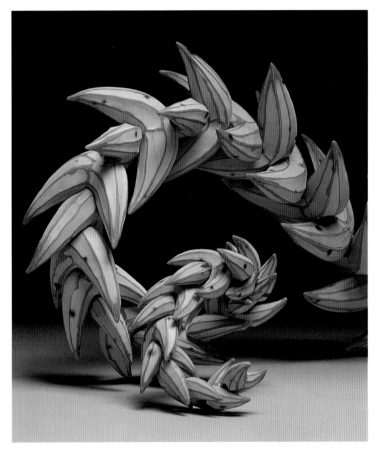

Exhibiting Artists

Mark Burleson
Buzz Coren
Robert Gardner
Hoss Haley
Stoney Lamar
Michael Sherrill
Brent Skidmore

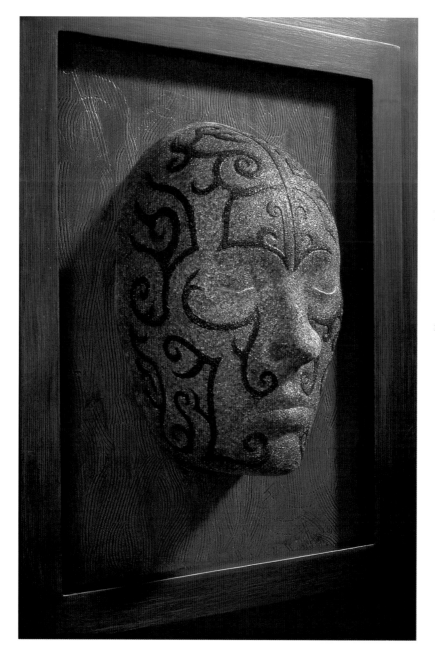

left: Alicia Lomné
 Into the Woods (Self Portrait
 with Tattoos), 1999
 Pâte de verre, painted wood
 17 x 13 x 5.5
 photo by Robert Vinnedge

right: Giles Bettison
 Cells Series, 1999
 Kiln-formed, blown and
 wheel-cut murrine glass
 14.5 x 5.5

The Bullseye Connection

300 NW Thirteenth Avenue
Portland, OR 97209
503.227.2797
Fax 503.227.2993
gallery@bullseye-glass.com

Showcasing works by artists who have collaborated with the Bullseye Glass factory in residencies or special projects

Staff: Lani McGregor, director; Shannon Keane, associate director

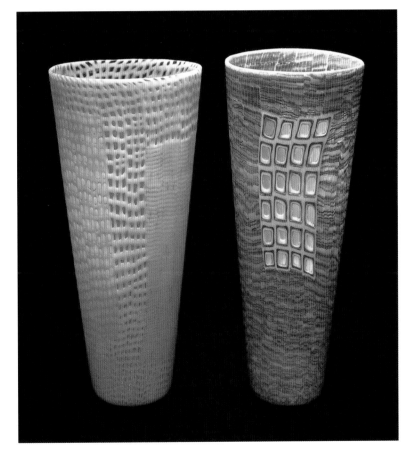

Exhibiting Artists

Giles Bettison
Claudia Borella
Ben Edols and
 Kathy Elliott
Silvia Levenson
Alicia Lomné
Jessica Loughlin
Julie Mihalisin and
 Philip Walling
Johnathon Schmuck
Anna Skibska
Richard Whiteley

left: Toshio Iezumi
Form (detail), 1999
Laminated plate glass,
ground and polished
9 x 14 x 10
photo by Keitaro Yoshioka

right: Junichiro Baba
Evening Sky, 1999
Cast glass
12 x 40 x 6
photo by Keitaro Yoshioka

Chappell Gallery

14 Newbury Street
Boston, MA 02116
617.236.2255
Fax 617.236.5522
amchappell@aol.com

Established and emerging artists working in glass and mixed media

Staff: Alice M. Chappell, director; Jessica Burko, manager; Christine Hadermayer, curatorial intern; Emily Abbott, student liason

Exhibiting Artists

Junichiro Baba
Sydney Cash
Alan Glovsky
Toshio Iezumi
Yoko Kuramoto
Martin Rosol
Naomi Shioya
Yoshihiko Takahashi

left: Petr Dvorak
Necklace, 1999
White gold, gold,
synthetic stones
photo by Karen Bell

right: Anna Heindl
Necklace and *Bracelet*, 1999
Oxidized silver, gold, fire
opals, carnelian
photo by Karen Bell

Charon Kransen

357 West 19th Street
New York, NY 10011
212.627.5073
Fax 212.633.9026
chakran@earthlink.net

Contemporary innovative jewelry, mostly from Europe

Staff: Charon Kransen, owner/director; Adam Brown; Micki Lippe

Exhibiting Artists

Whitney Abrams	Ulle Kouts
Paul Annear	Winfried Krueger
Nicolai Appel	Gabriela Kutschera
Alexandra Bahlmann	Gunilla Lantz
Ralph Bakker	Guntis Launders
Andrei Balasov	Nel Linssen
Michael Becker	Micki Lippe
Harriete Estel Bermen	Stefano Marchetti
Liv Blavarp	Kerstin Mayer
Andrea Borst	Saito Miho
Esther Brinkmann	Kazuko Mitsushima
Kim Buck	Sonia Morel
Anton Cepka	Kazuko Nishibayashi
Cathy Chotard	Ted Noten
Shao-Pin Chu	Barbara Paganin
Giovanni Corvaja	Alet Pilon
David Damkoehler	Roos Regenboog
Peter de Wit	Alida Roiseland
Petr Dvorak	Jacky Ryan
Lina Falkesgaard	Mette Saabye
Andrea Frahm	Margareth Sandstrom
Donald Friedlich	Bernard Schobinger
Bernhard Früh	Renate Scholz
Anna Gordon	Biba Schutz
Katy Hackney	Barbara Seidenath
Susanne Hammer	Stephan Seyffert
Sophie Hanagarth	Verena Sieber Fuchs
Torben Hardenberg	Asa Skogberg
Anna Heindl	Dorothee Striffler
Kozo Hiramatsu	Barbara Stutman
Yasuki Hiramatsu	Per Suntum
Soyeon Hong	Janna Syvanoja
David Huycke	Catherine Truman
Froukje Idsardi	Johan van Aswegen
Hilde Janich	Truike Verdegaal
Ike Juenger	Anuschka Walch
Bongrey Jung	Esther Ward
Vered Kaminski	Ginny Whitney
Yuri Kawanabe	Andrea Wippermann
Jae Youn Kim	Annamaria Zanella
Seung-Hee Kim	

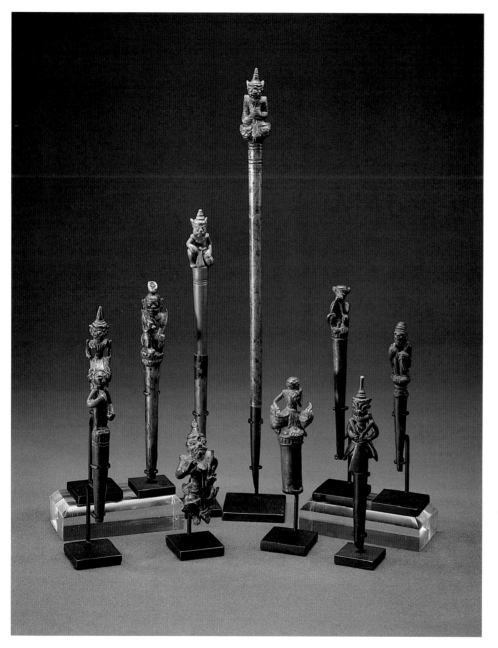

left: Collection of bronze
tattooing instruments and
counterbalances in various
mythical forms, late 19th
century, Burma
photo by Stan Schnier

right: Yao Shaman's mask
worn or hung during
important ceremonies to
frighten away ghosts
and bad spirits
18th/19th century, Laos
photo by Michael Madigan

Chinalai Tribal Antiques, Ltd.

52 Woodville Road
P.O. Box 815
Shoreham, NY 11786
516.821.4272
Fax 516.821.4272
cta@unix.asb.com

Textiles, objects, silver and spiritual artifacts from mainland Southeast Asia

Staff: Vichai Chinalai, Lee J. Chinalai, proprietors

left: Vladimir Bachorik
The Tower, 1999
Cast glass
15 x 10 x 6

right: Czeslaw Zuber
Painted Head, 1999
Optical glass, cut,
polished, painted
11 x 13.5 x 7.5

Compositions Gallery

317 Sutter Street
San Francisco, CA 94108
415.693.9111
Fax 415.693.9344
info@compositionsgallery.com

Celebrating its 20th anniversary, featuring an extensive selection of contemporary glass art by more than 50 American and international artists

Staff: Siegfried H. Ehrmann

Exhibiting Artists

Vladimir Bachorik
Latchezar Boyadjiev
John Healey
Susanne Precht
Margit Tóth
Czeslaw Zuber

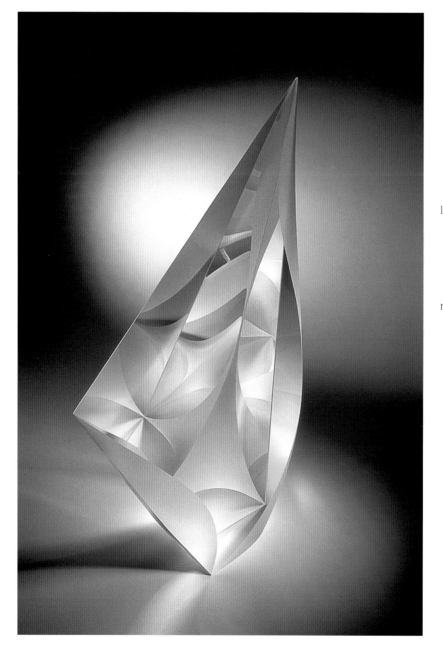

left: Christopher Ries
Bouquet of Light, 1999
Glass
21 x 11.5 x 6
photo by Creative Vision Studio

right: Christopher Ries
Holiday, 1998
Glass
17 x 13.5 x 4.25
photo by Creative Vision Studio

Coplan Gallery

608 Banyan Trail
Boca Raton, FL 33431
561.994.9151
Fax 561.994.5864
netters@flinet.com

Representing the best in contemporary glass, sculpture and photography

Staff: Richard Coplan; Al Marco

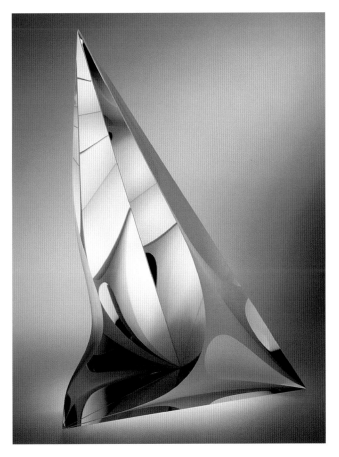

Exhibiting Artists

Manuel Hughes
David Mamet
Dan Meyer
Christopher Ries
Donald Sultan

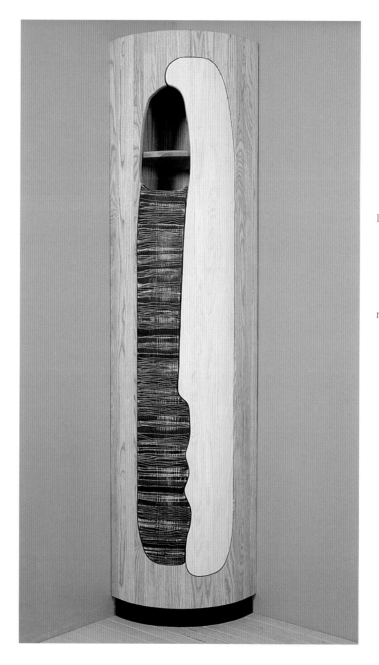

left: Peter Opsvik
Fisherman, 1998
Wood
79 x 21 x 15
photo by Kjellbjorn Tusvik

right: Peter Opsvik
Bluesman, 1998
Wood
31.5 x 21 x 6
photo by Kjellbjorn Tusvik

Cylindra Gallery

Tusvik
N–6222 Ikornnes
Norway
47.7025.0033
Fax 47.7025.0014
cylindra-objects@cylindra.no

Exhibiting the Cylindra Collection, which comprises more than 100 pieces
Staff: Kjellbjorn Tusvik; Åshild Tomassen

Exhibiting Artists

Peter Opsvik

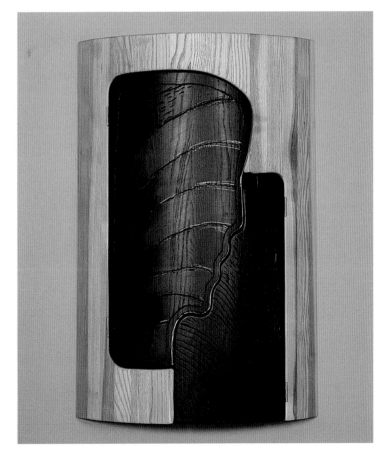

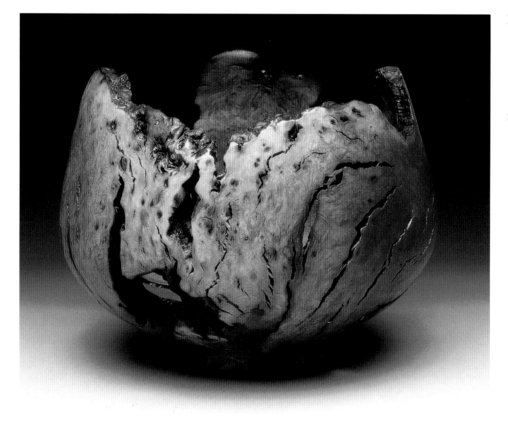

left: Rude Osolnik
 Untitled Bowl, 1999
 Manzanita burl
 7.125 x 8.5
 photo by David Peters

right: Hans Weissflog
 Spider Bowl, 1999
 Teak
 2.625 x 7.75
 photo by David Peters

del Mano Gallery

11981 San Vicente Boulevard
Los Angeles, CA 90049
310.476.8508
Fax 310.471.0897
delmano@aol.com

A special exhibition of turned and sculpted wood by artists featured in the book
"Contemporary Turned Wood: New Perspectives in a Rich Tradition"

Staff: Ray Leier, Jan Peters, owners; Kevin Wallace, manager

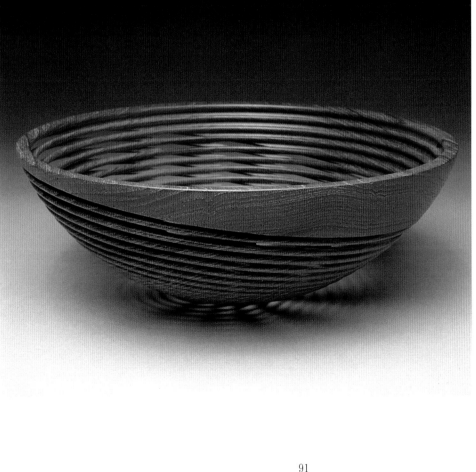

Exhibiting Artists

Ray Allen	Sam Maloof
Frank Amigo	Bert Marsh
Gianfranco Angelino	Terry Martin
Derek Bencomo	Hugh McKay
Anthony Bryant	John Dodge Meyer
Christian Burchard	Johannes Michelsen
Kip Christensen	Connie Mississippi
Robert J. Cutler	Bruce Mitchell
Virginia Dotson	Michael Mode
Dennis Elliott	Gael Montgomerie
David Ellsworth	William Moore
J. Paul Fennell	Rolly Munro
Melvyn Firmager	Rude Osolnik
Clay Foster	Nikolai Ossipov
Donald E. Frith	Stephen Paulsen
Giles Gilson	Michael Peterson
Louise Hibbert	Andrew Potocnik
Stephen Hogbin	Gene Pozzesi
Michelle Holzapfel	Richard Raffan
Robyn Horn	Gary Sanders
Michael Hosaluk	Norm Sartorius
Todd Hoyer	Jon Sauer
Stephen Hughes	Betty Scarpino
William Hunter	Mike Scott
Gary Johnson	Kay Sekimachi
Arthur Jones	David Sengel
Ray Jones	Mark Sfirri
Ron Kent	Jack Slentz
Ray Key	Hayley Smith
Bud Latven	Alan Stirt
Michael Lee	Bob Stocksdale
Po Shun Leong	Frank Sudol
Mark Lindquist	Ben Trupperbaumer
Mel Lindquist	Jacques Vesery
Steve Loar	Hans Weissflog
Craig Lossing	Vic Wood

left: Patrick Hall
Drawer front detail from
*An Alphabet of the Safe
and Misplaced*, 1999
Plywood, aluminum,
glass, etching ink
51 x 47 x 17.5
photo by Peter Whyte

right: Phill Mason
White Saturn and
Saturn Rings, 1999
Ringed broome pearl,
Tasmaninan white coral,
sterling silver, rose and yellow
18k golds, 22k bezel
6 x 2.25 and 1.25 x .625

Despard Gallery

15 Castray Esplanade
Hobart, Tasmania 7000
Australia
61.3.6223.8266
Fax 61.3.6223.6496
eajoyce@trump.net.au
www.despard-gallery.com.au

*Modern to contemporary fine and decorative art furnishing,
sculpture, jewelry, studio glass and ceramics*

Staff: Steven W. Joyce, director; Helene Czerny

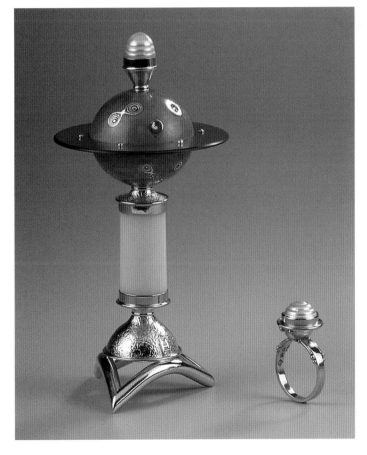

Exhibiting Artists

Lorraine Biggs
Mark Bishop
Glen Clarke
Patrick Hall
Phill Mason
Jenny Orchard
Peter Prasil
John Smith
Patrick Stronach
Marcus Tatton

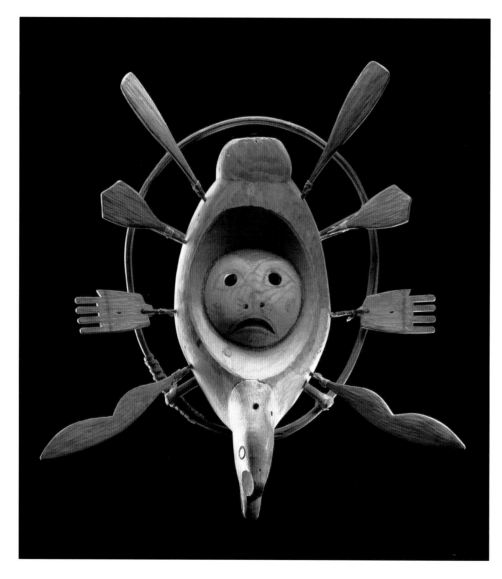

left: Dance Mask
 Yup ík Eskimo
 19th century
 Alaska

right: Robe (attush)
 Ainu, 19th century
 Hokkaido, Japan

Donald Ellis Gallery

RR #3
Dundas, Ontario L9H 5E3
Canada
905.648.1837
Fax 905.648.8711
ellisgal@interlynx.net

Historical 18th- and 19th-century Native American and tribal art

Staff: Donald Ellis; Mary Ann Bastien

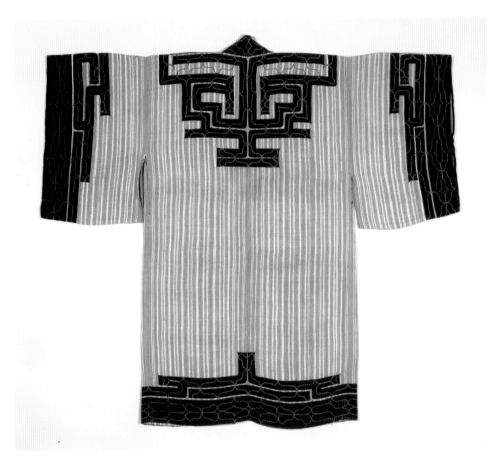

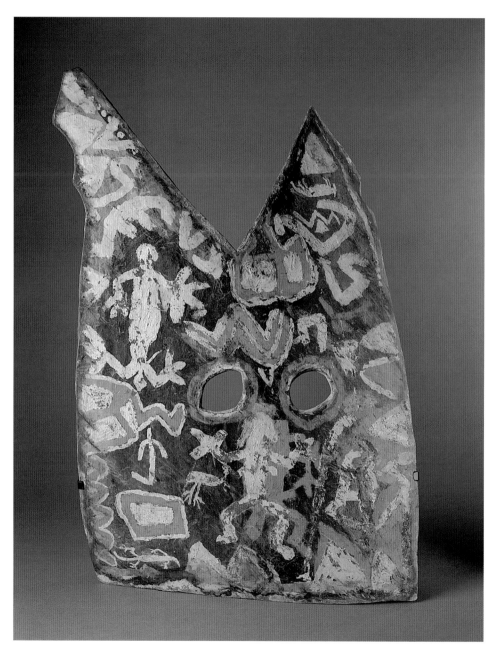

left: Ancestor Board, 1940s
Lake Murray area,
New Guinea
Wood, natural pigment
20 x 31
photo by Paul Lecat

right: Jizai (Hearth Hook)
Japan-Edo Period
19th century
Japanese chestnut
16 x 14 x 5
photo by Paul Lecat

Douglas Dawson

222 West Huron
Chicago, IL 60610
312.751.1961
Fax 312.751.1962
ddgallery@aol.com

Ancient and antique ethnographic art from Africa, Asia and the Americas

Staff: Douglas Dawson, director; Nancy Bender, manager;
Armando Espana; Roman Bilik; Michael Smith

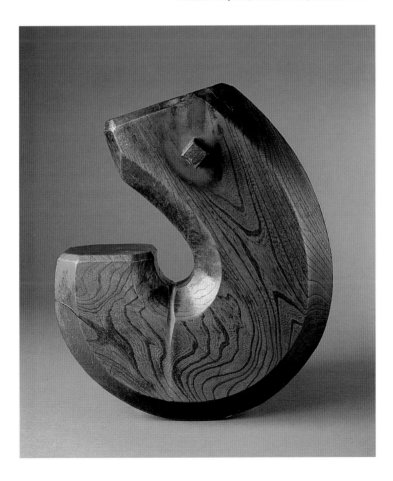

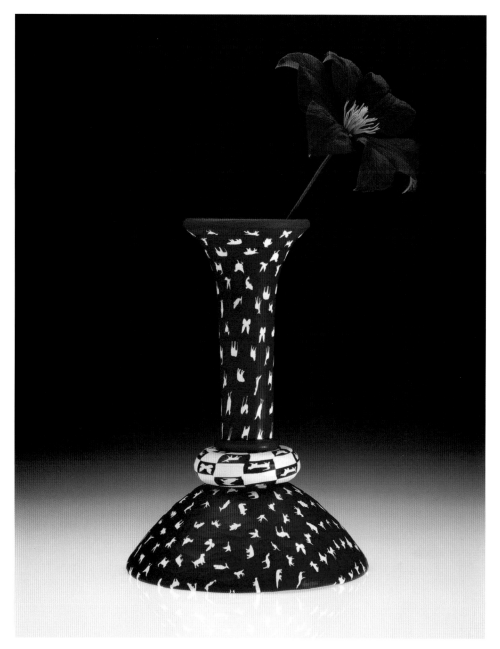

left: Richard Marquis
Silhouettes Marquiscarpa #99-4
(upside down), 1999
Fused, slumped, blown and
carved murrine glass
7 x 5.25 x 5.25
photo by Richard Marquis

right: Toots Zynsky
Lido Serena, 1999
Glass
12.25 x 23.75 x 7

Elliott Brown Gallery

619 North 35th Street, #101
Seattle, WA 98103
206.547.9740
Fax 206.547.9742
kate@elliottbrowngallery.com

Sculpture and decorative arts in traditional craft media with a focus on glass

Staff: Kate Elliott, director; Tina Oldknow; Jill Davis

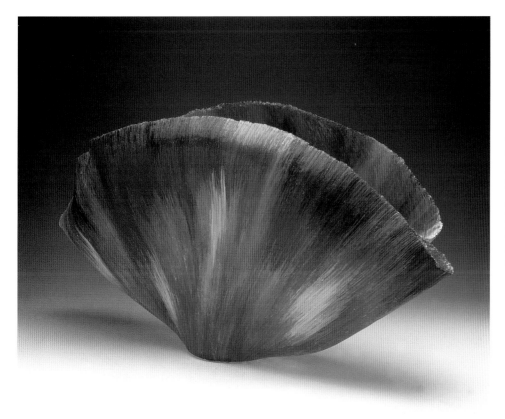

Exhibiting Artists

Hank Murta Adams
Laura de Santillana
Katherine Gray
Deborah Horrell
Mayme Kratz
Richard Marquis
John McQueen
Charles Parriott
Flo Perkins
Pike Powers
Ann Robinson
Karyl Sisson
Karla Trinkley
Jack Wax
Toots Zynsky

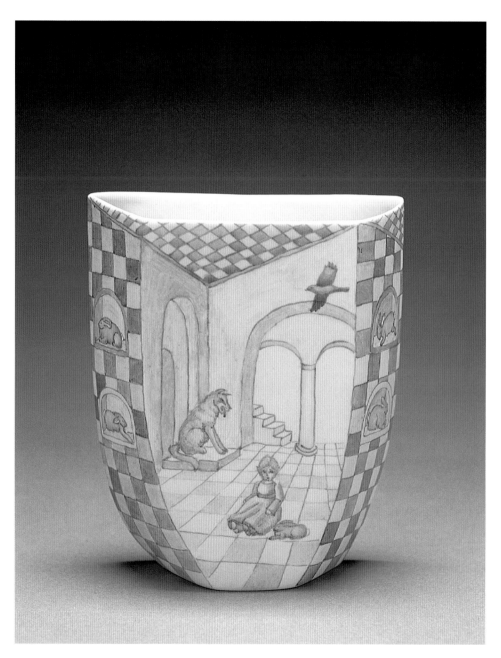

left: Jane Osborn-Smith
 St. Clare, 1999
 Ceramic
 4 x 3.25 x 1.5
 photo by Peter Aldridge

right: Susan Thayer
 After the Rain, 1999
 Ceramic
 7.25 x 10 x 2.5
 photo by Deon Reynolds

Ferrin Gallery

179 Main Street
Northampton, MA 01060
413.586.4509
Fax 413.586.4512
laferrin@ix.netcom.com
www.ferringallery.com

Specializing in contemporary American ceramics. Group Show at SOFA CHICAGO: "China Painting Today"

Staff: Leslie Ferrin, director; Donald Clark, managing director; Kirk Sklar

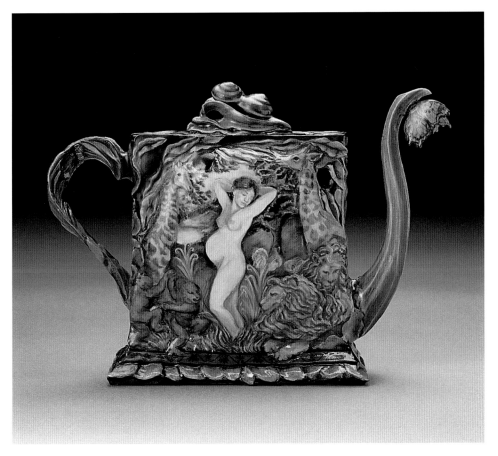

Exhibiting Artists

Cricket Appel
Chuck Aydlett
Mark Burns
Jack Earl
Deborah Kate Groover
Sergei Isupov
Charles Krafft
Les Lawrence
Keisuke Mizuno
Matt Nolen
Jane Osborn-Smith
Nancy Selvin
Richard Shaw
Michael Sherrill
Susan Thayer
Gerry Wallace
Maryann Webster
Kurt Weiser
Irina Zaytceva
Lia Zulalian

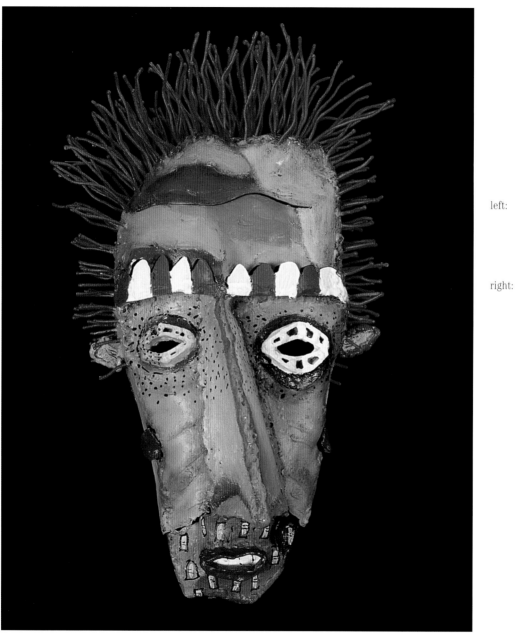

left: Bill Hickman
 Untitled, 1999
 Welded steel
 14 x 12 x 6

right: Rusty Wolfe
 Zipper, 1999
 Lacquer, plywood, MDF
 33 x 100 x 7
 photo by Jim McGuire

Finer Things Gallery

1898 Nolensville Road
Nashville, TN 37210
615.244.3003
Fax 615.254.1833
www.finerthingsgallery.com

Contemporary sculpture and painting with an emphasis on furniture as art

Staff: Kim Brooks, director

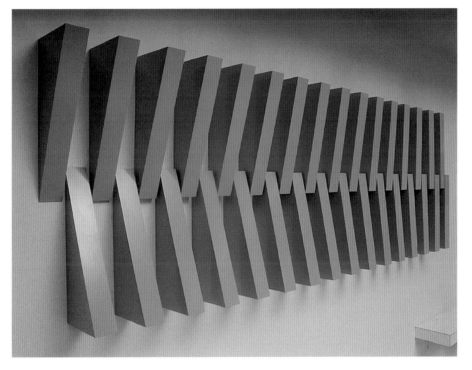

Exhibiting Artists

John Dickinson
Peter Harrison
Bill Hickman
Cam Langley
Adrienne Outlaw
Bruce Peebles
Joël Urruty
Kathy Anne White
Rusty Wolfe

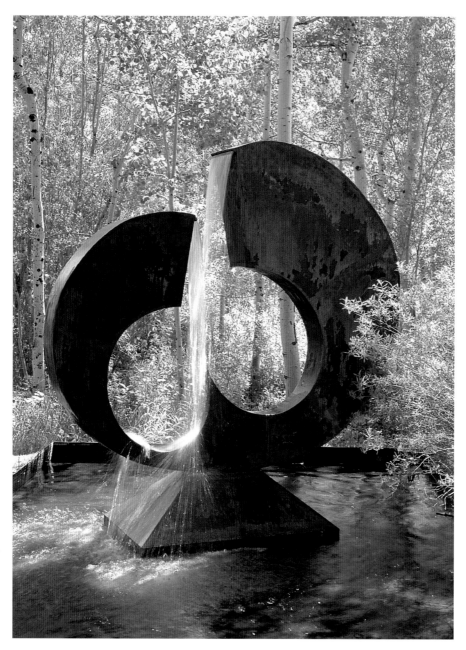

left: Mark Stasz
Crescendo, 1999
Steel

right: David Secrest
Shinza Bench I, 1999
Steel, sand-cast bronze
23 x 29.5 x 11.5

Gail Severn Gallery

620 Sun Valley Road
Ketchum, ID 83340
208.726.5079
Fax 208.726.5092
gseverngallery@svidaho.net

Contemporary painting and sculpture

Staff: Gail Severn, owner/director; Heather Jane Langley; Connie Love;
Bruce Kramer; Shirley Severn; Jeff Whitaker

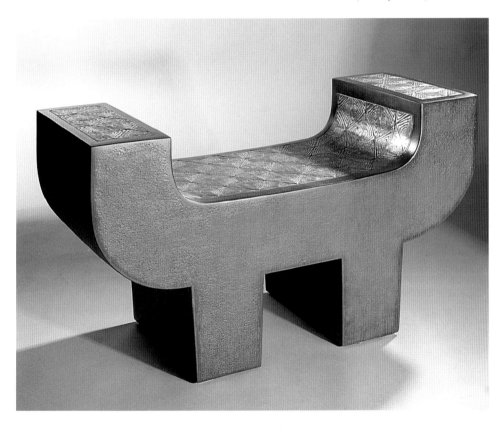

Exhibiting Artists

Dan Anderson
David de Villier
David French
Mark Lindquist
Melvin Lindquist
Robert McCauley
Kerry Moosman
Kenna Moser
Marcia Myers
Brad Rude
David Secrest
Julie Speidel
Mark Stasz
Jeff Whitaker

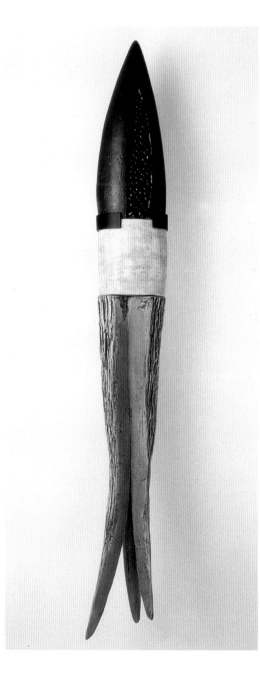

left: Marie-Andrée Côté
 Nature Improvisée XXI, 1999
 Stoneware
 40 x 6 x 7
 photo by Lucien Lisabelle

right: Eva and Milan Lapka
 Ara Pacis, 1997
 Metallic stoneware, glass
 20 x 36 x 20
 photo by Dorothy Manoukian

Galerie des Métiers d'Art du Quebec

350 Saint-Paul East, Suite 400
Montreal, Quebec H2Y 1H2
Canada
514.861.2787
Fax 514.861.9191
cmaq@metiers-d-art.qc.ca

*Specializing in work by contemporary Quebec artists focusing
on excellence in creativity and craftsmanship*

Staff: Yvan Gauthier, executive director; Louise Chapados; Diane Labelle; France Bernard

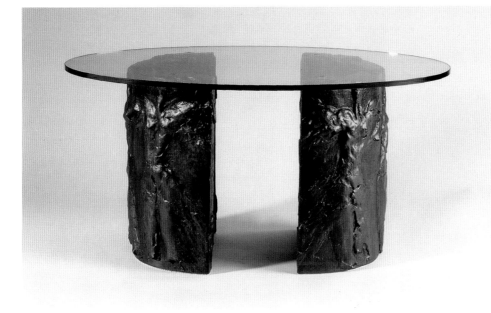

Exhibiting Artists

Patricia Ben Haim
Mitsuru Cope
Marie-Andrée Côté
Rosie Godbout
Eva and Milan Lapka
Donald Robertson

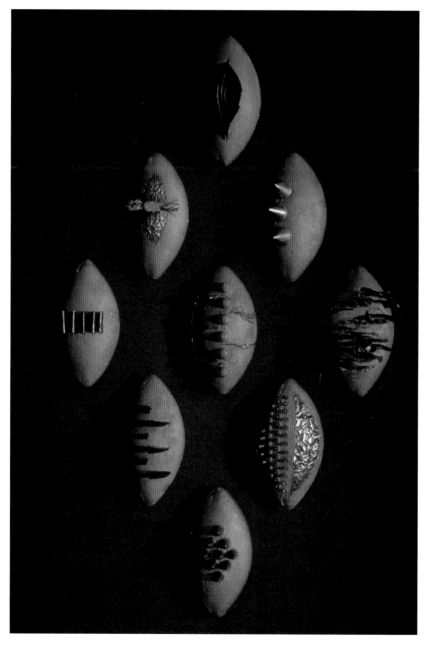

left: Susan Edgerley
From the One Series V
Sandcast glass, copper, wood
48 x 31 x 4
photo by Jocelyn Blais

right: Koen Vanderstukken
Shadow
Sandcast glass
24 x 9 x 5

Galerie Elena Lee Verre d'Art

1428 Sherbrooke West
Montreal, Quebec H3G 1K4
Canada
514.844.6009
Fax 514.844.1335
glasart@cam.org

Specializing in new directions of contemporary art glass for over 20 years

Staff: Elena Lee, president; Joanne Guimond, director; Anne Morasse; Katrin Leblond

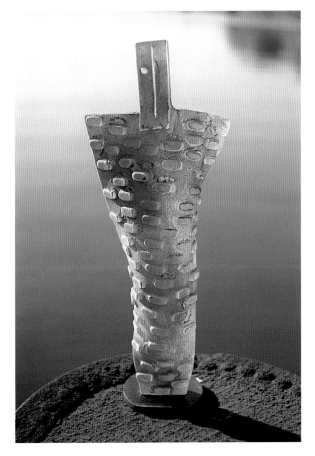

Exhibiting Artists

Brad Copping
Daniel Crichton
Susan Edgerley
Jeff Goodman
Naoko Takenouchi
Koen Vanderstukken

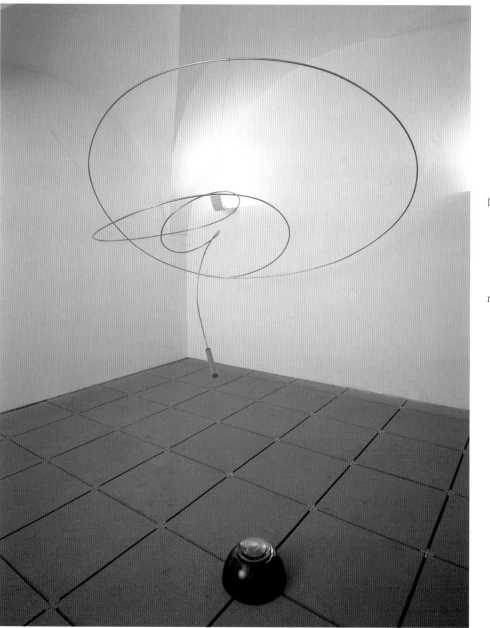

left: Vaclav Cigler
 Relationship, 1997
 Metal, glass
 118 x 118
 photo by Petr Dörfl

right: Zora Palová
 Green Ray, 1998
 Glass
 24 x 24 x 24
 photo by Zora Palová

Galerie Na Jánském Vršku

Jánský Vršek 15
Prague 11800
Czech Republic
42.02.5753.1546
Fax 42.02.2425.5694
jitka.pokorna@telecom.cz

Czech and international fine art of the 20th century

Staff: Jitka Pokorná; Radka Pudilová; Lucka Čepková

Exhibiting Artists

Ilja Bilek
Vaclav Cigler
Bohumil Eliaš
Ivana Houserova
Vladimir Kopecký
Stanislav Libenský and
 Jaroslava Brychtová
Bretislav Novak
Zora Palová
Frantisek Vizner

left: Pavel Hloska
 Gold in Triangle, 1998
 Optical glass, gold
 12 x 12 x 12
 photo by Pavel Hloska

right: Vladimir Zbynovsky
 Omphalos Cyclus
 Stone's Aura, 1999
 Yellow optical glass, limestone
 20 x 20 x 12
 photo by Peter Zupnik

Galerie Rob van den Doel

Anna Paulownastraat 105
The Hague 2518 BD
The Netherlands
31.70.364.6239
Fax 31.70.361.7612
info@galerierobvandendoel.com

Presenting contemporary glass from artists from Europe, USA, Japan and Australia

Staff: Rob van den Doel, Matisse P. Etienne, owners

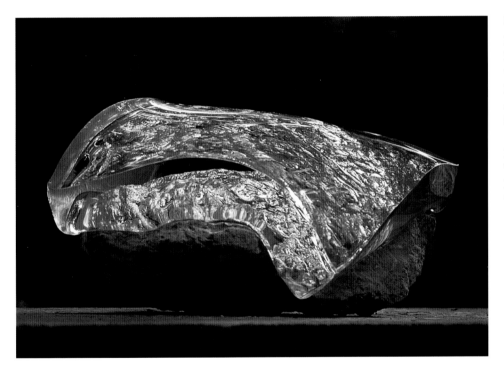

Exhibiting Artists

Milos Balgavy
Zoltan Bohus
Vaclav Cigler
Pavol Hloska
Andrej Jakab
Stanislav Libenský and
 Jaroslava Brychtová
Maria Lugossy
Winnie Teschmacher
Frantisek Vizner
Vladimir Zbynovsky

MR. BILL TRAYLOR FROM ALABAMA

left: Dale Gottlieb
*Mr. Bill Traylor from
Alabama,* 1999
Hand-knotted wool rug
84 x 60

right: Caroline Streep
Cornflower Brooch, 1998
Sterling silver, 18k and 22k
golds, fossil ivory, onyx, garnet
4.25h
photo by Ralph Gabriner

Gallery 500

Church and Old York Roads
Elkins Park, PA 19027
215.572.1203
Fax 215.572.7609

Contemporary American fine art and craft in all media

Staff: Harriet Friedberg, Rita Greenfield, owners

Exhibiting Artists

Larry Calkins
Mark Chatterley
Gregg Fleishman
Dale Gottlieb
Sonia GutierrezBecker
Janis Miltenberger
George Radeschi
Magan Stevens
Caroline Streep
Gretchen Wachs
Mark Wilkins

left: Norbert Muerrle
Brooch
Platinum, natural
brown diamond

right: Georg Spreng
Hearts
18k yellow gold,
natural gems

Gia Designer Jewelry

64 East Walton Street
Chicago, IL 60611
312.944.5263
Fax 312.944.6873
www.giajewelry.com

Exceptionally elegant, modern designer jewelry for today's minimal lifestyle

Staff: Gia Hammond

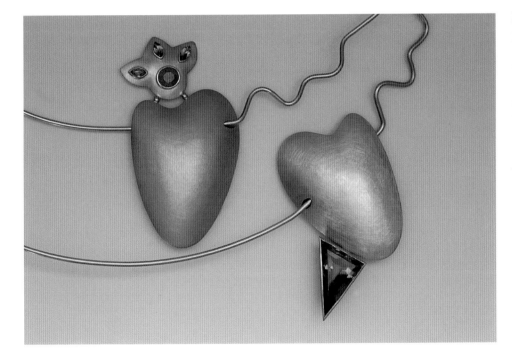

Exhibiting Artists

Damiani
Henrich Denzel
Egon Frank
Michael Good
Steven Kretchmer
Norbert Muerrle
Niessing
Orlando Orlandini
Andre Ribeiro
Georg Spreng
Michael Zobel

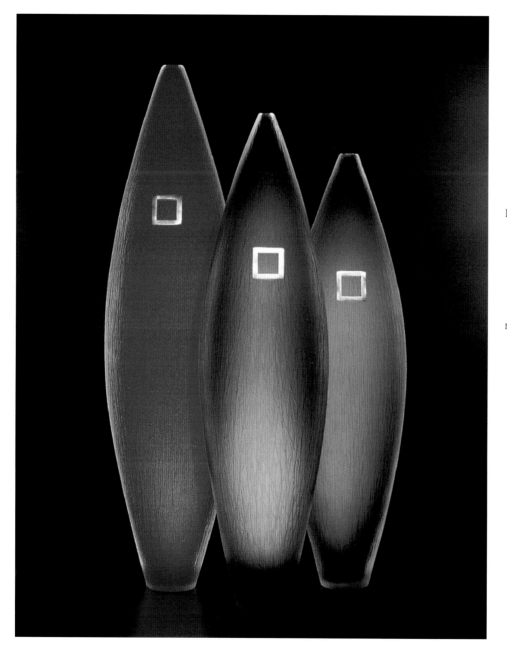

left: Matthew Curtis
Windows Group, 1999
Blown glass, cut surface,
silver inclusion
28 x 7 x 6
photo by Hirst/Curtis

right: Jane Gavan
Black Urn, 1998
Opaque glass beads
woven with wire
10 x 7 x 7
photo by Ute Wegman

Glass Artists' Gallery

70 Glebe Point Road
Glebe, Sydney, NSW 2037
Australia
61.2.9552.1552
Fax 61.2.9552.1552
glassartistsgallery@bigpond.com

Australia's only specialist glass gallery featuring a resource for over 70 artists

Staff: Maureen Cahill, director

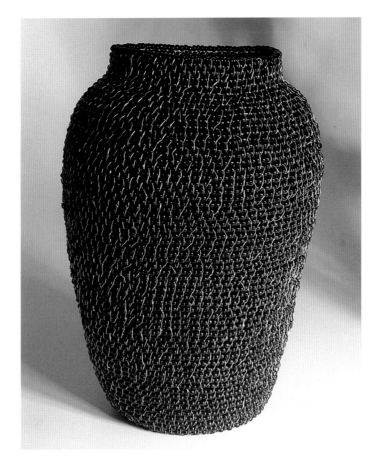

Exhibiting Artists

Deb Cocks
Matthew Curtis
Jane Gavan
Gerry King
Jim Randall
Simon Maberley

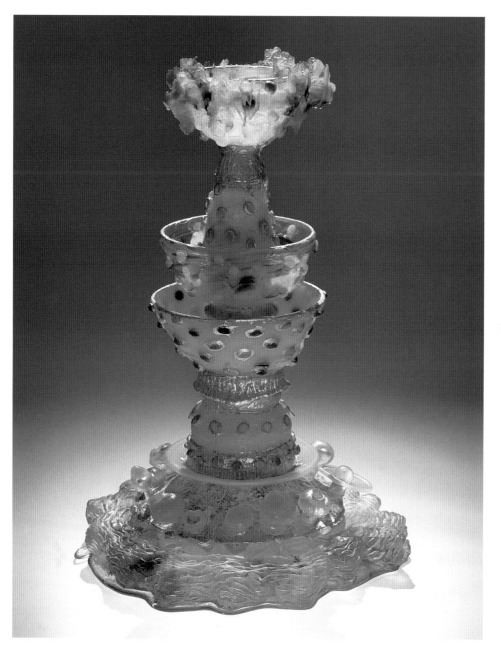

left: Rene Culler
Three of Cups, 1999
Blown, kiln-transformed
and cast glass
27 x 16 x 14
photo by Robert Muller

right: Brent Kee Young
Turning Point . . . Floating
Cast glass
6 x 20 x 11

The Glass Gallery

4720 Hampden Lane
Bethesda, MD 20814
301.657.3478
Fax 301.657.3478
salgall@worldnet.att.net

Presenting two contrasting sculptural groups: "A Spare Aesthetic" and "Exuberant Expressions"

Staff: Sally Hansen, director; Ned Hansen; Jennifer Blazina; Mark Fowler, coordinator

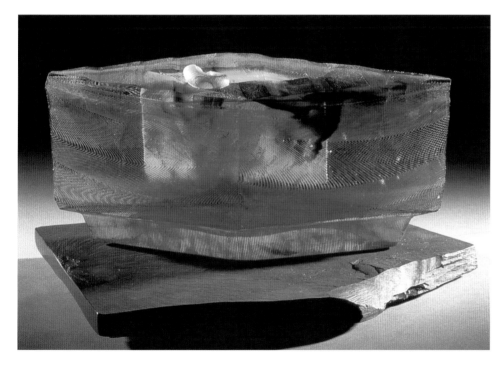

Exhibiting Artists

Jennifer Blazina
Rene Culler
Laura Donefer
Mark Fowler
Makoto Ito
Yoko Kuramoto
Brent Kee Young

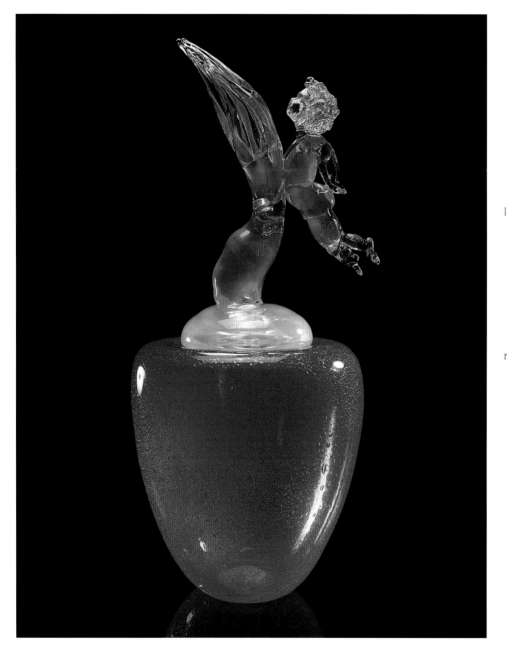

left: Dale Chihuly
Putti Gliding with Squid
Resting on Orange Aurora
Vessel, 1998
Blown glass
34.5 x 15 x 15
photo by Chuck Taylor

right: Daniel Clayman
Trough, 1999
Cast glass, bronze
18 x 18 x 14
photo by Cathy Carver

Habatat Galleries

7 North Saginaw Street
Pontiac, MI 48432
248.333.2060
Fax 248.333.2717

222 West Superior
Chicago, IL 60610
312.440.0288
Fax 312.440.0207

608 Banyan Trail
Boca Raton, FL 33431
561.241.4544
561.241.5793

117 State Road 7
Great Barrington, MA 01230
413.528.9123

Specializing in the finest works in contemporary glass

Staff: Ferdinand Hampson; Kathy Hampson; Lillian Zonars; Shannon Trudell; John Lawson

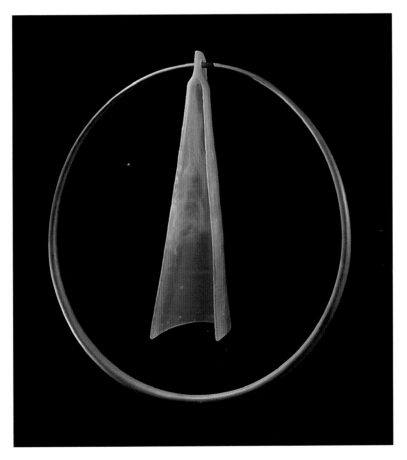

Exhibiting Artists

Dale Chihuly
Daniel Clayman
Kimiake Higuchi
Shinichi Higuchi
Pavel Hlava

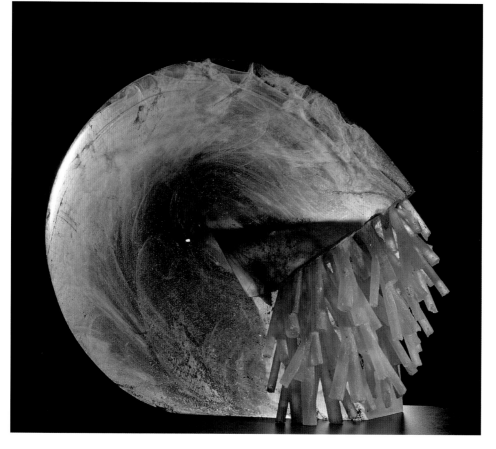

left: Ivan Mares
 Nautilus, 1999
 Kiln-cast glass
 34 x 35 (525 lbs.)
 photo by Gabriel Urbánek

right: Philip Moulthrop
 Bundled White Pine
 Mosaic Bowl, 1998
 10.5 x 13

Heller Gallery

420 West 14th Street
New York, NY 10014
212.414.4014
Fax 212.414.2636
info@hellergallery.com

Three decades of service to museums and collectors

Staff: Douglas Heller

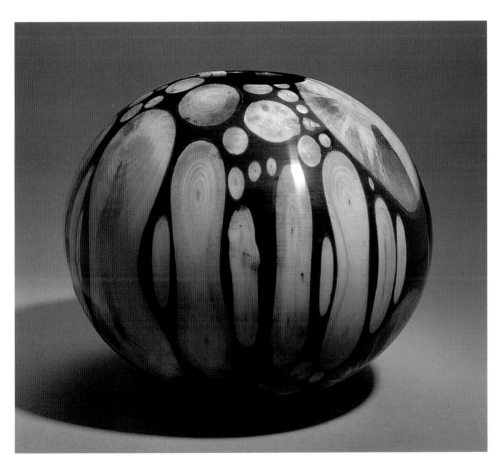

Exhibiting Artists

Rick Beck
David Groth
Petr Hora
Ivan Mares
Philip Moulthrop

left: Michael Heltzer
Kubis Nightstand, 1994
Stainless steel
25 x 24 x 22

right: Michael Heltzer
Sedona Cafe Series, 1996
Stainless steel

Heltzer

Suite 1800
Merchandise Mart
Chicago, IL 60654
312.527.3010
Fax 312.527.3176

Presenting furniture, lighting and textiles

Staff: Judith Simon, showroom director; Deanna Hansen, vice-president of operations;
Michael Heltzer, president; Jennifer Brooks, director of sales

Exhibiting Artists

Janet Benes
Michael Heltzer
Kyoko Ibe
Joe Litzenberger

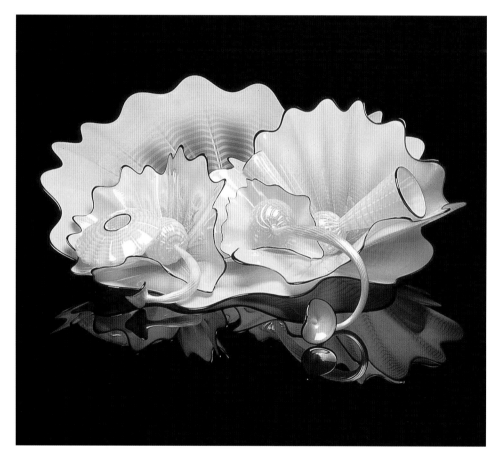

left: Dale Chihuly
Citron Yellow Persian Set with
Terra Carbon Lip Wraps, 1998
Blown glass
9 x 24 x 25
photo by Teresa Rishel

right: Dale Chihuly
Navaho Silver and Gilded
Sconces, 1999
Blown glass
54 x 50 x 20

Holsten Galleries

Elm Street
Stockbridge, MA 01262
413.298.3044
Fax 413.298.3275
artglass@holstengalleries.com

Contemporary glass sculpture

Staff: Kenn Holsten, owner/director; Jim Schantz, managing director; Christine Warren, associate

Exhibiting Artists

Dale Chihuly

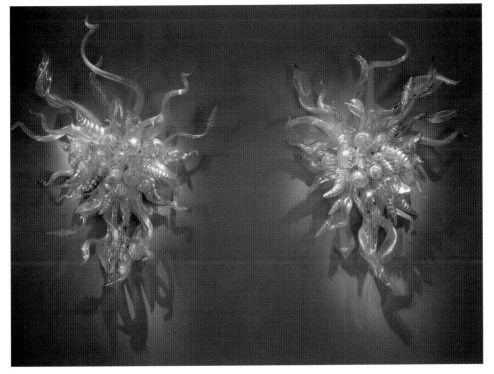

left: Dan Namingha
 Maidens, 1998
 Bronze
 35.5 x 5.5 x 7
 photo by Herbert Lotz

right: Troy Woods
 Never, 1998
 Maple, steel
 99 x 8 x 15

J. Cacciola Galleries

501 West 23rd Street
New York, NY 10011
212.462.4646
Fax 212.462.4556
jcacciola@aol.com

Contemporary American painting and sculpture

Staff: John Cacciola, president; Theresa Reeves, director; Kevin Jones

Exhibiting Artists

Frank Duchamp
Dan Namingha
Troy Woods

left: Diane Cooper
Genten Series, 1999
Mixed media
12 x 12 x 3
photo by Tom Van Eynde

right: Bradley Levin
Bowl, 1999
Beads, mixed media
6.25 x 16 x 16
photo by William Bengtson

Jean Albano Gallery

215 West Superior
Chicago, IL 60610
312.440.0770
Fax 312.440.3103

Contemporary American art with an emphasis on painting and sculpture

Staff: Jean Albano Broday; Gail Sellers; Genevieve Devitt

Exhibiting Artists

Diane Cooper
John Geldersma
Bob Gilormo
Linda Kramer
Bradley Levin

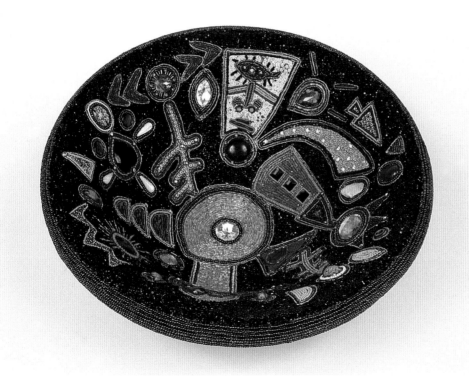

left: Iris Bodemer
Brooch and *Ring*, 1998
18k gold, tourmalines, coral

right: Barbara Seidenath
Snowy Pond (brooch), 1999
Enamel, silver, diamonds
2 x 2 x .125

Jewelers' Werk Galerie

2000 Pennsylvania Avenue NW
Washington, DC 20006
202.293.0249
Fax 202.659.4149

European and American jewelry artists

Staff: Ellen Reiben, director; Annie Nash, Setareh Atabeigi, assistants

Exhibiting Artists

Jane Adam	Susan Kim
Giampaolo Babetto	Daniel Kruger
Iris Bodemer	Claudia Langer
Stephen Bottomley	Yutaca Minegishi
Frederic Braham	Darcy Miro
Giorgio Cecchetto	Valerie Mitchell
Scott Cormier	Pavel Opočenský
Bettina Dittlmann	Ruudt Peters
Noam Elyashiv	Karen Pontoppidan
Sophia Epp	Robin Quigley
Andrea Frahm	Ondrej Rudavsky
Warwick Freeman	Rudi Sand
Karl Fritsch	Dorothea Schippell
Lisa Gralnick	Barbara Seidenath
Elke Hackner	Sondra Sherman
Susanne Hammer	Jiři Šibor
Michal Hejný	Marjorie Simon
Therese Hilbert	Winfried Sommer
Angela Hübel	Lisa Spiros
Michal Jank	Rachelle Thiewes
Hermann Jünger	Anuschka Walch

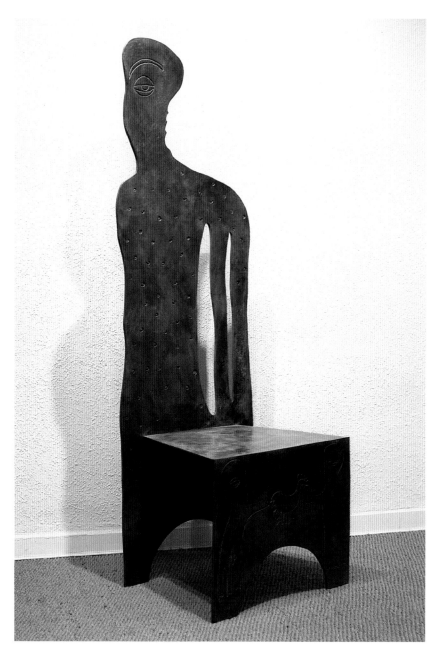

left: Manuel Mendive
Silla (Chair), 1997
Bronze
65 x 21 x 17

right: Wolf Vostell
Berliner Brot, 1997
Bronze, TV monitor
15 x 35 x 6

Joan Guaita-Art

Veri, 10
Palma de Mallorca
Baleares 07001
Spain
34.971.715989
Fax 34.971.715898

Dedicated to promoting Modern art specializing in Fluxus, Pop art and photography

Staff: Joan Guaita, director; Isabel Cabot, Bel Font, collaborators

Exhibiting Artists

Louise Bourgeois
Giri Georg Dokoupil
Manuel Mendive
Peter Phillips
Fabrizio Plessi
Bernardí Roig
Wolf Vostell

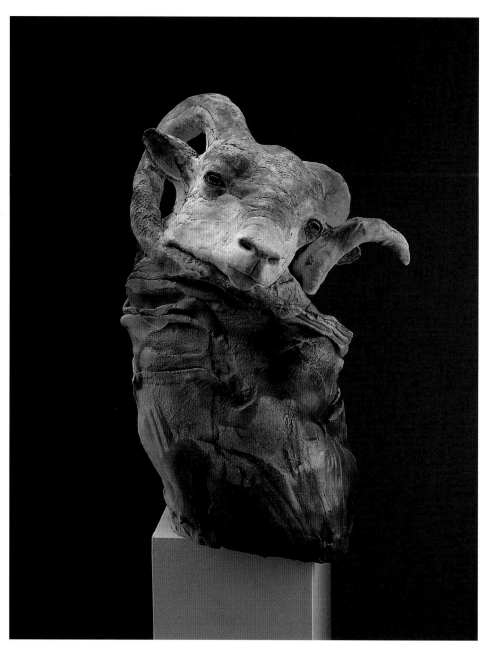

left: Pamela Earnshaw Kelly
Sorrel, 1999
Raku-fired ceramic
26.5 x 16 x 16
photo by Dan Van Zandbergen

right: Andy Buck
Moonwalker, 1999
Ebonized walnut, paint
17 x 73 x 12
photo by Bill Bochhuber

John Elder Gallery

529 West 20th Street, 7th floor
New York, NY 10011
212.462.2600
Fax 212.462.2510
mail@johnelder.com
www.johnelder.com

*Showcasing contemporary studio furniture and sculpture —
works that combine artistic vision with the artisan's joy of making*

Staff: John Elder; Don Thomas, director; Andrew Wheatcraft

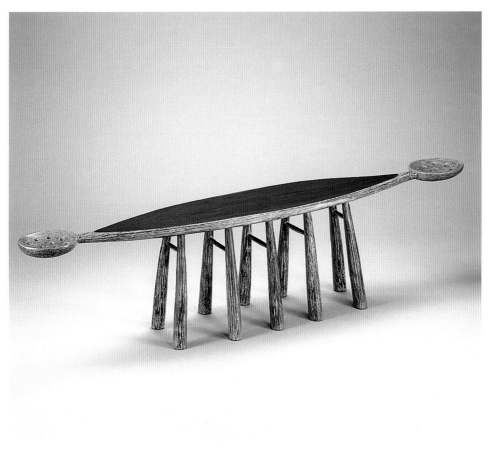

Exhibiting Artists

Robert Brady	Judy Moonelis
Andy Buck	Justin Novak
John Eric Byers	Flo Perkins
Sean Calyer	Timothy Philbrick
Lisa Clague	Peter Pierobon
Arthur Gonzalez	Ann Robinson
Chris Gustin	James Schriber
Thomas Hucker	Randy Shull
Michael Hurwitz	Bill Stewart
Nancy Jurs	Lee Stoliar
Pamela Earnshaw Kelly	Kukuli Verlarde
Paul Knoblauch	Stephen Whittlesey
Wendy Maruyama	Tetsuya Yamada
Dimitri Michaelides	Arnold Zimmerman
Jeffrey Mongrain	

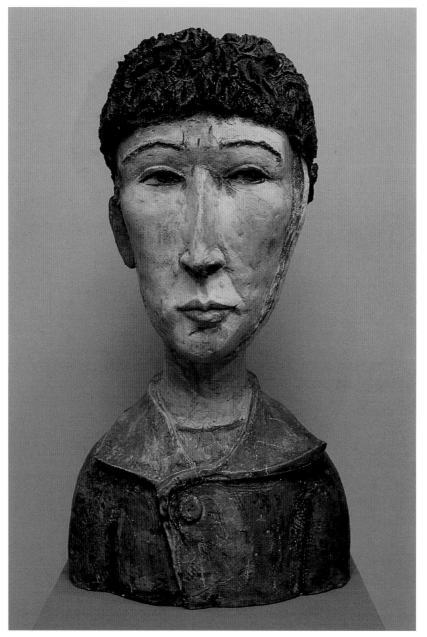

left: Peter VandenBerge
 VanGogh with Bandage, 1999
 Ceramic
 37 x 24 x 17

right: Esther Shimazu
 Coffee Chat, 1998
 Ceramic
 36 x 16 x 24

John Natsoulas Gallery

140 F Street
Davis, CA 95616
530.756.3938
Fax 530.756.3961
art@natsoulas.com

Dedicated to art history and education

Staff: John Natsoulas; Steven Rosenzweig

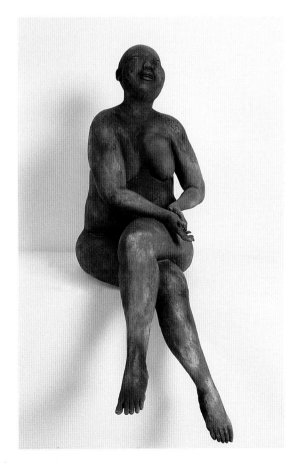

Exhibiting Artists

Robert Arneson
Clayton Bailey
Jim Bauer
Lisa Clague
David Furman
David Gilhooly
Rick Harney
Gerald Heffernon
Marilyn Levine
Rene Martucci
Rene Megroz
Lucian Pompili
Tom Rippon
Esther Shimazu
Barbara Spring
Yoshio Taylor
Peter VandenBerge

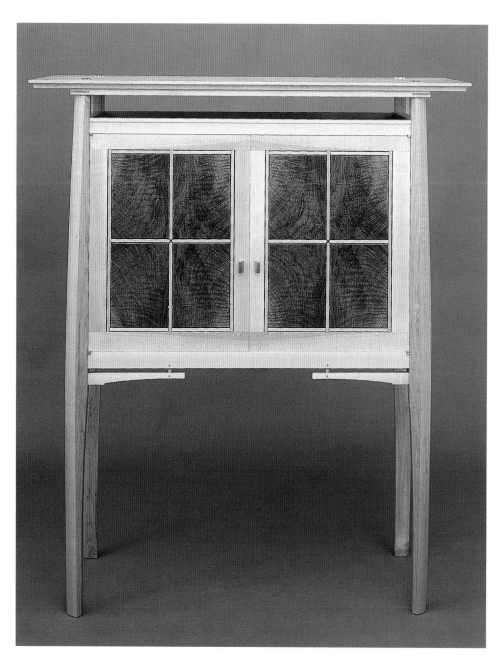

left: Charles Radtke
Fourth Cabinet from the
Inner Light Series, 1999
Hard maple, English walnut
51 x 43 x 16

right: Laura Foster Nicholson
Red Pebbles, 1999
Silk, cotton brocade
32 x 29

Katie Gingrass Gallery

241 North Broadway
Milwaukee, WI 53202
414.289.0855
Fax 414.289.9255
katieg@execpc.com

Fine craft with a special emphasis on fiber and fine wood craft

Staff: Katie Gingrass; Elaine Hoth; Christine Anderson

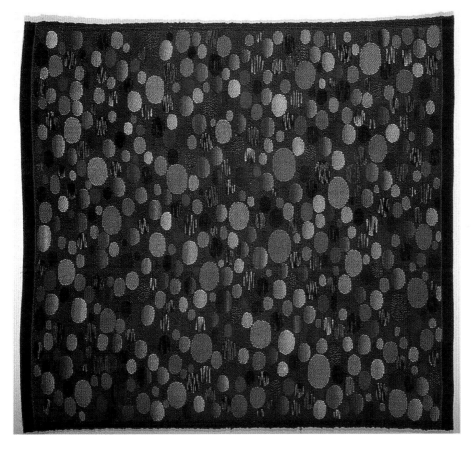

Exhibiting Artists

Jeanette Ahlgren

Joan Brink

Lucy Feller

Linda Fifield

Ron Isaacs

Laura Foster Nicholson

Charles Radtke

Tom Rauschke and
 Kaaren Wiken

John Skau

Billie Ruth Sudduth

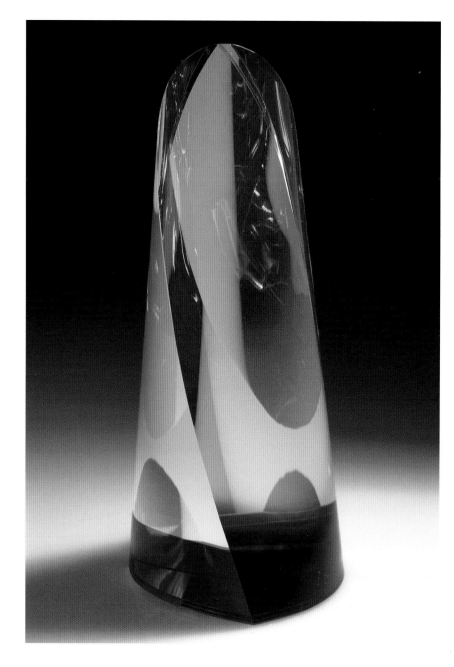

left: Denali Crystal (Peter Temple
and Desmond Hatfield)
Naiad, 1999
Glass
10.5h
photo by L.H. Selman Ltd.

right: Randall Grubb
Stingray Column, 1999
Glass
10.5h
photo by L.H. Selman Ltd.

L.H. Selman Ltd.

123 Locust Street
Santa Cruz, CA 95060
831.427.1177
Fax 831.427.0111
selman@paperweight.com

Small glass objects by the world's finest artists

Staff: Lawrence Selman, Marti Selman, owners; Suzanne Taylor, glass specialist

Exhibiting Artists

Rick Ayotte
Chris Buzzini
Denali Crystal
Randall Grubb
James Shaw
Victor Trabucco

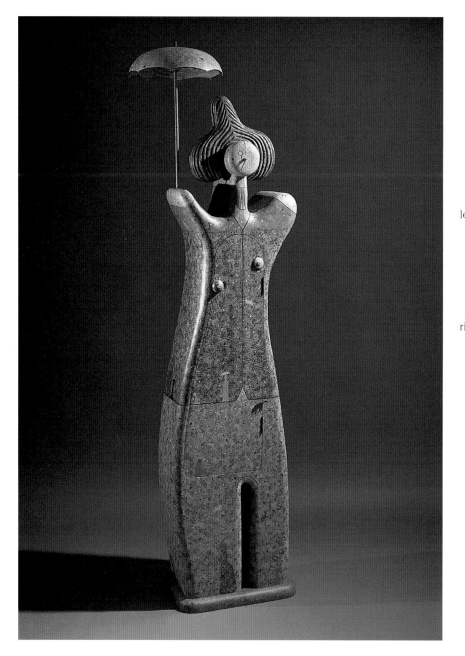

left: Tommy Simpson
 An Afternoon in
 Roseland cabinet, 1999
 Painted poplar, basswood
 80 x 17 x 11
 photo by Noel Allum

right: Dan Dailey
 Chandelier, 1999
 Glass, metal
 36 x 30 x 40
 photo by Bruer Schwarz

Leo Kaplan Modern

41 East 57th Street, 7th floor
New York, NY 10022
212.872.1616
Fax 212.872.1617
lkm@lkmodern.com

Contemporary art in glass and furniture

Staff: Scott Jacobson; Terry Davidson; Lynn Leff; Annie Hololob

Exhibiting Artists

Garry Knox Bennett
Greg Bloomfield
John Brekke
Wendell Castle
Jose Chardiet
Dan Dailey
Richard Ford
Fabiane Garcia
David Huchthausen
Richard Jolley
Kreg Kallenberger
Silas Kopf
John Lewis
Linda MacNeil
Albert Paley
Seth Randal
Paul Seide
Tommy Simpson
Jay Stanger
Cappy Thompson
Gianni Toso
Mary Van Cline
Ed Zucca

left: Charlene Nemec-Kessel
Devour, 1999
Embroidery
34 x 22 x 2

right: Mark Newport
Sampler: Spiderman, 1999
Embroidery on
comic book cover

Lyons Wier Gallery, Inc.

300 West Superior
Chicago, IL 60610
312.654.0600
Fax 312.654.8171
chgoartdlr@aol.com

Emerging and established artists with an emphasis on Realism

Michael Lyons Wier, director

Exhibiting Artists

Ann Coddington-Rast
Linda Dolack
Holly Greenberg
Susan Hall
Steve MacGowan
Darrel Morris
Charlene Nemec-Kessel
Mark Newport

left: Steve Madsen
Forbidden Fruit, 1999
Lathe-turned, dyed and
lacquered maple, aluminum
84 x 26 x 16
photo by Margo Geist

right: James R. Koehler
Oaxaca Stone III, 1996
Cotton warp, hand-dyed
wool weft
60 x 59.5

Mariposa Gallery

3011 Monte Vista NE
Albuquerque, NM 87106
505.265.7966
Fax 505.266.0005

113 Romero NW, Old Town
Albuquerque, NM 87104
505.842.9097
Fax 505.842.9658
fay@mariposa-gallery.com

Promoting contemporary New Mexico fine craft art since 1974

Staff: Fay Abrams, owner/director; Marsha Porter, gallery manager;
Elizabeth Dineen; marketing director; Holly Adams, manager, Monte Vista

Exhibiting Artists

Michael Boyd
Donna Contractor
Eddie Dominguez
Gretchen Ewert
Jeanne Halsey
Julianne Harvey
Richard Hogan
James Koehler
Steve Madsen
Jane Pate
John Suttman
Gretchen Wachs
Roger Wilbur
Daniel Zolinsky

left: Niningka Lewis
 Wati Ngintaka (Perentie Story)
 1998
 River red gum, acrylic paint
 8.75 x 23.25 x 11
 photo by Barry Skipsey

right: Knuckle Dawson
 Western desert shields, 1999
 Mulga wood, red ochre
 size variable
 photo by Barry Skipsey

Maruku Arts & Crafts

CMA Ininti Store
Ayers Rock, NT 0872
Australia
61.8.8956.2153
Fax 61.8.8956.2410
maruku@bigpond.com

Central Australian Aboriginal owned co-operative marketing artists' works in wood

Staff: Stephen Fox, director; Lilian Fox, wholesale manager; Walter Pukutiwara, chairman

Exhibiting Artists

Mr. Butler
Billy Cooley
Knuckle Dawson
Ivy Inkatji
Mr. Jackson
Niningka Lewis
Topsy Tjulyata
Billy Wara
Fred Ward

left: Jon Kuhn
Stellar Specter, 1998
Glass
23 x 14 x 20

right: Kéké Cribbs
Othoptera, 1999
Fired enamel on glass,
copper, fiberglass, steel
23 x 19 x 5

Marx-Saunders Gallery, Ltd.

230 West Superior
Chicago, IL 60610
312.573.1400
Fax 312.573.0575
marxsaunders@earthlink.net

Contemporary studio glass

Staff: Bonita Marx; Ken Saunders; Sybil Larney; Carrie Frifeldt

Exhibiting Artists

William Carlson
Jose Chardiet
Kéké Cribbs
Sidney Hutter
Jon Kuhn
Jay Musler
Joel Myers
Mark Peiser
Stephen Powell
Thomas Scoon
Paul Stankard
Therman Statom
Steven Weinberg
Jon Wolfe

left: Richard Jolley
Cerebral Hemisphere, 1999
Painted wood, glass, silver leaf
42 x 42 x 5.125
photo by Charles Brooks

right: Therman Statom
Sand Towers, 1999
Glass, mixed media
24 x 23 x 13.5
photo by Victor Bracke

Maurine Littleton Gallery

1667 Wisconsin Avenue NW
Washington, DC 20007
202.333.9307
Fax 202.342.2004
mlittle972@aol.com

Specializing in the sculptural work of contemporary masters in glass

Staff: Maurine Littleton, director; Mitchell Loadholtz; Penelope V. Kelly; Jason Micallef; Michael Eaton

Exhibiting Artists

Gary Beecham
Lia Cook
Fritz Dreisbach
Kyohei Fujita
Richard Jolley
Susie Krasnican
Harvey Littleton
John Littleton
Don Reitz
Tommie Rush
Therman Statom
James Tanner
Mary Van Cline
Kate Vogel

left: Leah Wingfield
Su Boca Que Era Mia
(Those Lips That Were Mine)
1999
Glass
24 x 14 x 6
photo by Balfour Walker

right: David Reekie
Venetian Floors III, 1999
Glass, wood

Miller Gallery

560 Broadway
New York, NY 10012
212.226.0702
Fax 212.334.9391
info@millergallery.com
www.millergallery.com

*Contemporary sculpture in glass and mixed media by the finest American
and international artists, with an emphasis on figurative work*

Staff: Bob Miller; Ellie Miller

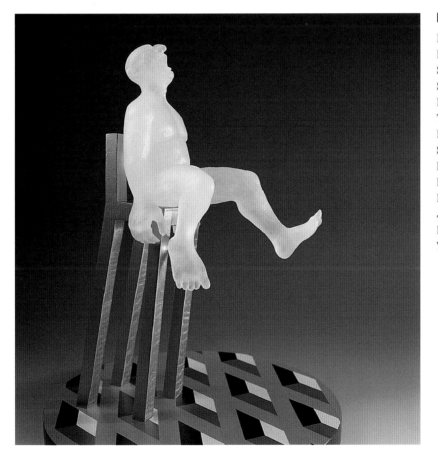

Exhibiting Artists

Mark Bokesch-Parsons
Peter Bremers
Stuart Braunstein
Stephen Clements
Brian Hirst
Tracey Ladd
Lucy Lyon
Stanley Mar
Robert Mickelsen
David Reekie
Martin Rosol
Jeffrey Spencer
Leah Wingfield
Yan Zoritchak

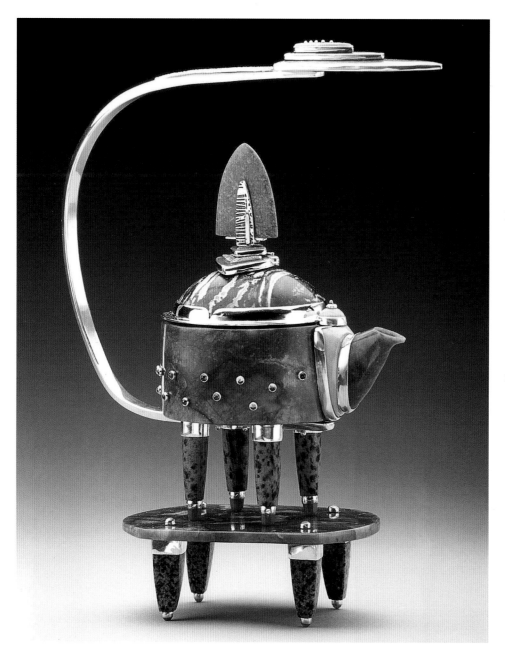

left: Michael Boyd
Teapot, 1999
Sterling silver, fine silver,
20k and 22k gold, black jade,
green jade, verasite, zosite,
citrine, serpentine, bustamite,
various jaspers and agates
9.5 x 7 x 3.5
photo by Tim Brown

right: Kate Anderson
Davis Teapot, 1999
Knotted waxed linen
7 x 11 x 2
photo by Clark Kincaid

Mobilia Gallery

358 Huron Avenue
Cambridge, MA 02138
617.876.2109
Fax 617.876.2110
mobiliaart@aol.com

Three Exhibitions at SOFA CHICAGO : "Sculptural Jewelry" ; "The Teapot Redefined II," alternative materials exploring the classic shape; "The Great Balancing Act," curated by George Bowes, ceramic teapots and cups

Staff: Irving Cooper; Adele Cooper; Libby Cooper; JoAnne Cooper; Susan Cooper

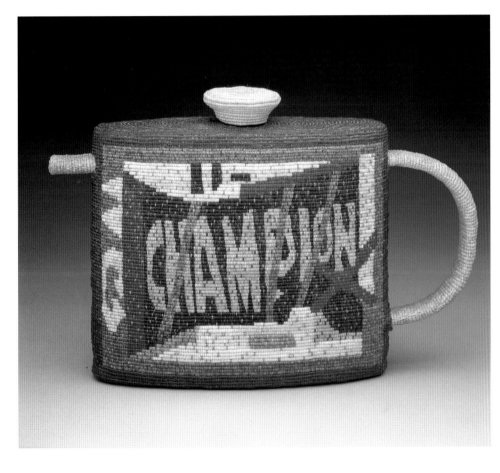

Exhibiting Artists

Dan Adams	Eva Kwong
Renie Breskin Adams	Susan Lindsay
Jeanette Ahlgren	Beth Lo
Kate Anderson	Kirk Magnus
Linda Arbuckle	Elaine McBride
Anna Arnold	Merrill Morrison
Jan Baum	Harold O'Connor
Linda Behar	Kelly Palmer
Harriete Estel Berman	Joan Parcher
Mary Berringer	Karen Paust
Margaret Bohls	Daniel Peters
Flora Book	Greg Pitts
Michael Boyd	Liz Quackenbush
William Broullard	Kim Rawdin
Mark Burleson	Suzan Rezac
Kristen Cliffel	Tom Rippon
Susan Collett	Greg Roberts
Mike Corney	Marjorie Schick
Valerie Jo Coulson	Richard Shaw
Marilyn Da Silva	Leslie Sills
Eddie Dominguez	Christina Smith
Arline Fisch	Judith Solomon
Julia Galloway	Julie Tesser
John Garrett	Linda Threadgill
Bill Griffith	Cynthia Toops
Chris Gustin	Jennifer Trask
Jan Hopkins	Andrea Uravitch
Dan Jocz	Pier Voulkos
Kathy King	Barbara Walter
Rena Koopman	Ellen Wieske
Shana Kroiz	Joe Wood

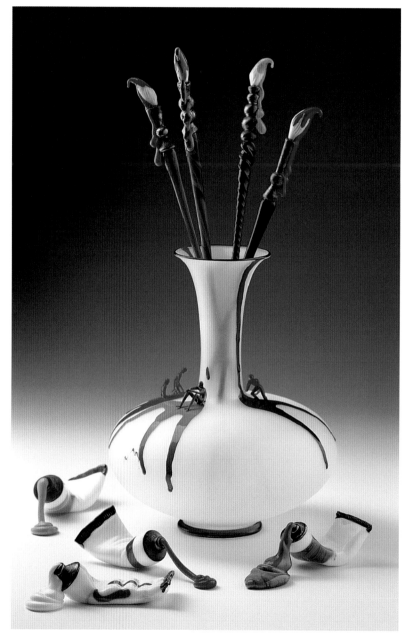

left: Cesare Toffolo
 Colori II, 1999
 Lampworked glass
 20 x 8
 photo by F. Ferruzzi

right: Fanny Ferre
 Man with Birds, 1999
 Ceramic sculpture
 36 x 32 x 24
 photo by Fanny Ferre

Mostly Glass Gallery

3 East Palisade Avenue
Englewood, NJ 07632
201.816.1222
Fax 201.816.9582
info@mostly-glass.com
www.mostly-glass.com

Innovation in glass art and other art media

Staff: Sami Harawi, Charles Reinhardt, owners

Exhibiting Artists

Jonathan Andersson
Livio De Marchi
Fanny Ferre
Nada Le Cavelier
Claudia Lezama
Hermann Mejer
Norberto Moretti
James Nowak
Alison Ruzsa
Davide Salvadore
Emilio Santini
Henry Shawah
Madonna Thierry
Claudio Tiozzo
Cesare Toffolo

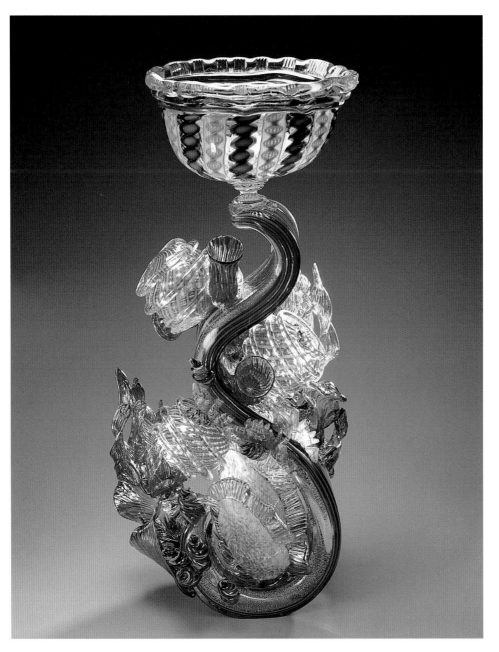

left: James Nowak
Pacific Series, 1999
Blown glass
18 x 10
photo by Eva Heyd

right: Livio De Marchi
Jeans in Pausa, 1999
Wood
30 x 18 x 14
photo by Mark E. Smith

left: Peter Carrigy
Spinifex Country, 1999
Purple heart acacia, red gum,
orchre, paint
8 x 30 x 16
photo by Alex Makeyev

right: Robert Howard
The Wave, 1999
Australian red cedar
6 x 16 x 13
photo by Greg Piper

Narek Galleries

292 Wanna Wanna Road
via Queanbeyan, NSW 2620
Australia
61.2.6299.2731
Fax 61.2.6299.2731

Contemporary Australian wood art

Staff: Karen O'Clery, director

Exhibiting Artists

Peter Carrigy
Robert Howard
Peter Kovacsy

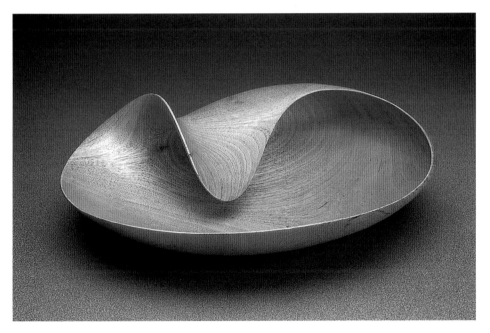

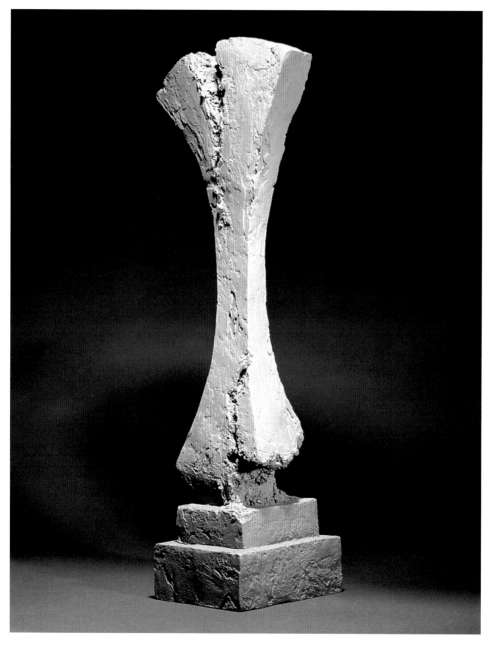

left: Kevin Robb
Dead Sea Series C, 1999
Cast bronze, edition of 3
31 x 12 x 8
photo by Kevin Robb

right: Eileen Shahbazian
Weighted Time, 1996
Bronze, rope, burlap
33 x 8 x 3
photo by Russel Sasaki

Niemi Fine Art Gallery

39370 North Route 59, Unit B
Lake Villa, IL 60046
847.265.2343
Fax 847.356.6908
gallery@bruceniemi.com

Contemporary artworks focusing on excellence in creativity, craftsmanship and design

Staff: Bruce A. Niemi, owner; Susan Niemi, director

Exhibiting Artists

Michael D. Bigger
Bruce A. Niemi
Fritz Olsen
Kevin Robb
Eileen Shahbazian
C.T. Whitehouse

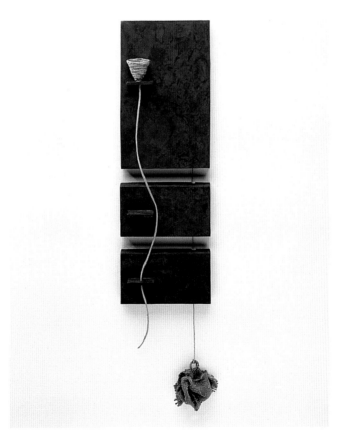

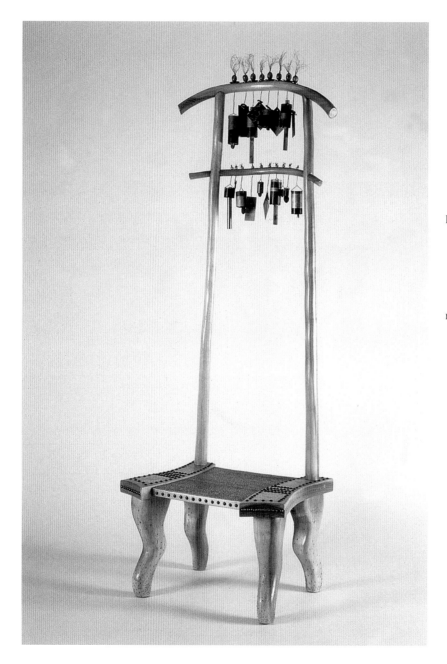

left: Cheryl Riley
Dogon Chair, 1997
Poplar, brass tacks,
copper, cain
76 x 24 x 21

right: Peter Dudley
Union, 1999
Avodire, maple, mahogany
30 x 68 x 33

The O. Group

152 Franklin Street
New York, NY 10013
212.431.5973
Fax 212.431.0259

Specializing in high-end decorative arts from all periods

Staff: Cardell Oliphant; Don Joint; Brice Brown; Susan Donatucci

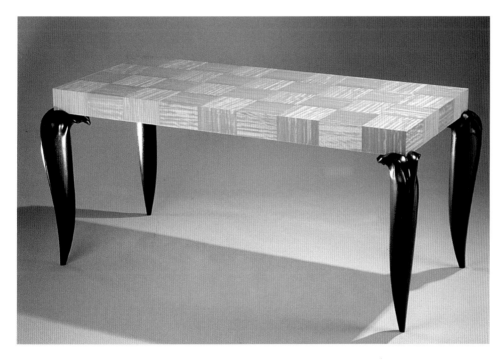

Exhibiting Artists

Peter Dudley
Thomas Hucker
Terrence Main
Forrest Myers
Pauly & Co
Gaetano Pesce
Cheryl Riley
Eva Zeisel

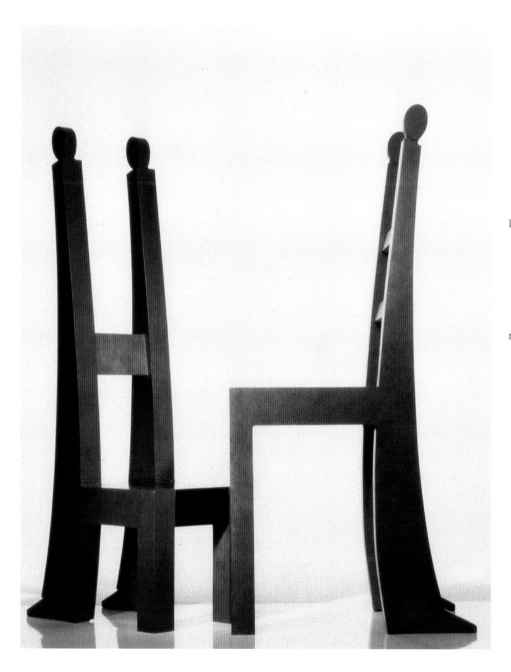

left: Danielle Carignan
Jerome's Chair and Table
1999
Wood
64 x 17 x 26 and
64 x 26 x 31

right: Janis Kerman
Pendant, 1999
18k gold, emerald crystal,
hessonite garnet, rhodalite
1.25 x 1.25

Option Art

4216 de Maisonneuve Blvd. W., #302
Montreal, Quebec H3Z 1K4
Canada
514.932.3987
Fax 514.938.3171
optionart@gointernet.com

Presenting fine contemporary Canadian craft

Staff: Barbara Silverberg; Dale Barrett

Exhibiting Artists

Jean Pierre Boselli
Danielle Carignan
Janis Kerman
Louise Lemieux-Bérubé
Raymond Warren

left: Lia Cook
Presence/Absence: Cover, 1999
Handwoven rayon, cotton
45 x 25

right: Edward Eberle
Catching a Wave, 1998
Porcelain
16.5 x 17.25 x 17.25

Perimeter Gallery, Inc.

210 West Superior
Chicago IL 60610
312.266.9473
Fax 312.266.7984
artchicago@aol.com

Featuring the masters in craft

Staff: Frank Paluch; Meredith Keay; Susan Zagorski; Rob Davis

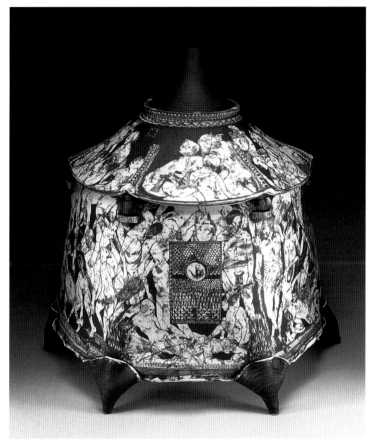

Exhibiting Artists

Lia Cook
Olga de Amaral
Jack Earl
Edward Eberle
Kiyomi Iwata
Ken Loeber
Dona Look
John Mason
Beverly Mayeri
John McQueen
Bruce Metcalf
Eleanor Moty
Toshiko Takaezu
Lenore Tawney
Peter Voulkos
Dick Wickman

left: Charlotte Brown
 A Walk in the Meadow, 1999
 Mixed media
 45 x 45 x 4

right: Toni Putnam
 Sun/Moon Chair, 1998
 Bronze
 54 x 24 x 24

Portals Ltd.

742 North Wells
Chicago, IL 60610
312.642.1066
Fax 312.642.2991
artisnow@aol.com

Contemporary artisans doing mixed media bronze, decoupage and wooden whistles

Staff: Nancy N. McIlvaine, president; William B. McIlvaine, vice president;
Anne E. Ross, Alexandra S. Tomson, associates

Exhibiting Artists

Julia Andres
Charlotte Brown
Wendy Ellis-Smith
Toni Putnam
Constance Roberts

left: Philip Baldwin and
 Monica Guggisberg
 Cortigiane e Guardiano, 1999
 Glass, metal
 36h (plus stand)
 photo by Thomas Plain

right: Laszlo Lukacsi
 Rhomboide, 1999
 Glass
 20h

Portia Gallery

207 West Superior
Chicago, IL 60610
312.932.9500
Fax 312.932.9501
portia1@interaccess.com

The finest contemporary glass sculpture highlighting artists from around the world

Staff: Elysabeth Alfano, Nancy Alfano, directors;
Amy O'Daniel, associate director; Alex Herzog, assistant

Exhibiting Artists

Philip Baldwin and
 Monica Guggisberg
Kyohei Fujita
David Levi
Laszlo Lukacsi
Paul Nelson
Bretislav Novak
Pino Signoretto
Mary White

left: Cybèle Young
*I Knew I Shouldn't Have
Upholstered This Couch,
It's Awfully Wet In Here*, 1999
Copperplate etching on
Japanese paper
10.5 x 13 x 2.25 (framed)

right: Greg Payce
Wane, 1999
Earthenware, terra sigillata
10.625 x 30 x 7

Prime Gallery

52 McCaul Street
Toronto, Ontario M5T 1V9
Canada
416.593.5750
Fax 416.593.0942
prime@ican.ca

*Exhibiting contemporary Canadian artworks; pieces ranging from functional,
to aesthetic and idea based; established in 1979*

Staff: Suzann Greenaway, owner; David H. Kaye

Exhibiting Artists

Dorothy Caldwell
Léopold L. Foulem
Richard Milette
Matthias Ostermann
Greg Payce
Cybèle Young

left: Alessandro Diaz de Santillana
Punta al Cielo
Glass
13.5 x 8 x 8

right: Marc Leuthold
Porcelain Oval
Porcelain
15 x 17 x 1.5

R. Duane Reed Gallery

215 West Huron
Chicago, IL 60610
312.932.9828
Fax 312.932.9753

1 North Taylor
St. Louis, MO 63108
314.361.8872
Fax 314.361.1788
reedart@primary.net

Specializing in nationally known artists in the fields of painting, glass, ceramic, and fiber

Staff: R. Duane Reed, owner; Kate Anderson, St. Louis director; Lynn Schuberth, Chicago director; Glenn Scrivner, director of off-site operations; Merrill Strauss; Robert Pogatetz; Stefani Bardin; Elizabeth Harding

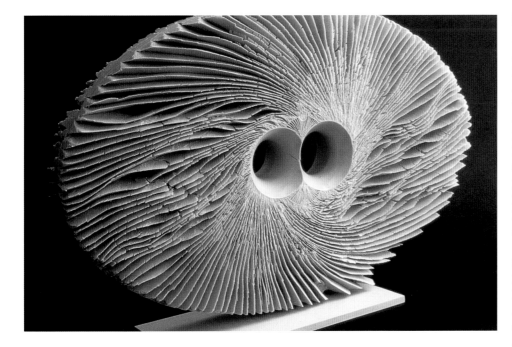

Exhibiting Artists

Ken and Kate Anderson
Sonja Blomdahl
Patricia Degener
Alessandro Diaz de Santillana
Christine Federighi
John Garrett
Mary Giles
Lissa Hunter
Sabrina Knowles
Marc Leuthold
Marvin Lipofsky
Rebecca Medel
Julie Mihalisin and
 Philip Walling
Stacey Neff
Barbara-Rose Okun
Danny Perkins
Jenny Pohlman
Ginny Ruffner
Jane Sauer
Anna Skibska
Karen Willenbrink

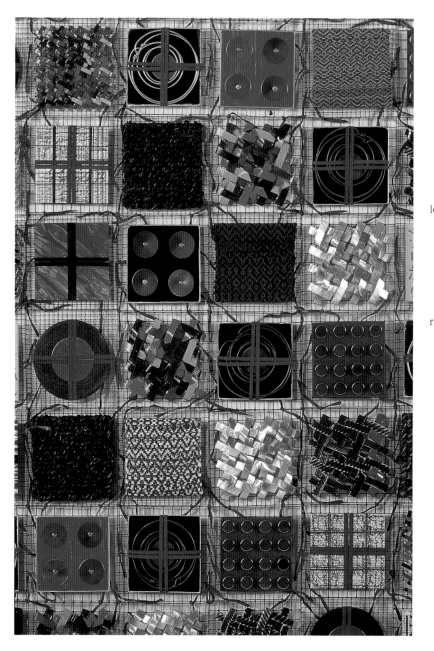

left: John Garrett
The Ensign's Confession
(detail), 1999
Mixed media
76 x 76
photo by David Kingsbury

right: Anna Skibska
Untitled
Glass
20 x 42 x 23
photo by David Kingsbury

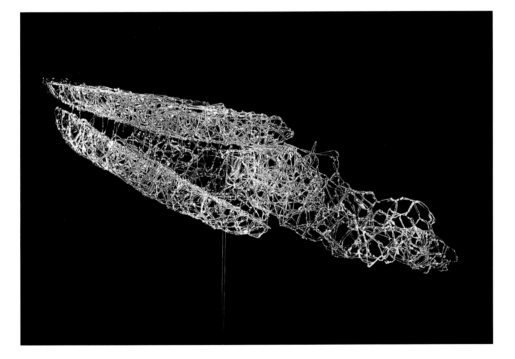

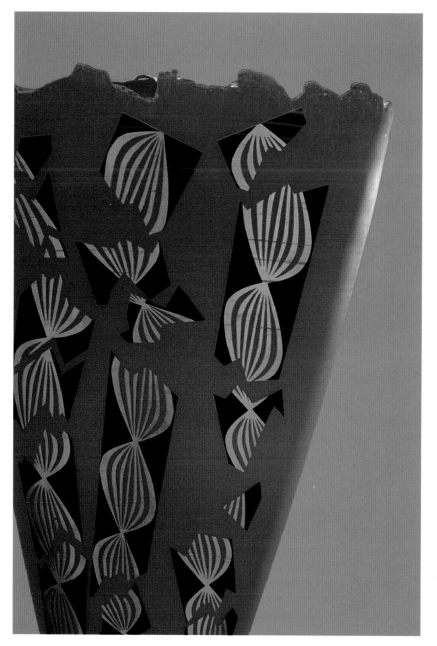

left: Robert Wynne
 Red Canvas, 1998
 Glass
 23 x 12.5 x 5
 photo by Greg Piper

right: Colin Heaney
 Egg Diablo & Blue, 1998
 Glass, bronze
 12 x 8 x 8
 photo by Greg Piper

Raglan Gallery

5-7 Raglan Street
Manly, NSW 2095
Australia
61.2.9977.0906
Fax 61.2.9977.0906

Contemporary Australian work in glass, ceramics, sculpture, painting and Aboriginal art

Staff: Jan Karras, director; Charlene Dalglish

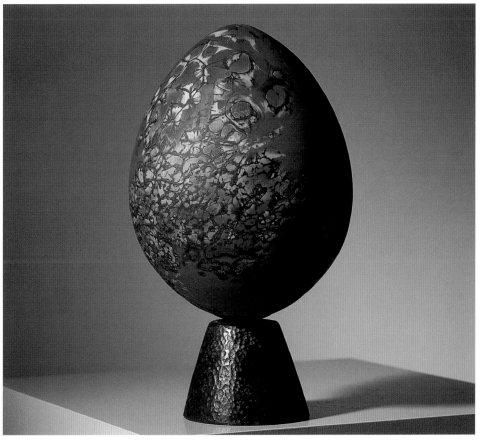

Exhibiting Artists

Diogenes Farri
Colin Heaney
Derek Smith
Margo Stephens
Robert Wynne

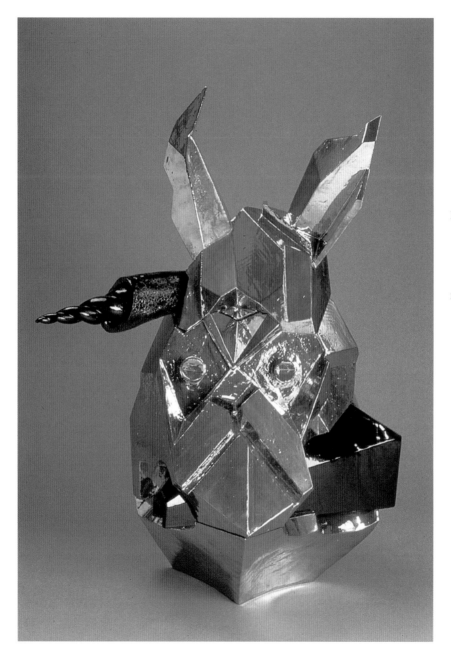

left: Howard Kottler
 Slots, 1987
 Glazed earthenware
 31 x 18 x 21

right: Howard Kottler
 Odd Balls Pot, 1967
 Glazed earthenware
 30 x 13 x 9
 photo by Eduardo Calderon

REVOLUTION

525 West 22nd Street, #4D
New York, NY 10011
212.463.8037
Fax 212.242.1439
revolutnny@aol.com

23257 Woodward Avenue
Ferndale, MI 48220
248.541.3444
Fax 248.541.1914
gallery@revolutn.com

Contemporary works of art in all disciplines

Staff: Paul Kotula, director, Michigan and New York;
Jo Whitsell, associate director, New York; Sandra Schemske, assistant director, Michigan

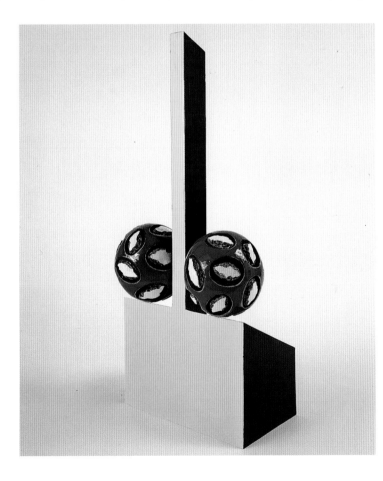

Exhibiting Artists

David Chapman
John Gill
Tony Hepburn
The Estate of Howard Kottler
Jae Won Lee
Jim Melchert
James Shrosbree
Robert Turner
Anne Wilson

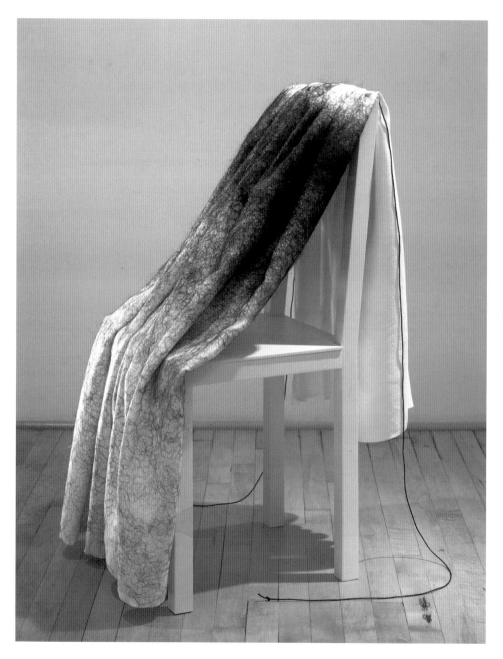

left: Anne Wilson
Lost, 1998
Cloth, wood, leather, hair
36 x 22 x 23.5
photo by Tim Thayer

right: Jim Melchert
Desire as Terrain, 1995
Glazed earthenware
48 x 48 x 2
photo by Lee Fatheree

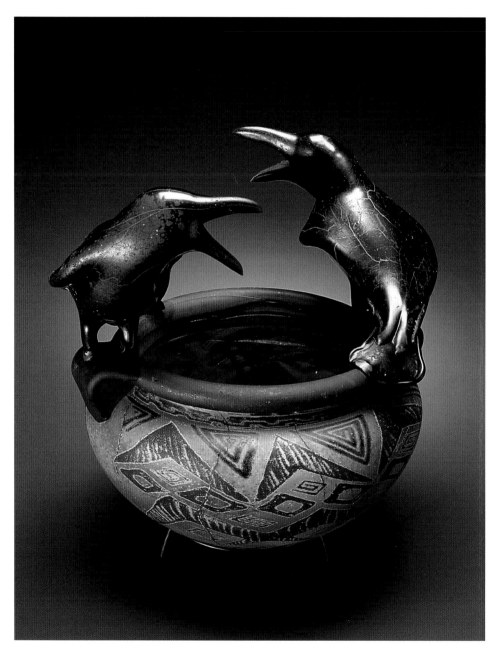

left: William Morris
 Ravens on Urn, 1999
 Blown glass
 18 x 18 x 16
 photo by Rob Vinnedge

right: Lino Tagliapietra
 Saturno, 1999
 Blown glass
 26 x 29

Riley Hawk Galleries

2026 Murray Hill Road
Cleveland, OH 44106
216.421.1445
Fax 216.421.1435
cheri@rileyhawk.com

642 North High Street
Columbus, OH 43215
614.228.6554
Fax 614.228.6550
sherrie@rileyhawk.com

16 Central Way
Kirkland, WA 98033
425.576.0762
Fax 425.576.0772
seattleinfo@rileyhawk.com

Search for form in three dimensions

Staff: Tom and Cindy Riley, owners; Tom and Sherrie Hawk, directors; Cheri Discenzo, director

Exhibiting Artists

Chris Buzzini
Irene Frolic
Kyohei Fujita
Dante Marioni
Duncan McClellan
William Morris
Nick Mount
Marc Petrovic
Catherine Rahn
Kari Russell-Pool
Paul Schwieder
Lisabeth Sterling
Lino Tagliapietra
Andreas von Zadora-Gerlof
Janusz Walentynowicz

left: Janusz Walentynowicz
Self Portrait, 1998
Glass, mixed media
38 x 33 x 5

right: Andreas von Zadora-Gerlof
Frog Musicians, 1999
Jade, gemstones
5h
photo by David Behl

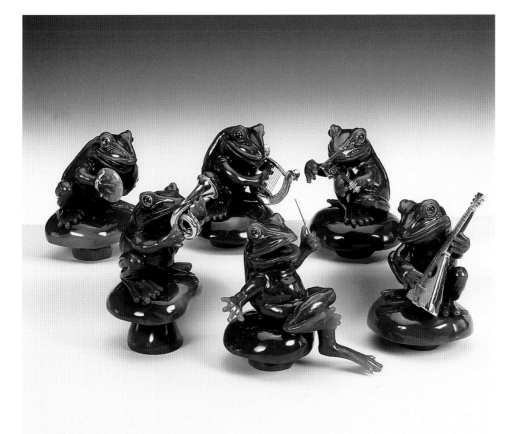

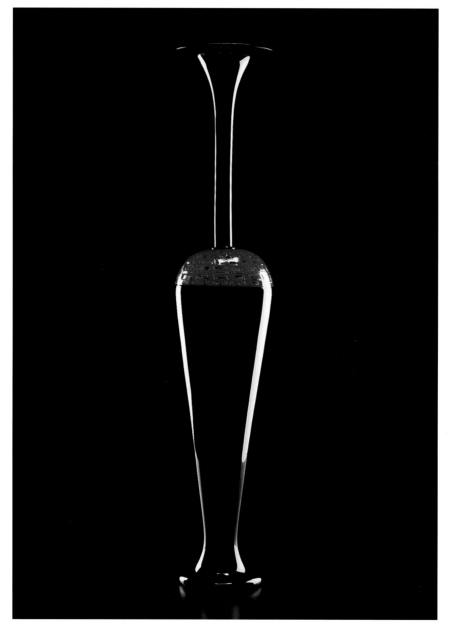

left: Dante Marioni
Finestra, 1999
Blown glass
40 x 8
photo by Roger Scheiber

right: Marc Petrovic
Couples boat house with oars
Glass
35 x 17 x 9
photo by Cathy Carver

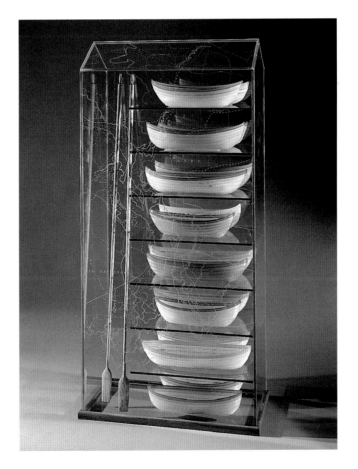

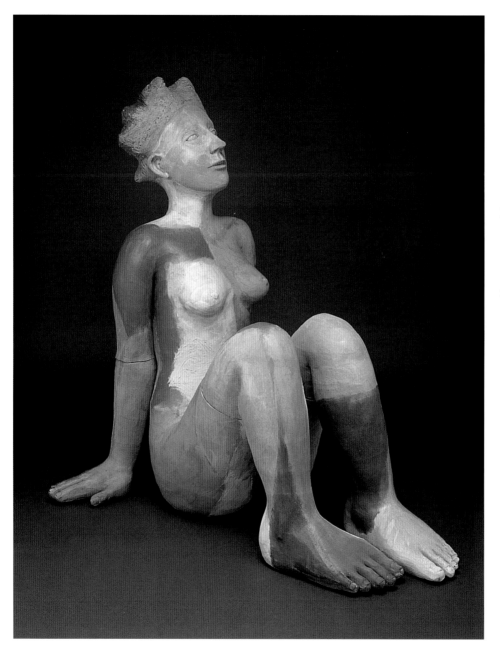

left: Mavis McClure
Angelic Anasuze, 1999
Ceramic
48 x 52 x 34

right: Sherri Smith
Several Kinds of Symmetry
1997
Cotton, silk, wool weaving
84 x 84

Sandy Carson Gallery

New location
760 Sante Fe Drive
Denver, CO 80204
303.573.8585
Fax 303.573.8587

125 West 12th Avenue
Denver, CO 80204
303.573.8585
Fax 303.573.8587
scarson@ecentral.com

Representing painting and sculpture by national and regional artists

Staff: Sandy Carson, owner; Beth McBride, gallery director

Exhibiting Artists

Derek Davis
Judith Poxsom Fawkes
Shane Fero
Jeremy Jernegan
Mavis McClure
Myron Melnick
Sherri Smith
Thomas Stender

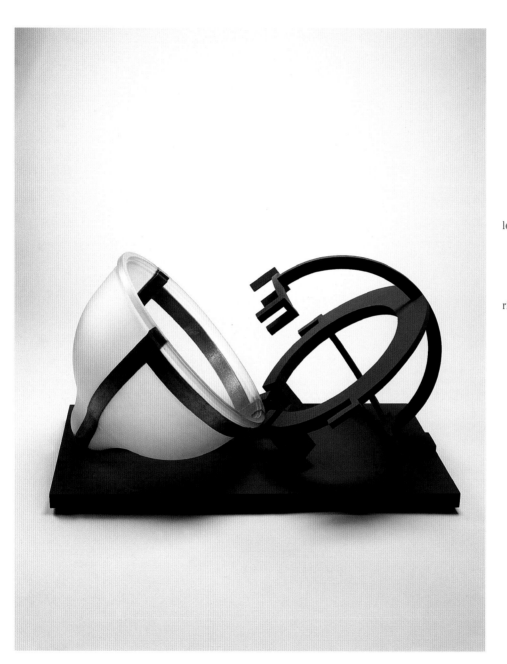

left: Mateï Negreanu
Untitled, 1999
Glass, lead, wood
photo by Claude Germain

right: Ales Vasicek
Play, 1999
Malted crystal glass, metal

Serge Lechaczynski/Galerie Internationale du Verre

à la Verrerie de Biot
Chemin des Combes
Biot 06410
France
33.49.365.0300
Fax 33.49.365.0056
verrerie@biotverre.fr
www.biotverre.fr

Specializing in three-dimensional sculpture with glass

Staff: Serge Lechaczynski, director; Jean Lechaczynski, Anne Lechaczynski, assistants

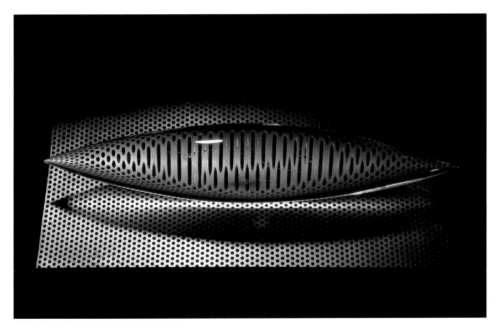

Exhibiting Artists

Antoine Leperlier
Mateï Negreanu
Colin Reid
Ales Wasicek

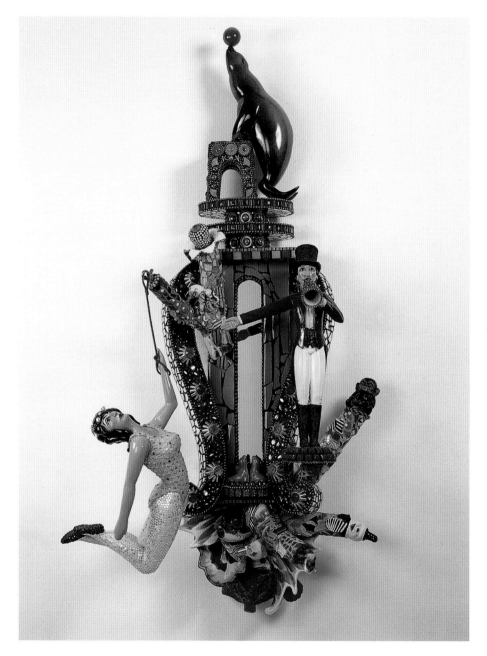

left: Judy Onofrio
 Presenting a Most
 Astonishing Feat, 1999
 Mixed media
 55 x 29 x 16
 photo by Gus Gustafson

right: Judy Onofrio
 Carrot Trick, 1999
 Mixed media
 54 x 25 x 16
 photo by Gus Gustafson

Sherry Leedy Contemporary Art

2004 Baltimore Avenue
Kansas City, MO 64108
816.221.2626
Fax 816.221.8689
leedyart@gvi.net

Contemporary art in all media representing internationally and nationally known artists

Staff: Sherry Leedy; Jennifer Bowerman; Marcus Cain

Exhibiting Artists

Jun Kaneko
Judy Onofrio

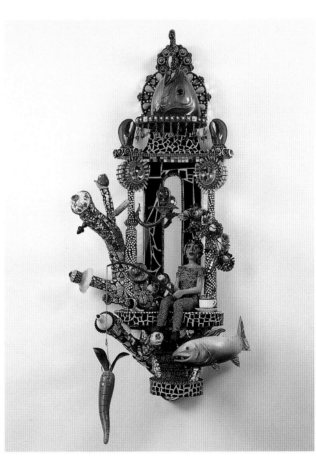

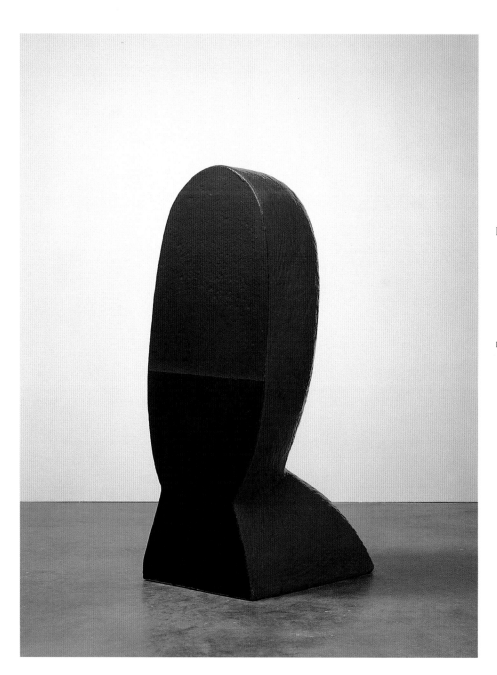

left: Jun Kaneko
Egyptian King, 1996
Ceramic
54 x 22 x 22.5
photo by
Takashi Hatakeyama

right: Jun Kaneko
Egyptian Queen, 1996
Ceramic
55.5 x 22 x 22.5
photo by
Takashi Hatakeyama

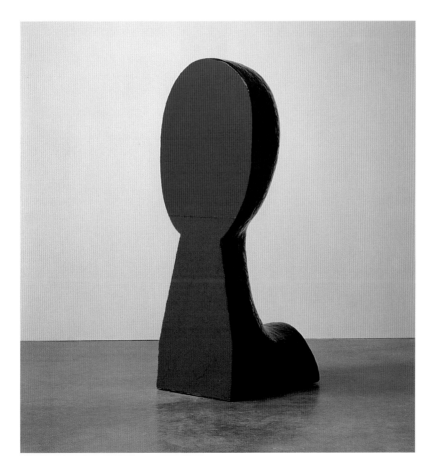

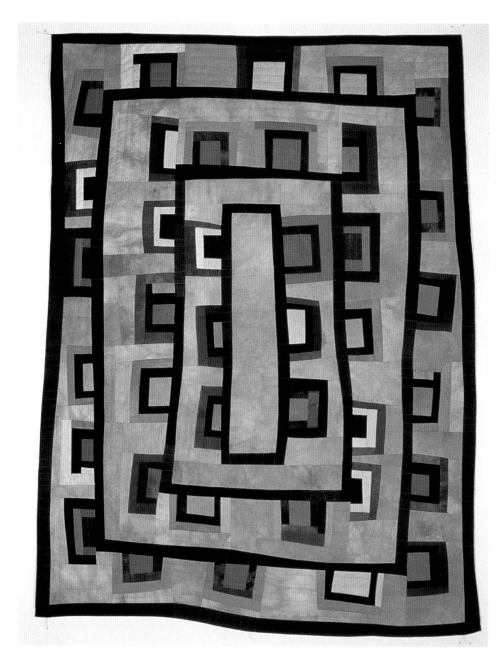

left: Nancy Crow
 Construction #2, 1996
 Hand piece, dyed and
 quilted cotton
 51 x 40
 photo by J. Kevin Fitzsimons

right: Adrian Arleo
 Flight, 1999
 Clay, mixed media
 25 x 18.5 x 12

Snyderman/Works Galleries

303 Cherry Street
Philadelphia, PA 19106
Snyderman: 215.238.9576
Works: 215.922.7775
Fax 215.238.9351

Contemporary ceramics, fiber, glass, studio furniture, jewelry, painting and sculpture

Staff: Rick and Ruth Snyderman, owners; Bruce Hoffman, director

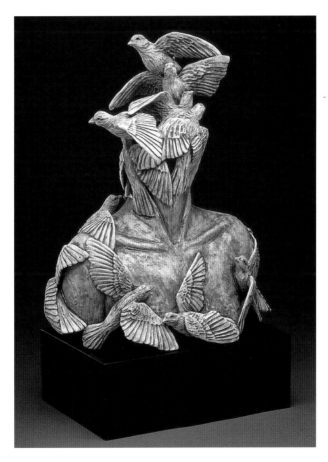

Exhibiting Artists

Adela Akers
Dan Anderson
Adrian Arleo
Olga Dvigoubsky Cinnamon
Mardi Jo Cohen
Nancy Crow
Scott and Lisa Cylinder
Carol Eckert
Chris Giffin
Pat Hickman
Judith Hoyt
Ferne Jacobs
Michael James
Dave Jones
Lewis Knauss
Esther Knobel
Patti Lechman
Ed Bing Lee
C.A. Michel
Norma Minkowitz
Martha D. Opdahl
Marilyn Pappas
Cynthia Schira
Jen Smith
Corky Stuckenbruck
Deborah Warner
C.W. Wells
Dave and Roberta Williamson

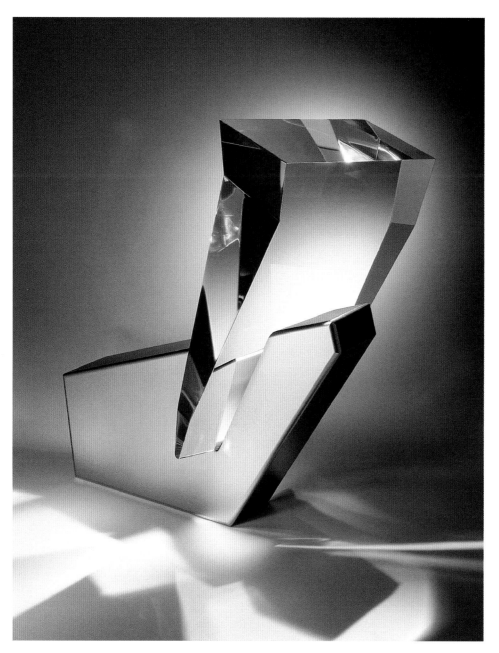

left: David Dowler
Thunder & Lightning, 1999
Glass, steel
16.25 x 14

right: Peter Aldridge
Passage: An Interval of Time
1981
Glass
10.75 x 17

Steuben

717 Fifth Avenue
New York, NY 10022
212.752.1441
Fax 212.832.4944
kedelson@corning.com

Steuben has collaborated with artists to produce unique works in glass since its founding in 1903

Staff: Peter Aldridge, vice president/creative director; Kathi Edelson, manager/public relations; Sheryl Dubitsky, sales manager; William Warmus, consultant

Exhibiting Artists

Peter Aldridge
David Dowler
Eric Hilton

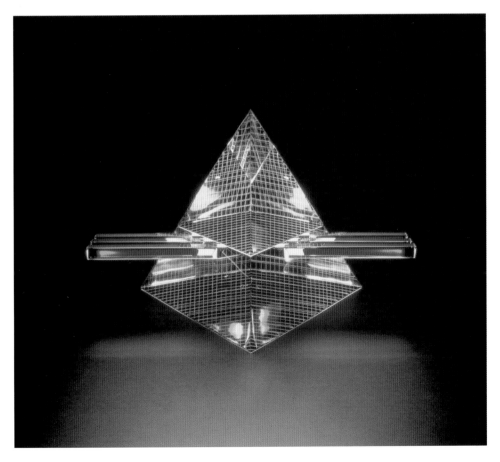

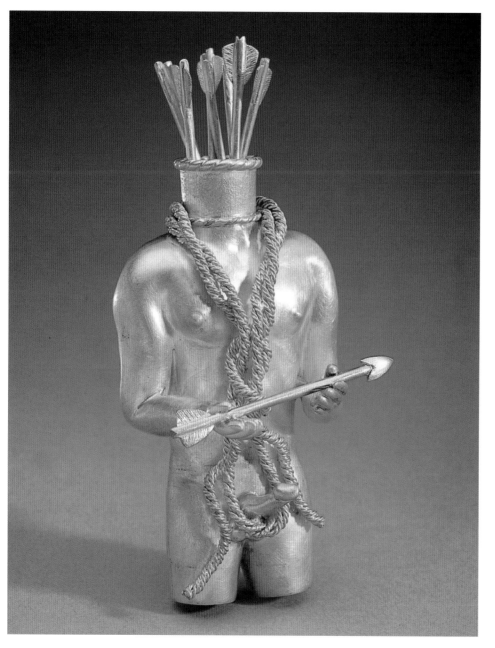

left: Keith Lewis
Sebastian (Imaginary
Self Portrait), 1999
Sterling silver, 18k gold
3.5 x 2.5 x 1

right: Sandra Enterline
Three pieces from
1000 Souvenirs Series, 1999
Sterling silver, glass vials,
various contents

Susan Cummins Gallery

12 Miller Avenue
Mill Valley, CA 94941
415.383.1512
Fax 415.383.0244
scumminsg@aol.com

Contemporary American artists — with a concentration on jewelry and figurative sculpture

Staff: Susan Cummins, owner/director; Julie Allen; Julie Gustafson; Mija Riedel

Exhibiting Artists

Margaret Barnaby	Lisa Lockhart
Bennett Bean	Bruce Metcalf
Jamie Bennett	Heidi Nahser
Kathleen Browne	Maria Phillips
Petra Class	Kent Raible
Andrew Cooperman	Tina Rath
Sandra Enterline	D.X. Ross
Pat Flynn	Axel Russmeyer
Karen Gilbert	Cheryl Rydmark
Lisa Gralnick	Joyce Scott
Myra Mimlitsch Gray	Sam Shaw
Barbara Heinrich	Sara Shepherd
Joana Kao	Sondra Sherman
Kranitzky/Overstreet	Kiff Slemmons
Mariko Kusumoto	Pat Telesco
Keith Lewis	Heather White
Jacqueline Lillie	Roberta Williamson

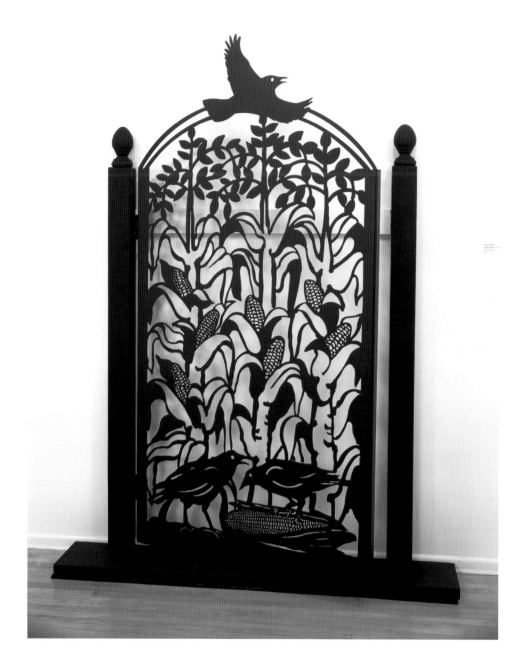

left: Victor Cicansky
 Garden Gate, 1999
 Laser-cut steel, paint
 72 x 45 x 3
 photo by Don Hall

right: Victor Cicansky
 Tangled Prairie
 Crabapple Table, 1999
 Bronze, patina,
 acrylic, glass
 18 x 32 x 48
 photo by Don Hall

Susan Whitney Gallery

2220 Lorne Street
Regina, Saskatchewan S4P 2M7
Canada
306.569.9279
Fax 306.352.2453
swgallery@hotmail.com

Specializing in work by prairie artists working in a variety of media

Staff: Susan Whitney, director

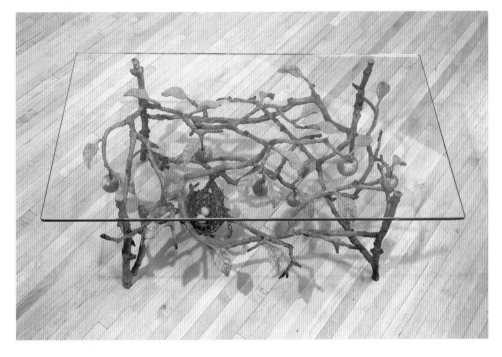

Exhibiting Artists

Irene Avaalaaqiaq
Victor Cicansky
Joe Fafard
Don Hefner
Jefferson Little
Jeff Nachtigall

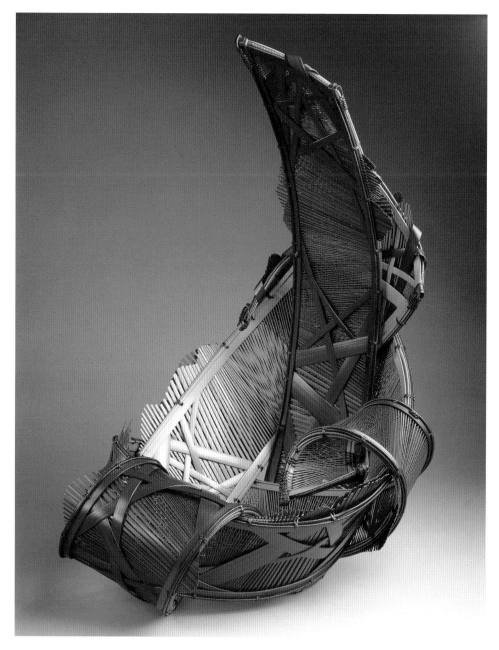

left: Torii Ippu
Dancing Wave, 1998
Bamboo
20 x 15 x 26.5
photo by Pat Pollard

right: Kogyoku Monden
Budding Beauty, 1997
Bamboo
12 x 25
photo by Pat Pollard

Tai Gallery/Textile Arts, Inc.

1571 Canyon Road
Santa Fe, NM 87501
505.983.9780
Fax 505.989.7770
gallery@textilearts.com

African, Indonesian, Japanese, Pre-Columbian and other textiles from around the world;
contemporary and antique Japanese bamboo baskets

Staff: Robert T. Coffland; Mary Hunt Kahlenberg; Nancy G. Mackey

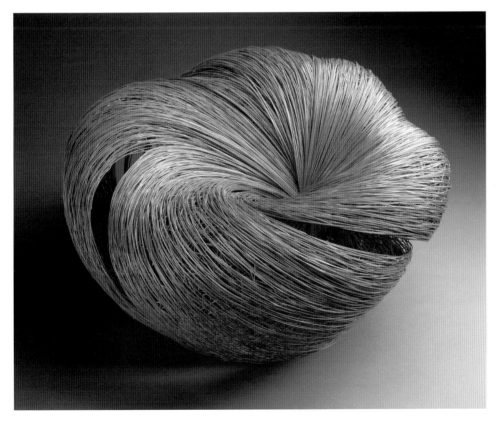

Exhibiting Artists

Motoshi Abe
Norboru Fujinuma
Takesonosai Higashi
Torii Ippu
Sono Katsushiro
Seiho Kibe
Chikuho Minoura
Kogyoku Monden
Kenichi Nagakura
Hayakawa Shokosai IV
Hodo Yako
Rynn Yamaguchi

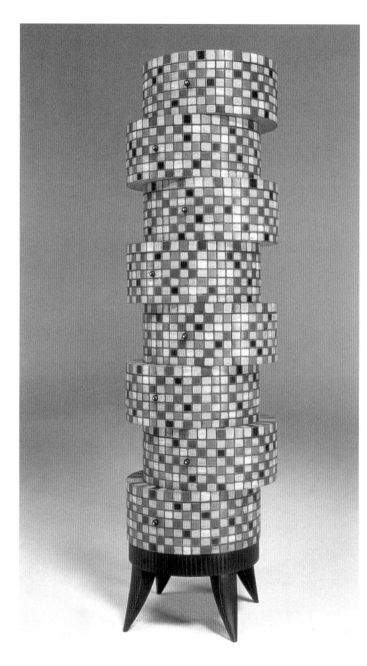

left: John Eric Byers
 Hat Box Chest of Drawers
 1999
 Mahogany, milk paint, wax
 72 x 21 x 20

right: James Lovera
 Green Molten Lava Flow
 1999
 Porcelain
 7.5 x 4.5
 photo by Lee Hocker

Tercera Gallery

550 Sutter Street
San Francisco, CA 94120
415.773.0303
Fax 415.773.0306

534 Ramona Street
Palo Alto, CA 94301
650.322.5324
Fax 650.322.5639

24 North Santa Cruz Avenue
Los Gatos, CA 95030
408.354.9484
Fax 408.354.0965

Focusing on fine art, studio furniture, ceramics, lathe-turned objects, sculpture and jewelry

Staff: Seb Hamamjian, JoAnn Edwards, owners; Ken Edwards

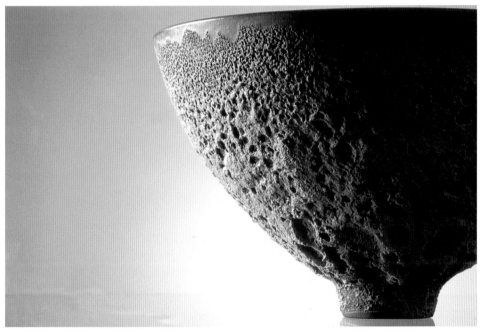

Exhibiting Artists

John Eric Byers
Michael Cullen
Fabiane Garcia
Michael Hosaluk
Yoshiro Ikeda
James Lovera
Merryll Saylan
Yuko Shimizu
Seiko Tachibana
Delos Van Earl

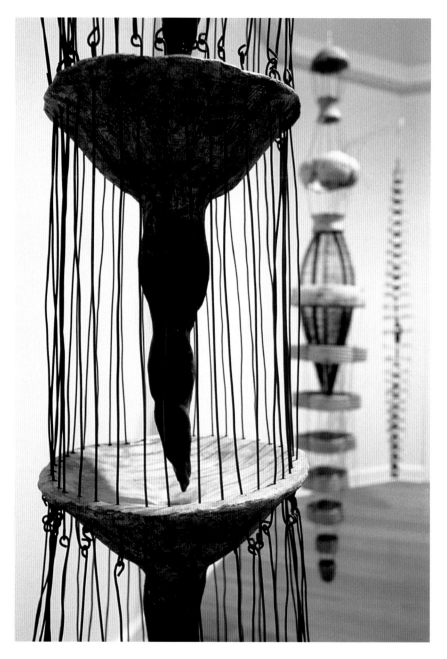

left: Thais Charbonnet
 The Source (*Infinity* in the
 background), 1997
 Ceramic, wire

right: Terri Logan
 Untitled, 1999
 Silver, river stones
 photo by Jerry Anthony

Thomas Mann Gallery

1804 Magazine Street
New Orleans, LA 70130
504.581.2113
800.923.2284
Fax 504.568.1416
tmd@thomasmann.com

A gallery of contemporary metals

Staff: Thomas Mann, owner; Audra Choate, gallery director

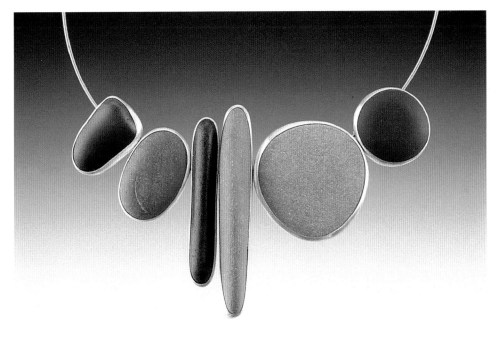

Exhibiting Artists

Boris Bally
James Carter
Thais Charbonnet
Lisa Fidler
Brent Guarisco
Mary Kanda
Terri Logan
Thomas Mann
Gabriel Ofiesh
Biba Schutz
Adam Shirley

left: Arlan Huang
 Oowah, 1998
 Blown glass, sandblasted
 26d

right: Kim Chang
 Sorry, Sorry, 1999
 Blown glass, paradise paint
 9 x 8.5

UrbanGlass

647 Fulton Street
Brooklyn, NY 11217
718.625.3685
Fax 718.625.3889
www.urbanglass.com

An international art center dedicated to the creation and appreciation of glass art

Staff: John Perreault, executive director; Brett Littman, assistant director;
Olga Valle-Tetkowski, gallery director; Beth Lipman, education director

Exhibiting Artists

Kim Chang
Suzanne Charbonnet
Arlan Huang

221

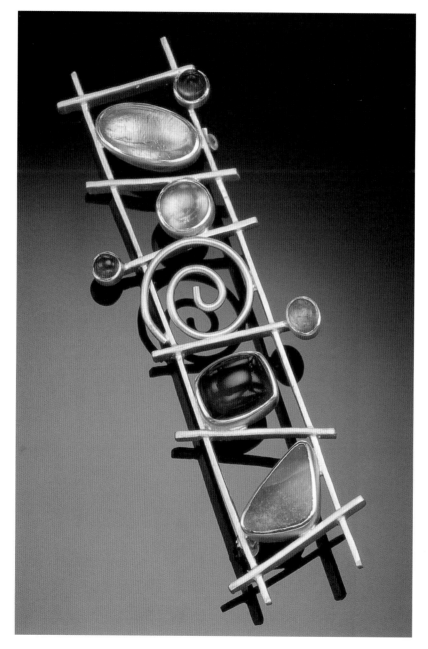

left: Sydney Lynch
Ladder Pin, 1999
Sterling silver, 18k and 22k
gold, amethyst, tourmaline,
moonstone, opal
3 x 1

right: Guy Michaels
*Grey Anza Borego
Alabaster Vase*, 1999
Alabaster, cocobolo
rosewood, maple
9 x 14

William Zimmer Gallery

Box 263
Kasten & Ukiah Streets
Mendocino, CA 95460
707.937.5121
Fax 707.937.2405

Contemporary fine art in traditional and craft mediums

Staff: William and Lynette Zimmer, co-directors; Yarrow Summers, Malindi Zimmer, associates

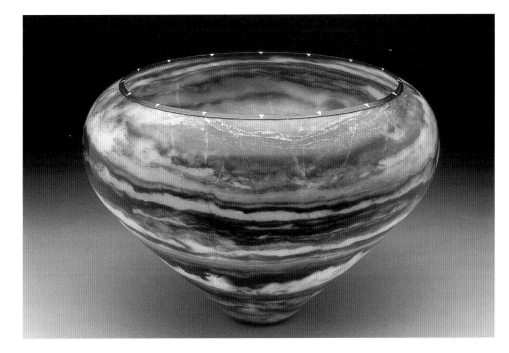

Exhibiting Artists

Carolyn Morris Bach
Peter Beard
Cherie Christensen and
 Franz Arner
David Crawford
John Dodd
Robert Ellison
Peter Hayes
Archie Held
John Jordan
Juan Kelly
Sydney Lynch
Guy Michaels
Stephen Paulsen
Paul Reiber
Sang Roberson
Melvin Schuler
John Tyler
Gerald Walburg

left: Irmgard Zeitler
 Jabot, 1999
 Metal, 18k gold,
 citrine, diamonds
 4.5 x .75
 photo by R. H. Hensleigh

right: Harlan Butt
 Earth Beneath Our Foot:
 Incense Burner #2, 1999
 Metal, silver, enamel, bronze
 6 x 5 x 5
 photo by Harlan W. Butt

Yaw Gallery

550 North Old Woodward
Birmingham, MI 48009
248.647.5470
Fax 248.647.3715

Representing national and international goldsmiths and silversmiths

Staff: Nancy L. Yaw; James J. Yaw; Edith Robertson

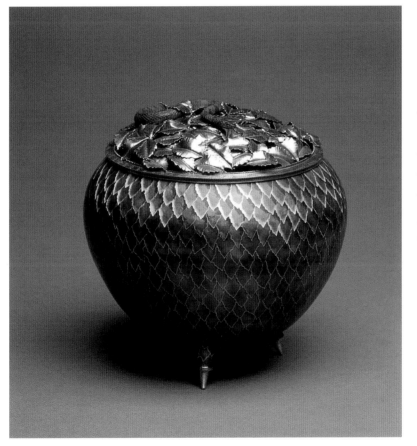

Exhibiting Artists

Chieko Akagi
Michael Banner
Bikakis & Johns
Falk Burger
Harlan W. Butt
Jack da Silva
Gary Griffin
Susan Hoge
Nicole Jacquard
Olle Johanson
Anthony Lent
Michaela Merz
Cornelia Roethel
Cheryl Rydmark
Irmgard Zeitler

RawSpace

Herb Babcock
Pillared Series
Represented by
Habatat Galleries, #607

Michael Bauermeister
Vessels and Landscape
Represented by
del Mano Gallery, #1120

Michael Bigger
Ozona
Represented by
Niemi Fine Art Gallery, #1101

Mark Chatterley
A Pleasure Ride
Aepresented by
Gallery 500, #528

Cherie Christensen and Franz Arner
Represented by
William Zimmer Gallery, #333

Richard Ellison
Represented by
William Zimmer Gallery, #333

John Healy
Time Framed
Represented by
Habatat Galleries, #607

Hoss Haley
Represented by
Blue Spiral 1, #1106

Archie Held
Represented by
William Zimmer Gallery, #333

Richard Jolley
Degrees of Magnitude
Represented by
Maurine Littleton Gallery, #100

Jean-Pierre Larocque
Untitled (Head)
Represented by
REVOLUTION, #709

Thomas Mann
Sacre Coeur Mechanique
Represented by
Thomas Mann Gallery, #301

Dan Namingha
Vertical Passages
Represented by
J. Cacciola Galleries, #808

Bruce Niemi
Two Can Dream II
Represented by
Niemi Fine Art Gallery, #1101

Fritz Olsen
Harvey
Represented by
Niemi Fine Art Gallery, #1101

Jenny Orchard
Represented by Despard Gallery, #509

Bruce Peebles
Diva
Represented by
Finer Things Gallery, #1128

Catherine Rahn
Represented by
Riley Hawk Galleries, #620

Henry Richardson
Represented by
The Glass Gallery, #701

Lucy Ruth Wright Rivers
Bead Ball
Represented by
Aron Packer, #700

Kevin Robb
Represented by
Niemi Fine Art, #1101

Donna Salem
I and Thou
Represented by
Jean Albano Gallery, #329

Jack Schmidt
Precious Stone Series
Represented by
Habatat Galleries, #607

Lucy Slivinski
Represented by
Aron Packer, #700

Barbara Spring
City Inspector Scene
Represented by
John Natsoulas Gallery, #1312

Julie Speidel
Represented by
Gail Severn Gallery, #111

Mark Stasz
Represented by
Gail Severn Gallery, #111

Therman Statom
Represented by
Maurine Littleton Gallery, #100

Delos Van Earl
Represented by
Tercera Gallery, #823

Mark Warwick
Common Ground
Represented by Belloc Lowndes
Fine Art Gallery, Inc., #833

C.T. Whitehouse
Represented by
Niemi Fine Art Gallery, #1101

Albert Young
Untitled
Represented by
Habatat Galleries, #607

Arnold Zimmerman
Fountain of the Fool's Paradise
Represented by
John Elder Gallery, #300

RawSpace

An exhibit of large-scale works by artists represented at SOFA, presented warehouse-style

within the exposition. View freestanding sculpture in all media, including fountains

and other works not easily shown within the context of a gallery booth.

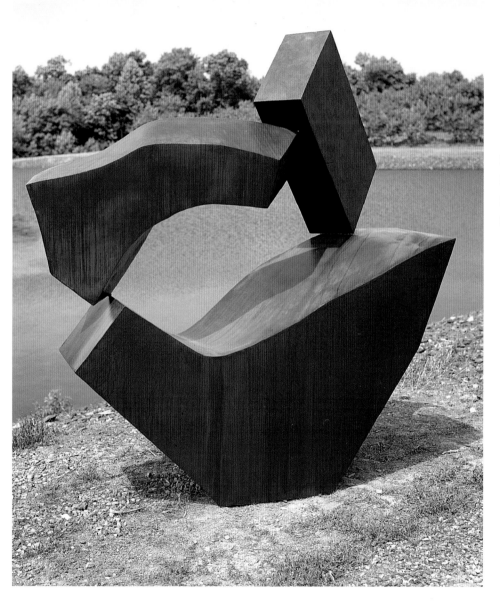

Mark Warwick
Common Ground, 1998
90 x 37 x 84
Steel, graphite

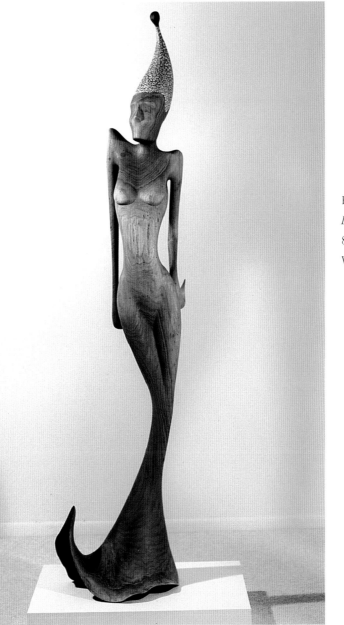

Bruce Peebles
Diva, 1997
84 x 24 x 16
Wood, eggshells

Mark Chatterley
A Pleasure Ride, 1999
Crater glazed sculpture
78 x 42

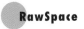
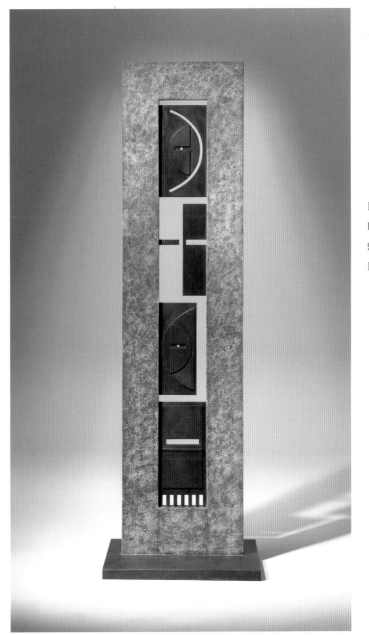

Dan Namingha
Vertical Passages
97.5 x 30 x 20
Bronze

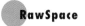
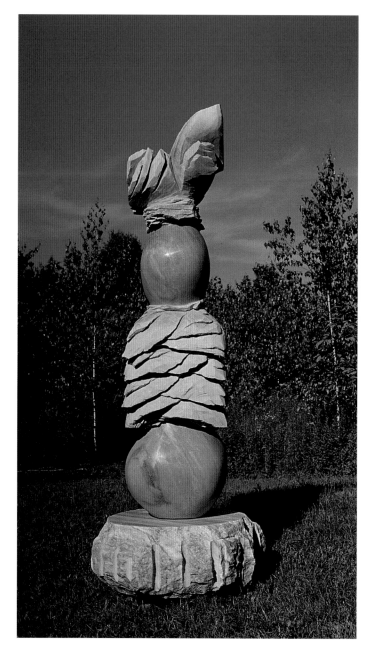

Fritz Olsen
Harvey, 1999
94 x 23 x 24
Marble
Photo by Fritz Olsen

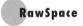
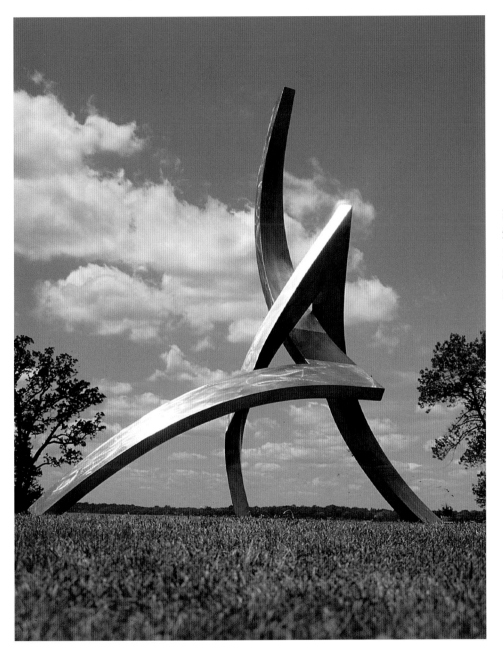

Bruce A. Niemi

Two Can Dream II, 1999

160 x 175 x 80

Stainless steel

Photo by Bruce Niemi

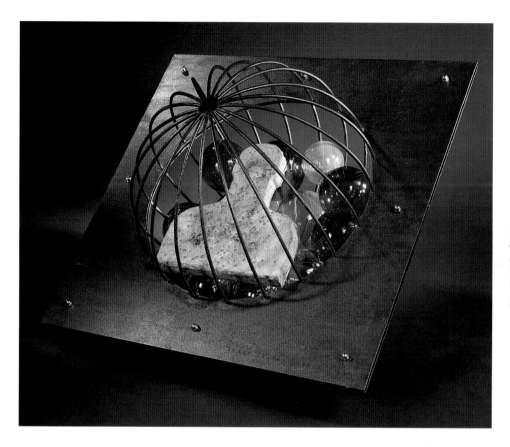

Richard Jolley
Degrees of Magnitude, 1999
Three large spheres
36 x 60
Steel, glass, copper

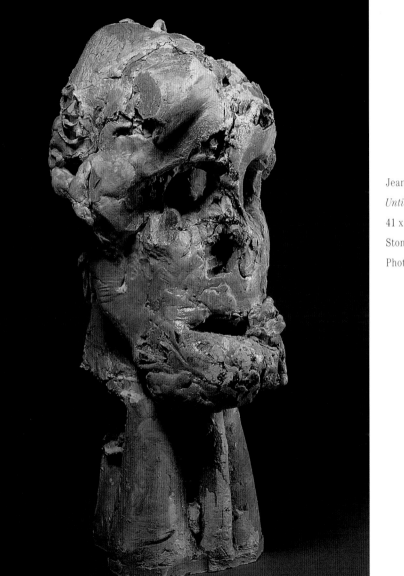

Jean Pierre-Larocque
Untitled (Head), 1996
41 x 20 x 22
Stoneware, engobes
Photo by Andrew Neuhart

American Ceramics
9 East 45 Street
New York, New York 10017

Tel 212.661.4397
Fax 212.661.2389

Harry Dennis
Publisher

Ronald Kuchta
Editor

Johan Creten

*Attar of Roses:
Between Rose Buds
and Female Genitalia*

Johan Creten seems to be achieving a genial, if unexpected, balance in his work. Clay was not his first medium and may not be his last, but it suits his present concerns and had apparently proved happily adaptive. In addition to its earthiness, sensuality, sheer familiarity and time implications, he has exploited the material for its bright, even tackily garish colors and the light-capturing qualities of glaze.

Creten's work can be characterized as layered, complex, ironic or sometimes slightly melancholic. Never would it be described as clear, crisp, direct or orderly. One might see in these two groups of adjectives the national differences (inevitably oversimplified, but with an essential truth) between the more baroque character of Belgian art and the minimalist inclinations of their neighbors, the Dutch. Creten has wit, imagination and ambition. Despite some stays in New York and his considerable proficiency in English, he maintains a clearly European perspective.

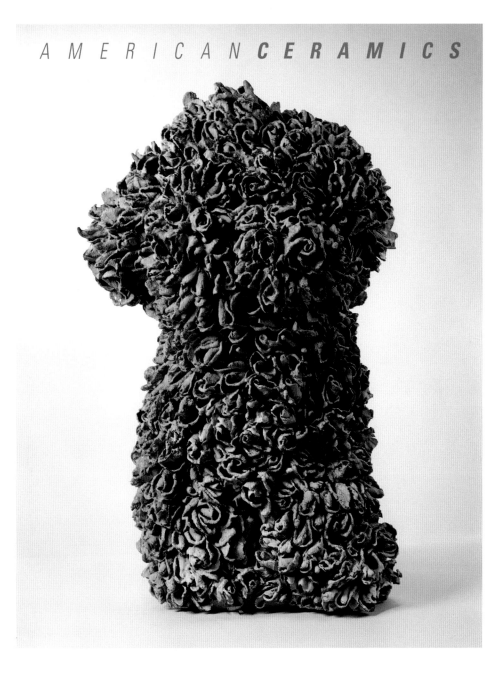

AMERICAN **CRAFT** JUNE/JULY 98 $5

THE ART O

The Glass Skin

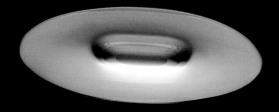

LEFT: **JUDY HILL** (United States) *Very Gently Now*, 1997, cast glass, raku ceramic, 12 ½ by 5 by 5 inches. OPPOSITE PAGE TOP: **IVAN MAREŠ** (Czech Republic) *Egg*, 1997, mold-melted and cut glass, 29 ½ by 41 by 29 ½ inches. BOTTOM: **TOSHIO IEZUMI** (Japan) *Surface 300597*, 1997, sheet glass, glued, polished, 1½ by 17½ by 11½ inches.

Published bimonthly by the American Craft Council, a nonprofit organization providing national leadership to the craft movement in America through educational programming that fosters appreciation of the crafts. Annual membership, including a subscription to AMERICAN CRAFT magazine, $40. To join the American Craft Council call 1-888-313-5527.

F CRAFT

Lois Moran, Editor and Publisher
Pat Dandignac, Managing Editor
Kiyoshi Kanai, Design Director
Don Zanone, Advertising Manager

72 Spring Street
New York, NY 10012
Phone: 212.274.0630
Fax: 212.274.0650

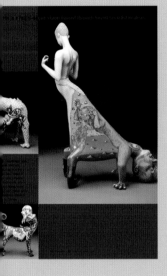

AMERICAN CRAFT

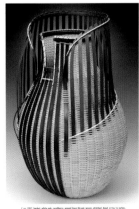

By WERNER TRIESCHMANN Photographs by JERRY ANTHONY

It is a brilliant, sunny summer Saturday in the Ozark Mountains. The dawn is clear and cool, but the heat is coming. Leon Niehues is here, as he is every day, in his expansive, unfinished, two-story studio, which sits at the end of a short path at the top of a green hill above his home in Huntsville, Arkansas. The artist — a compact man with a trim, sandy brown goatee who is 47 but looks at least 10 years younger works over in his hands a small string of flat sun beads, as if by holding the objects he will receive a secret signal on whether to discard them. The choice of whether to incorporate beads into the sleek, elegant vessels he constructs is not one Niehues will make lightly. To call the basket maker Leon Niehues a careful artist is an understatement.

That is how it goes for Leon Niehues (pronounced NEE-hoose). Slow deliberation and unstinting determination have been the hallmarks of his career, now into its third decade. Along the way, Niehues has forged his own path, ignoring many of the usual avenues to achieving artistic and commercial success. He has no formal training and claims to have picked up basket making by happenstance and because it was better than working in a sawmill. The most helpful tool in the early days was a book on the subject he checked out of the library.

Niehues lives in a remote, rural area, yet his baskets are displayed in galleries and museums around the country and abroad. The most striking element of his basketry is that he has reduced the number of elements used to three: white oak, coralberry and waxed linen. The self-imposed limitation has done anything but reduce the impact of the work. "I came here in 1989 and I saw his work at the first Riverfest Lan annual festival on the banks of the Arkansas River I ever went to, remembers Alan Du Bois, curator of Little Rock's Decorative Arts Center. He had a booth there. His work just stood out. These containers deceive the viewer. They seem primitive and modern, functional and decorative, intricate and simple all at once. With a close look, one can see the layers and appreciate the meticulous construction. Step back and the beauty of the forms comes into focus. Niehues likes to keep a handful of his baskets around him while he toils away from morning to night. Tall and slender, they stand in corners like quiet, exotic birds.

Leon Niehues Weave Master

Niehues and his wife, Sharon, moved from Kansas to the Arkansas hills in the mid 1970s, caught up in what has been called the back-to-the-land movement. Before the couple landed in Huntsville, they resided in the even smaller community of nearby Pettigrew, where they spent 18 years in a small country house at the end of a dirt road. But the attraction to the landscape was immediate.

The area is unspoiled, beautiful and cheap, Niehues says. The landscape changed me, but I was ready. It probably was a compromise. I felt very comfortable in the country. My family are still on farms in Ohio. Some people, it bothers them to be alone in the middle of a dark night. Not me. That Leon and Sharon have thrived and raised three children on an income generated by baskets here in Huntsville, a mostly sleepy town in the heart of northwest Arkansas, is no more surprising than the whole of the Ozarks. These mountains are filled with contradicting souls. An hour away, Eureka Springs, a tourist town built on the side of a mountain, is home to New Age shops selling crystals. The Great Passion Play and the Christ of the Ozarks, a large, white statue of Jesus that can be seen from miles away. And the mountains have a grand tradition of attracting wood-workers and craftsmen of various stripes. It is perhaps this mingling of different sensibilities that makes an outsider like Niehues, quiet as he is, feel at home.

I've always felt people were more accepting in Arkansas, he says. I think it is a good place for somebody that works with his hands. Working with his hands is exactly what Niehues does. But the life he has woven for himself did not come about because of a grand scheme. I never planned this, he says. Sometimes the best things happen that way. The opportunities for work weren't plentiful when the couple arrived in Arkansas, and the chances remain fairly limited to this day. Apart from the jobs to be had at various sawmills, there s more than enough work for those who can stand tending chickens. Niehues wanted neither. Part of the reason to turn to baskets was purely practical, he admits. I also must say that I was aware at the time that there was a revival of interest in crafts.

Leon, 1997, basket, white oak, coralberry, waxed linen thread, woven, stitched, dyed, 22 by 14 inches.

Collecting?

We can help.

ART NOW

Gallery Guide

If you think *QUILTS*

are just from *Grandmother's Flower Garden,*

Overgrown Garden by Jane Sassaman from *A/QM* issue #3.
Photo by Brian Belda, courtesy of Quilt National.

Whiteadder by Pauline Burbidge from *A/QM* issue #7.
Photo by Keith Tidball.

Come explore the world of contemporary quilts in each issue of *ART/QUILT Magazine*—
THE source for what's new in art quilts. Subscribe and have it all delivered to you!

(p.s.— we still do flowers, but oh, what a garden!)

then maybe you also think *art glass* stopped with *Tiffany* & *ceramics* are just to hold *flowers*

Color Blocks #70 by Nancy Crow from *A/QM* issue #4. Photo by J. Kevin Fitzsimons.

Linen Closet by Emily Richardson from *A/QM* issue #8.
Photo by Rick Fine.

ART/QUILT Magazine

Ceramics
Art and Perception

1999
ISSUE 36

INTERNATIONAL

AUS13 US$13 £8 ¥2000 NZ$17 incl gst CAN$18 DM2.

ISSN 1035-1841

Ceramic TECHNICAL

ISSN 1324-4175

Ceramics
Art and Perception

Now celebrating eight years of publishing, this magazine has met with acclaim internationally with more than 10,000 copies distributed each quarter. Subscribe and enjoy:

- Well written articles
- Colour pictures on every page
- Contributions from all over the world
- Thought-provoking and stimulating articles
- Reviews, events, wide-ranging topics

Ceramics
TECHNICAL

A magazine devoted to research in the field of ceramics that is of interest to artists, studio potters, and everyone interested in skills and understanding of materials and processes in ceramic art. Subjects range from the latest advances in computer technology available for the potter, through clays, glazes, kilns and firing, to techniques for forming and decorating.

CAC

Chicago Artists' Coalition

24 Years of Service to the Visual Arts Community

The Chicago Artists' Coalition (CAC) is an artist-run non-profit service organization for visual artists. Founded in 1974, our purpose is to create a positive environment in which artists can live and work. Our primary objectives include improved benefits, services, education, and networking opportunities for artists; garnering greater financial support for the arts from government and foundation sources; and increasing exposure and recognition for artists in the media and at major institutions. Membership is open to artists nationwide.

CHICAGO Artists' News

CAC publishes the **monthly newspaper** *Chicago Artists' News*, which includes features on current events in the artworld, as well as an extensive classified section of exhibition opportunities, jobs, space, art openings, member announcements, and much more. For many local artists, *Chicago Artists' News* is "the voice of the Chicago art community."

CAC also publishes several **books**, **guides** and **lists**. These are availiable to all members of the public but discounted to members. Books include the *Artists' Yellow Pages*, and the *Artists' Gallery Guide*; our *Artists' Self Help Guides* focus on seperate topics including contracts, copyright, funding and publicity, and our lists focus on everything from *Public Art Commissions* to *Model Lists* and *Artists' Retreats*.

SERVICES

CAC also provides artists with a **slide registry** (perused regularly by prospective art buyers), a **job referral service**, access to **group health insurance plans**, a **credit union** that provides free checking and low interest loans, **discounts** at many leading art supply stores, and special **programs** on such practical matters as taxes, art on the internet, etc. We also hold monthly **"salons"** where artists can network in an informal environment, as well as a host of other services that promote visual artists as practicing professionals in today's world.

Our Web site, CAC Online, includes information on CAC, excerpts from Chicago Artists' News and numerous other "goodies." The site has a separate, online slide registry (available to members for an extra fee to cover its outside production), which is helping our members to reach across a global range. Many online members are reporting international contacts through the Web registry.

Since 1996, CAC has sponsored **Chicago Artists' Month**, an event intended to draw public and media attention to the valuable contributions made by visual artists to the city of Chicago—and to celebrate the diversity and vitality of Chicago art. This effort, going on in the greater metropolitan area throughout the month of November, features exhibitions, lectures, studio tours and much more. CAC also mounts the **Chicago Art Open** during the month, an exhibition of more than 250 Chicago artists under one roof—the largest non-juried show dedicated to Chicago artists in decades.

CAC is an information and reference center. We take great pride in our support network for artists. We function as a valued resource for artists, the general public, and the art community at large.

For information on how you can become part of this active organization, write, call or visit our web site:

Chicago Artists' Coalition

11 E. Hubbard Street, 7th Floor, Chicago, IL 60611

phone: 312.670.2060, fax: 312.670.2521, http://www.caconline.org

Chicago's most comprehensive guide to the city's art galleries and services.

Published three times per year: January / April / September
Subscriptions: $12 per year

CHICAGO GALLERY NEWS
730 N. Franklin, Chicago, Il. 60610
phone: (312) 649-0064
fax: (312) 649-0255
e mail: cgnchicago@aol.com

Chicago Gallery News

Chicago's Most Comprehensive Guide to the City's
Art Galleries and Services

Chicago Gallery News · 730 North Franklin · Chicago IL 60610 · September – December 1999 · Volume 14 · #3 · S4

Interior View of
R. Duane Reed Gallery

BULK RATE
US Postage PAID
Chicago, IL
Permit, No. 1172

Art and Object-Making

A major resource on trends and
developments in the contemporary arts worldwide. Each issue
contains 120 pages and over 400 color
plates depicting innovative concepts
and new work by leading artists and
designer/craftspeople across a wide
spectrum of styles, techniques and
media, accompanied by authoritative
and comprehensive text that is essential
documentation for anyone involved in
the visual and applied arts.

Inspirational work and vital information from the British crafts scene

Published bi-monthly by the Crafts Council, *Crafts* magazine covers the full range of crafts disciplines and is the leading authority on the applied and decorative arts in Great Britain.

Crafts includes regular in-depth coverage of the best in ceramics, textiles, wood, glass, jewellery, metal, furniture, calligraphy, automata and bookbinding.

A year's subscription normally costs $63 including airmail delivery – but if you subscribe now you will get 2 issues free – that's 8 issues for the price of 6, which means your subscription will last for 16 months. Just quote reference C40 when ordering.

To subscribe, please call our hotline on +44 207 806 2542 or fax us on +44 207 837 0858.

Alternatively you can write to us at this address: *Crafts* magazine, c/o Mercury Airfreight Int Ltd, 365 Blair Road, Avenue 1, NJ 07001, USA

CRAFTS
The British applied and decorative arts magazine

THE MAGAZINE
FIBERARTS

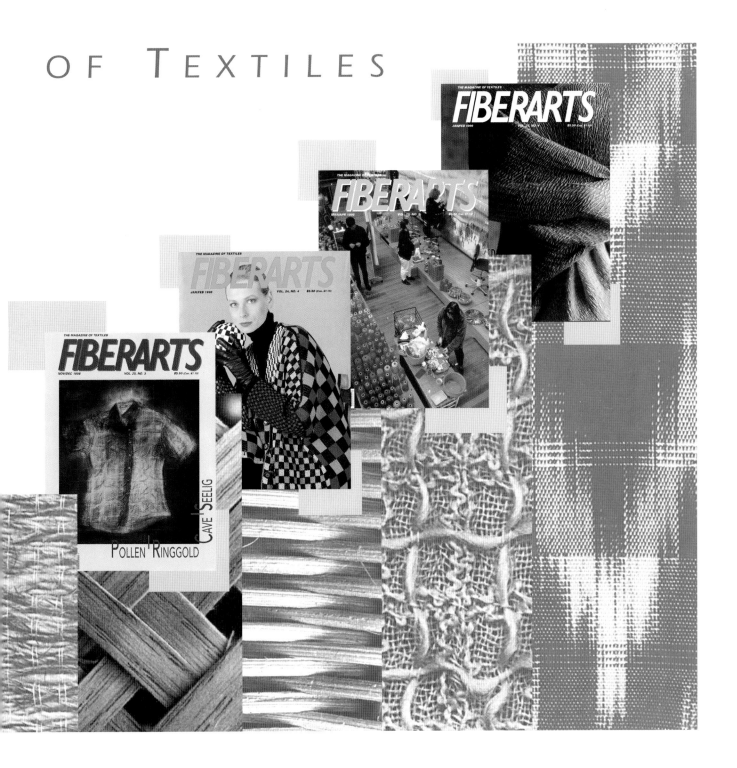

The Outsider

A publication of Intuit: The Center for Intuitive and Outsider Art

VOLUME 3 / ISSUE 3 / SUMMER '99

Outsider + Folk Art
from Chicago Collections

Intuit

The Center for Intuitive and Outsider Art

Intuit: The Center for Intuitive and Outsider Art
promotes public awareness, understanding, and appreciation of intuitive
and outsider art through a program of education and exhibition.

What is "intuitive and outsider art?" Work by artists
who demonstrate little influence from the mainstream art world, and
who instead seem motivate by their unique personal visions.
This definition includes art brut, non-traditional folk art,
self-taught art, and visionary art.

Founded in 1991, Intuit is based in Chicago and offers a
wide variety of exhibitions, slide lectures, film screenings
and study tours of outsider art environments.

Membership benefits include a subscription to The Outsider magazine,
which includes features, book reviews, artist profiles, outsider art
environment information, and a worldwide calendar of events.

Eddie Lee Kendrick: A Spiritual Journey
September 17, 1999 - November 27, 1999
Features the remarkable and fantastically colored works on paper and
fabric of this self-taught, spiritually driven, rural Southern artist.

Intuit: The Center for Intuitive and Outsider Art
756 N. Milwaukee Ave.
Chicago, IL 60622
312.243.9088

Visit Intuit's website at http://outsider.art.org

Don't miss Elvis 2000! Taking place on Saturday, January 8, 2000
Featuring an exhibit and auction fundraising event
paying tribute to Elvis on his 65th Birthday

METALSMITH

Christina DePaul, *La Mano di Tradizione (The Hand of Tradition)*, an installation at the Cleveland Museum of Art 1996, marble, granite, steel, copper, aluminum photos, 15 x 18 x 27. This installation is one of seventeen commissioned for a city-wide exhibition, *Urban Evidence*, organized by the Cleveland Center for Contemporary Art, the Cleveland Museum of Art, and SPACES, to celebrate the bicentennial of the city.

PHOTOGRAPH BY HOWARD AGRIESS

Tremendous
Delightfull
Fascination

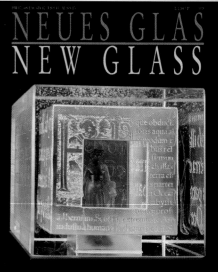

NEUES GLAS
NEW GLASS

Salo • Ježek • Hlava • Leperlier
Jutta Cuny-Franz Memorial Award

The Best of
International
Glass Art
Around the World

Tony Tasset, *Spew*, 1993.

object magazine

contemporary craft + design + 3D art

Object features glass in all four editions in 1999.

Robyn Campbell,
cast glass, 1999.

Subscribe

SPECIAL SOFA PRICE

US $35 FOR 4 ISSUES AIRMAILED ANYWHERE IN THE USA, CANADA OR EUROPE

Object magazine takes an investigative approach to contemporary craft, design and 3D art, viewing global issues from the perspective of the Pacific Rim. *Object* is an award winning colour publication with feature articles, reviews, debates, world news and quality design and photography.

To subscribe or obtain a free sample issue send your name, address and payment details to the address below:

Object magazine is published quarterly by the Centre for Contemporary Craft and assisted by the Australia Council for the Arts, the NSW Ministry for the Arts and the Thomas Foundation.

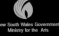

OBJECT MAGAZINE
THIRD FLOOR CUSTOMS HOUSE 31 ALFRED STREET
SYDNEY 2000 AUSTRALIA
tel 61 2 9247 9126 **fax** 61 2 9247 2641
email object@object.com.au **website** www.object.com.au

Surface Design Association

Innovation
Transformation
Contemplation

Surface Design Association ·11th International Conference · May 29-June 9, 2000

workshops - exhibitions - seminars

Kansas City Art Institute · Kansas City, Missouri

trunkshow - gallery talks - vendors

KEYNOTE SPEAKERS : LAUREL REUTER and VERNAL BOGREN SWIFT

JURIED STUDENT EXHIBITION
Jurors: Junco Sato Pollack
Glen Kaufman

JURIED YARDAGE EXHIBITION
Jurors: Ana Lisa Hedstrom
Ann Sutton

For More Information Contact:
SDA
P.O.Box 300286
Kansas City, Missouri 64130
Phone: 816-836-0913
Fax: 816-254-8521

Surface Design Association

MEMBERSHIP BENEFITS

- Four issues of the Surface Design Journal. Surface Design Journal, the Association's quar terly journal, offers in-depth coverage of critical and aesthetic concerns to surface designers, individual artists, and other professionals in the field. Every issue covers aspects of surface design and gives perceptive observations unequaled by any other publication. Each article is accompa nied by full-color reproductions of work by con temporary surface design artists.

- Four issues of SDA Newsletter. SDA Newsletter focuses on regional accomplishments of our members, calendar items, professional and tech nical advisories, exhibition opportunities and additional announcements of interest to the membership.

- National and regional conferences

- Networking opportunities

- Eligible to submit slides of your work to the Journal Exposure section

- Eligible to submit slides of your work to the SDA Slide Registry

- Publicize your work and professional activities

- Free 30-work non-commercial classified

- Study Tours

Founded in 1977, Surface Design Association is an internationl not-for-profit organization dedicated to the promotion of, as well as education and critical thinking about surface design. Our current membership of 2750 includes independent artists, designers for industry, educators, scientists, manufacturing technicians, entrepreneurs, curators, gallery directors, and students.

$45 membership starts in the month payment is received. SDA will send you the latest publi- cations to start your membership. Send $7 for sample journal or for more information write:

**Surface Design Association–Membership
PO Box 360
Sebastopol, CA 95473-0360**

sda website address:
www.art.uidaho.edu/sda

sda email:
**sda@metro.net
Tel: (707) 829 3110**

glass straight from the murano glass masters

VETRO

Venezia
Aperto Vetro

ARCHIMEDE
SEGUSO

VETRO

BERTIL
VALLIEN

ERMANNO
NASON

VETRO

William
Morris

Richard
Meitner

ALFREDO
BARBINI

VETRO

UMBERTO
MASTROIANNI

LINO
TAGLIAPIETRA

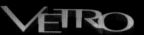

Centro Studio Vetro
Fondamenta S. Lorenzo 17/18b
30141 Murano VENEZIA
TEL. +39.041.5274771
FAX +39.041.52.76.028
e-mail: csvetro@gpnet.it

- Vetro

Your fast lane to glass -

Centro Studio Vetro is a newly established non-profit cultural association devoted to promoting culture and art connected to glass, upheld by relentless passion for this fascionating material. Centro Studio 0 Vetro was set up by four young glass masters from Murano: Norberto Moretti (Chairman), Davide Salvadore, Claudio Tiozzo and Cesare Toffolo, who initially had the idea. The purpose is to foster and promote, both in Italy and abroad, the interchange between all the people involved in the creation, technology and enhancement of glass.
The first international project undertaken by Centro Studio Vetro is the publication of "Vetro" magazine which will feature glass in all its facets as well as the men and women, traditions and places part of this ageless tradition.

The endeavour is to grow and stimulate the curiosity awareness of every single reader. We are actively looking for contributions, letters, images and information on exhibitions, events, research, artists and everything concerning glass. Thak you in advance for subscribing to **Vetro**, thus supporting us in our work and, at the same time, becoming a member of Centro Studio Vetro.

Subscribe to Vetro - The Murano glass magazine: you will receive 4 issue a year.

name
city code
state
fax telephone
e-mail
profession

Payment: **50 US dollars** by: ☐ cheque made out to Centro Studio Vetro
 ☐ credit card

card number
expiry date
card member signature

Museum of
Contemporary Art

M/CA

See things
differently.

Chuck Close, *Cindy* (detail), 1988.
Gift of Camille Oliver-Hoffmann in memory of Paul W. Oliver-Hoffmann

220 East Chicago Avenue Information: 312.280.2660
www.mcachicago.org Membership: 312.397.4040

The MCA will stimulate your senses in ways you can hardly imagine. Stop by for an hour or spend the day — the museum is just steps from North Michigan Avenue.

The MCA Collection, displayed in grand, naturally lit, barrel-vaulted galleries overlooking Lake Michigan, showcases superb artworks from the early twentieth-century to the present day.

culturecounter, the MCA store and bookstore offers an exciting and evolving array of contemporary works, wares, books, and toys to enrich, enliven, and enlighten our everyday lives.

M/CA

culture
counter

312.397.4000

american craft museum

The Nation's Preeminent Art Museum
for Contemporary Crafts

Membership Benefits

Current and Upcoming Exhibitions

THE BEADED UNIVERSE:
Strands of Culture
October 21, 1999 - January 30, 2000

A world encompassing, cross-cultural exhibi-
tion of the oldest and smallest portable art
form - the bead. The exhibition was inspired
by and based on *The History of Beads* by Lois
Sherr Dubin. The exhibition features hun-
dreds of beads and beaded objects from cul-
tures around the world: talismans from
ancient and modern societies, religious arti-
facts from the Buddhist, Christian and
Islamic worlds; and work by modern artists
and traditional beadworkers.

THE VENETIAN RENAISSANCE:
20th Century Italian Glass from
the Olnick Spanu Collection
February 10 - May 14, 2000

The first comprehensive overview of glass art
and objects created in Italy in the 20th centu-
ry, as well as the first public exhibition of a
heretofore unknown private collection. The
Olnick Spanu collection has been assembled
over the course of 12 years by Giorgio Spanu
and Nancy Olnick. Today the collection
numbers over 400 works, ranging in date from
the 1920's to the present day. Italian art
glass of the 20th century represents a high
point in the history of the medium

TRIO OF EXHIBITIONS
JUNE 1 - SEPTEMBER 3, 2000
JUDY CHICAGO:
RESOLUTIONS: A Stitch in Time
SANDY SKOGLUND:
INSTALLATION
TOMMY SIMPSON/PILOBOLUS:
THE GARDEN OF MY HEART

Judy Chicago's installation, RESOLUTIONS:
A Stitch in Time will feature work created by
the artist with two dozen needle workers.
Sandy Skoglund's work is dependent upon the
transformation of materials and in this instal-
lation, she is assisted by urbanGlass, an inno-
vative Brooklyn studio as she explores hand-
made glass. The Garden of My Heart,
designed to incorporate a dance performance,
will be created along with a new dance by
Pilobolus Dance Theatre that will premiere at
the American Craft Museum.

OBJECTS FOR USE: Made With Pride
September 14 - January 7, 2001
Curated by the Museum's director emeritus,
Paul Smith, this exhibition will be a state-
ment of tribute to the creativity and workman-
ship of an outstanding group of geographical-
ly and culturally diverse American craftspeo-
ple, who create unique handmade objects
expressly made to combine function and
beauty, transforming wood, metal, fiber, clay
and paper into useful objects that enrich our
lives and our surroundings.

GARRY KNOX BENNETT
January 18 - April 29, 2001
This exhibition is part of a Modern Master
series, presenting one person retrospectives of
mid-career artists who have become signifi-
cant in their fields. It is the first large-scale
retrospective of the work of Garry Knox
Bennett and will emphasize his achievement
as an artist whose work links furniture and
sculpture.

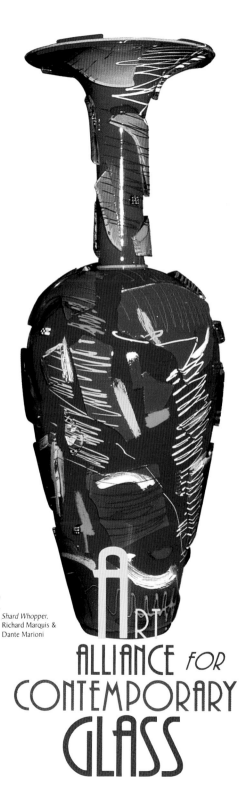

Shard Whopper,
Richard Marquis &
Dante Marioni

ALLIANCE FOR CONTEMPORARY GLASS

ART ALLIANCE FOR CONTEMPORARY GLASS

The Art Alliance for Contemporary Glass is a not-for-profit organization whose primary objectives are to promote art made from glass and educate collectors, critics, curators and others who wish to learn more about the contemporary glass movement.

WHAT DO OUR COLLECTIVE DUES MEAN

Each year, the AACG honors one institution with a $1,500 grant. Past recipients include the Rhode Island School of Design, the Penland School of Arts & Crafts, the Pilchuck Glass School, UrbanGlass (formerly the New York Experimental Glass Workshop), the Glass Art Society, Bullseye Connection and the University of Illinois Glass Program.

Support grants have been given to other institutions including Glass Art Society (GAS), Illinois State University, Boston Museum of Fine Arts, Seattle Art Museum, Metropolitan Museum of Art, Milwaukee Art Museum, Pennsylvania College of Art, Pilchuck Glass School, Santa Barbara Museum, Mint Museum of Art, Huntington Museum, Charles A. Wustum Museum, University of Illinois I-Space, Tucson Museum of Art, and Cleveland Museum of Art.

In 1993, the AACG and the Creative Glass Center of America donated $27,500 to the Corning Museum for the acquisition of a Tom Patti sculpture.

Complimentary subscriptions to *GLASS Magazine* have been sent to 50 critics and 100 museums to spread information about art made from glass.

Funding is provided each year for four critical magazine articles on the subject of art made from glass.

WHAT YOUR MEMBERSHIP PROVIDES FOR YOU

- Information
- Communication among artists, collectors, critics and galleries
- Promotion of glass as an art form
- Educational Programs; Exchange Information with other collectors through our Visitor Network

- Invitations to relevant programs including our Annual Meeting, GLASSWEEKEND and S.O.F.A.
- Leadership in helping to establish local collector groups
- Subscription to *Glass Focus*

Application For Membership

Name _____

Street Address _____

City _____ State _____ Zip _____

Home Phone _____ Home Fax _____

Office Phone _____ Office Fax _____

Individual $45 ☐ Family $65 ☐ Friend $250 ☐ Sponsor $500 ☐

Send your completed application to:
AACG Treasurer
PO BOX 7022 Evanston, IL 60201
(Web) http://www.ContempGlass.org

we invite you to join the art jewelry forum

**participate with others from across the country who
share your enthusiam for contemporary art jewelry**

our mission To promote education, appreciation and support
for contemporary art jewelry.

our goals To sponsor educational programs, panel discussions,
and lectures about national and international art jewelry.

To encourage and support exhibitions, publications, and programs
which feature art jewelry.

To organize trips with visits to private collections, educational
institutions, exhibitions, and artists' studios.

For information on the **art jewelry forum,** call 415-775-0991,
fax 415-775-1861, or write us at Art Jewelry Forum, 38 Miller Ave,
Suite 14, Mill Valley, CA 94941.

The Art Jewelry Forum is an affiliate of the San Francisco Craft & Folk Art
Museum which creates exhibitions focusing on contemporary craft, ethnic
art, and 20th Century American Folk Art.

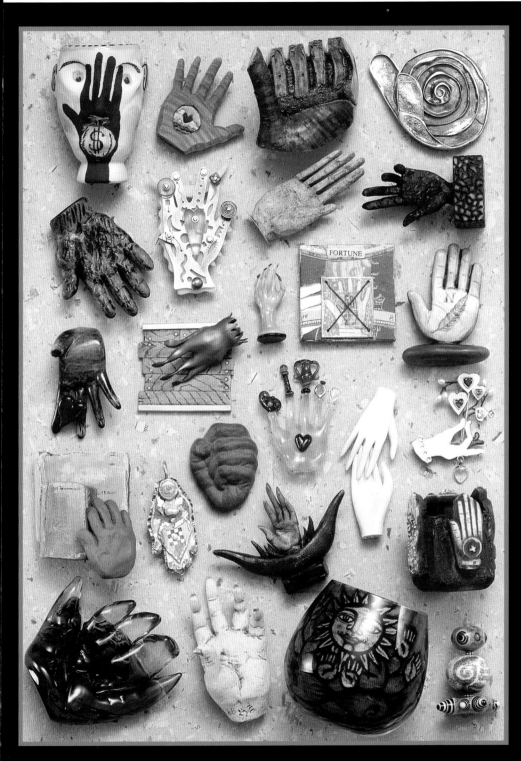

hands for CERF

Hands for CERF is a work consisting of 25 miniature hands created by well-known artists and encased as a single collection in a display box. It will be on display at **CERF's** booth during the exhibition. This piece will be raffled to raise funds for the Craft Emergency Relief Fund's programs that help craftspeople return to work after crises such as fire, theft, illness, and natural disasters. Tickets are $50 each, or 5 for $200, and will be available at our booth or by calling **CERF** at (802) 229-2306.

Contributors to the collection are:

David Bacharach · Dorothy Gill Barnes · Ken Bova · Robert Brady · Nancy Carman · Michael Corney · Christine Federighi · Shane Fero · Pat Garrett · Martha Giberson · Charles & Tami Kegley · Dana Major · Thomas Mann · Laura Marth · Robert Mickelsen · James Minson · Richard Notkin · Tom Rauschke & Kaaren Wiken · Joellyn Rock · Nancy Selvin · Esther Shimazu · Josh Simpson · Cappy Thompson · Graceann Warn · Lana Wilson

Hands for CERF Committee

Cornelia Carey · Trudy Evard Chiddix · Lisa Englander · Lucy Feller · Leslie Ferrin · Lloyd E. Herman · Marge Brown Kalodner

Drawing: Nov. 6, 1999 at SOFA Chicago.

You do not need to be present to win.

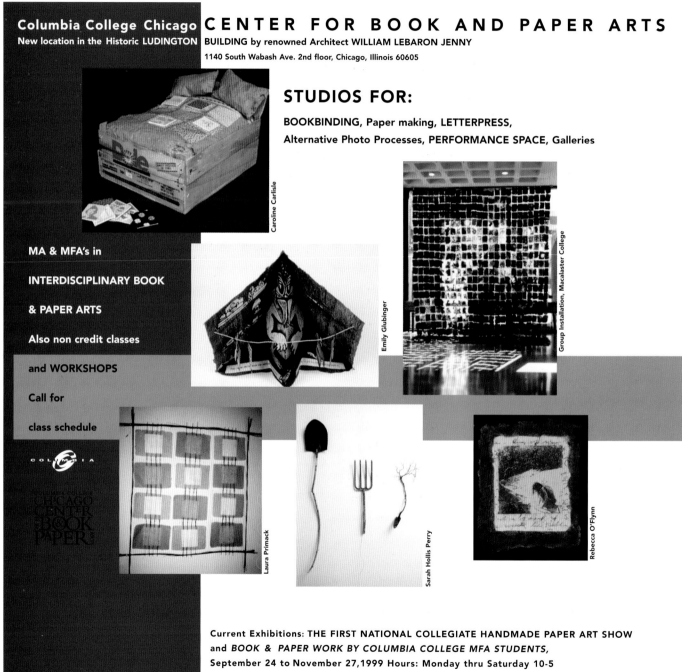

Columbia College Chicago

New location in the Historic LUDINGTON

CENTER FOR BOOK AND PAPER ARTS

BUILDING by renowned Architect WILLIAM LEBARON JENNY

1140 South Wabash Ave. 2nd floor, Chicago, Illinois 60605

STUDIOS FOR:

BOOKBINDING, Paper making, LETTERPRESS,
Alternative Photo Processes, PERFORMANCE SPACE, Galleries

Caroline Carlisle

Emily Glubinger

Group Installation, Macalaster College

MA & MFA's in

INTERDISCIPLINARY BOOK

& PAPER ARTS

Also non credit classes

and WORKSHOPS

Call for

class schedule

COLUMBIA

CHICAGO CENTER BOOK PAPER

Laura Primack

Sarah Hollis Perry

Rebecca O'Flynn

Current Exhibitions: THE FIRST NATIONAL COLLEGIATE HANDMADE PAPER ART SHOW
and BOOK & PAPER WORK BY COLUMBIA COLLEGE MFA STUDENTS,
September 24 to November 27,1999 Hours: Monday thru Saturday 10-5
312•344•6630, Fax: 312•344•8082, www.colum.edu/centers/bpa

The **CHICAGO WOMEN'S CAUCUS** for **ART**

The CWCA is one of 39 local chapters of the National Women's Caucus for Art and is the largest national organization for women in the visual arts. The 4000+ membership is diverse, open to men and women, and ranges widely in age, culture, color, sexual persuasion and political preference. The WCA is committed to:

- Educating the public about the contributions of women and minorities in the visual arts.
- Incorporating a culturally diverse and gender neutral approach to arts curricula at all educational levels.
- Ensuring inclusion of women and minorities in the history of art.
- Promoting a system that provides the opportunity for economic survival in the arts.
- Formulating and supporting legislation that contributes to the goals outlined above.

Why become a member of the CWCA?

WCA 25th Anniversary show at Artemesia, 1997

■ **History**
- celebrating our 25th year
- documentation of Chicago women artists through interviews, photography, and video

■ **Programs**
- prominent speakers
- varied locations
- interface with larger Chicago art community
- opportunity for members to discuss their work
- recent programs have included panel/slide presentation of Chicago women artists at Harold Washington Library

■ **Exhibitions**
- national and local
- distinguished jurors and curators
- 25th anniversary exhibit in 1998

■ **Networking**
- social events
- summer picnic
- winter members' party
- smaller groups based on interest/geography

■ **Outreach**
- developing a program for the Chicago schools which documents women in the visual arts in Chicago

■ **Newsletter**
- published quarterly
- articles on artists, exhibitions and professional development
- commentaries
- exhibition opportunities listed
- members may submit articles

for more information:
The Chicago Women's Caucus for Art
700 N. Carpenter, 3rd floor
Chicago, IL 60622
phone (312) 226-2105

Contemporary
Art Workshop

Celebrating its 50th anniversary!

painting

printmaking

photography

drawing

sculpture

installation

gallery

studios

workshop

tours

Monica Balc-Giff,
Give and Take, 1999,
fired clay, silk organza,
and sand, 2' x 9' x 9'

CONTEMPORARY ART WORKSHOP is one of the oldest alternative artists' spaces in the country. Founded in 1949 by a small group of artists including sculptor John Kearney, Leon Golub, and Cosmo Campoli, the workshop has maintained a commitment and dedication to the work of emerging and under-represented artists of Chicago and the Midwest. In addition to monthly gallery programs and open

sculpture workshop, the Contemporary Art Workshop houses John Kearney's studio and over 21 active studio spaces.

The current gallery exhibition features sculpture by Monica Balc-Giff and Young-Suk Yoo, and runs through December 7, 1999.

Contemporary Art Workshop
542 West Grant Place, Chicago, IL 60614
773.472.4004

A non-profit, tax exempt corporation dedicated to the arts

JOIN THE ONLY ORGANIZATION
THAT FOSTERS COMMUNICATION AMONG
COLLECTORS, CURATORS, CRITICS, DEALERS AND
ARTISTS

Friends of Fiber Art International™

MEMBERS ENJOY THE BENEFITS OF
- extraordinary weekend conferences that bring together the movers and shakers, buyers and makers of contemporary of fiber art
- short get-togethers concurrent with fiber-related events such as SOFA and artist conferences
- an outspoken newsletter that takes the advocacy of fiber art seriously and highlights the achievements of its members

FOUNDED IN 1991 **FRIENDS OF FIBER ART**
HAS AWARDED MORE THAN $90,000 IN GRANTS TO
- encourage scholarship and critical writing about contemporary fiber art
- support professionally-mounted, well-documented travelling shows of art produced in fibrous materials that reach a large audience

FRIENDS OF FIBER ART MAKES A DIFFERENCE through unique and innovative programs designed to instruct and inspire the art appreciative public about the "collectibility" of fiber art.

Support this vital mission. Join almost 700 **Friends** in 46 of the United States and 19 other nations who believe the best gift one can give a fiber artist is a fiber collector.

Send your check with the application at the right

Friends of Fiber Art International
Post Office Box 468, Western Springs, IL 60558

MEMBERSHIP APPLICATION

Consider becoming an upper-level member. **Friends of Fiber Art International** is a federally recognized not-for-profit organization. Donor's dues are tax deductible.

Please check all that apply

Enclosed find my check for

- ☐ $ 35 Friend
- ☐ $ 50 Associate
- ☐ $ 100 Sponsor
- ☐ $ 250 Patron
- ☐ $ 500 Benefactor
- ☐ $1000 Guarantor

- ☐ Artist
- ☐ Collector
- ☐ Curator (museum)
- ☐ Critic
- ☐ Gallery

Other _____

Name and address_____

Day phone_____

Evening phone_____

Fax_____
SOFA CHICAGO 99

Friends of Fiber Art International™
Box 468, Western Springs, IL 60558

THE GEORGE R. GARDINER MUSEUM OF CERAMIC ART
LE MUSÉE DE L'ART CÉRAMIQUE GEORGE R. GARDINER

SADASHI INUZUKA
Offering 1998
ceramic and granite

THE GEORGE R. GARDINER MUSEUM OF CERAMIC ART WAS OPENED BY HELEN AND GEORGE GARDINER IN MARCH 1984. This specialized ceramics museum has important collections of pre-Columbian sculpture and vessels from Mexico, Central and South America; Italian Renaissance Maiolica; 17th century English Delftware and Slipware; and 18th century European porcelain including figures from the Italian Comedy.

Through acquisitions and the generous support of many donors the Museum's permanent collection has grown to include Ming and Qing blue and white porcelain and international contemporary ceramics.

Le Musée de l'art céramique George R. Gardiner a ouvert ses portes en mars 1984 sous l'égide de Helen et George Gardiner. Il offre d'importantes collections de sculptures et de vases précolombiens en provenance du Mexique et de l'Amérique centrale et du Sud; des majoliques de la Renaissance italienne; des pièces anglaises du XVIIᵉ siècle, notamment des faïences stannifères et des terres cuites à engobe; et des porcelaines européennes du XVIIIᵉ siècle, en particulier des figures de la Commedia dell'arte.

Grâce au soutien généreux de nombreux donateurs et à des acquisitions successives, la collection permanente du Musée comprend aujourd'hui des porcelaines Ming et Qing à décor bleu et blanc et des céramiques contemporaines de différents pays.

Seated female figure
earthenware
Mexico, Jalisco
100 B.C. - A.D. 250
49.5 x 26.1 x 26.7 cm

Charger, with Adam and Eve
tin-glazed earthenware
England, Lambeth
c. 1685
8.5 x 41 cm

Portrait Dish, Lisandro
tin-glazed earthenware with
lustre decoration
Italy, Deruta
c. 1520
9 x 42.6 cm

Octavio
modelled by F.A. Bustelli
hard-paste porcelain
Germany, Nymphenburg
c. 1755-60
18 x 9.7 x 7.6 cm

We are grateful to the following for their generous assistance:

 Ministère des Affaires étrangères et du Commerce international Department of Foreign Affairs and International Trade Canada

 2000

The Canada Council for the Arts Le Conseil des Arts du Canada SINCE 1957 / DEPUIS 1957

THE GEORGE R. GARDINER MUSEUM OF CERAMIC ART
111 Queen's Park, Toronto, Ontario, Canada M5S 2C7
Tel: (416) 586-8080 Fax (416) 586-8085
email: mail@gardinermuseum.on.ca
www.gardinermuseum.on.ca

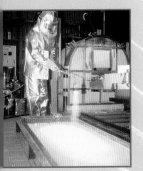

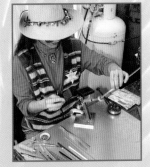

PIER WALK '99

is a production of **3-D CHICAGO,**
a nonprofit organization founded in 1995.

The mission of **3-D CHICAGO** is to assemble and present
exhibitions, educational programs, and documentary material
illustrating the significant role of Chicago artists and institutions
in creating, supporting, and promoting the sculpture of Chicago
for local, national, and international audiences.

This exhibition is sponsored by

Sears, Roebuck and Co.
with additional funding from

American Airlines

Capital Development Board, State of Illinois

Illinois Arts Council, a state agency.

3-D CHICAGO appreciates the assistance of the
Chicago Department of Cultural Affairs and the
Chicago Children's Museum in this endeavor.

Pilchuck Glass School

Pilchuck has the largest and most comprehensive educational program in the world for artists who create with glass.

glass blowing flame working

hot glass sculpture mosaic

kilncasting architectural glass

mixed media stained glass

design glass engraving

sandcasting glass plate printmaking

neon

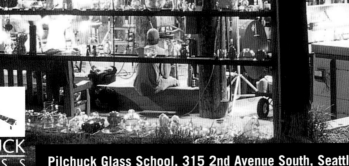

PILCHUCK GLASS SCHOOL

**Pilchuck Glass School, 315 2nd Avenue South, Seattle, Washington 98104
206.621.8422, fax 206.621.0713, www.pilchuck.com**

Rigorous. Exhilarating. Transformative.

Providence, RI

RHODE ISLAND SCHOOL OF DESIGN

For more information, call 401 454-6100

or check www.risd.edu

From top: Eunjung Park, MFA Ceramics '99,
Steve Withicombe, Furniture Design '99,
Ruth Adler Schnee, Interior Architecture '45

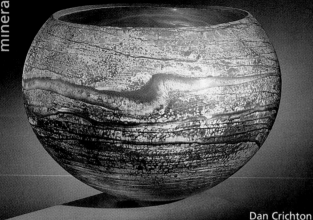
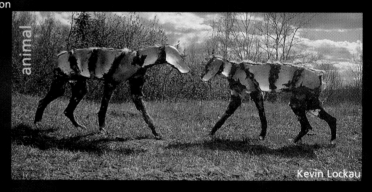

THE ARTS & CRAFTS MOVEMENT IN AMERICA

Arthur Wesley Dow and
American
Arts & Crafts

through January 2, 2000

**664 North Michigan Avenue
Chicago**
*(northwest corner of
Michigan Avenue and Erie Street)*

Hours:
Tues 10–8
Wed–Sat 10–7
Sun 12–5

**For ticket
information call
312.664.3939**
or visit
**www.
ticketweb.com**

Family Fair Program: Decorative Pottery
View ceramics in the galleries and then
return to the studio to create your own pottery.
Sunday, November 7, 1 to 3 pm
For more information call 312.654.2255.

TERRA MUSEUM *of* AMERICAN ART

TERRA

Above: NEWCOMB POTTERY,
Vase (chinaberry design), ca. 1902. Earthenware.
7 7/8 inches h. x 8 1/2 inches w. Thrown by Joseph Meyer.
Decorated by Hariet Joor. New Orleans Museum of Art.
Organized by The American Federation of Arts. Support has
been provided by the National Patrons of the AFA. This
exhibition is a project of ART ACCESS II, a program of the AFA
with major support from the Lila Wallace-Reader's Digest Fund.

The Three Arts Club of Chicago

three arts club
1300 North Dearborn Pkwy
Chicago, Illinois 60610
www.threearts.org

a cultural center & artist residence where all the arts come together

SHIBORI DESIGN BY NAN BANTA SCHUMM

TEXTILE ARTS CENTRE

916 WEST DIVERSEY PARKWAY, CHICAGO, IL 60614

TELEPHONE: 773/929-5655

FAX: 773/929-9837

HOURS: WEDNESDAY-FRIDAY: 12:00-6:30 P.M.

SATURDAY-SUNDAY: 12:00-5:00 P.M.

Come visit us ...
We're a unique non-profit
organization that offers:
● *A gallery with outstanding fiber art exhibits,*
● *an Artisan Shop full of unique merchandise*
from artists around the country, and
● *classes and workshops*
in various textile techniques.

http://collaboratory.nunet.net/textilearts

PARTIALLY FUNDED BY A CITYARTS PROGRAM 2 GRANT FROM THE CITY OF CHICAGO DEPARTMENT OF CULTURAL AFFAIRS AND THE ILLINOIS ARTS COUNCIL, A STATE AGENCY.

AVHQ

AUDIO VISUAL HEADQUARTERS

We are America's leader in presentation
excellence. Our highly skilled technical staff
is backed by a state-of-the-art inventory of
projection, sound, video, lighting & videowall
equipment. With full service offices in
Chicago as well as major convention cities
across the nation, AVHQ is there to ensure the
success of your meetings, corporate events,
conventions & trade shows.

Call AVHQ for more information
or help with your next event
at 800-966-5596 x339

AVHQ is a proud sponsor of the
SOFA CHICAGO 1999 Lecture Series.

REACHING OUT TO THOSE
WHO HAVE BEEN TOUCHED BY HIV.

**DuPont Pharmaceuticals
Company salutes
The AIDS Foundation.**

Reaching out to those in need is important, especially to those in our community who are living and coping with HIV. As a company involved in the discovery and development of new treatments for HIV, we understand that meeting the needs of people living with HIV includes patient support as well as medical therapy. We want to join with other companies, caregivers and the community in...

Reaching out. Looking ahead.™

 DuPont Pharmaceuticals
http://www.dupontpharma.com

WWW.WARMUS.COM

ANNUAL CONTEMPORARY FURNISHINGS FORUM

Chicago Design Show™

November 2-5, 2000

The Merchandise Mart

Chicago, Illinois USA

Thursday & Friday
To the Trade

Saturday & Sunday
To the Trade & the Public

Fourth annual forum to advance understanding of design for today's lifestyles.

Educational programming and museum-quality cultural displays to enhance the overall experience by giving meaningful perspective to new products and current trends.

More than 200 carefully selected exhibitors, including major Italian manufacturers as part of

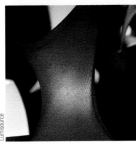

CHICAGO
99
ITALIAN
DESIGN
FURNITURE SHOW

Attendees:
Approximately 17,000 in 1999

- Interior Designers
- Architects
- Retail Buyers
- Hospitality Specifiers
- Collectors
- Consumers

Sponsored by:
Merchandise Mart Properties, Inc.
and *Interior Design* magazine

To Register: Call 800/677-MART (6278). To Exhibit: Call 312/527-7948.

Visit our Web site at **www.chicagodesign.com**

Is It Art?

Art is defined as a composition of elements arranged in a manner that affects the senses.

Is It Functional?

Designed for a particular use; it's function? to rejuvenate.

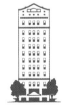

THE CLARIDGE HOTEL

CHICAGO

THE CLARIDGE HOTEL. 163 ROOMS EXHIBITING THE MOST DESIRED FORM OF FUNCTIONAL ART. 1244 N. DEARBORN, CHICAGO, ILLINOIS 60610 • (312) 787-4980 • WWW.CLARIDGEHOTEL.COM

FIND IT HERE.

Chicago Tribune

chicagotribune.com

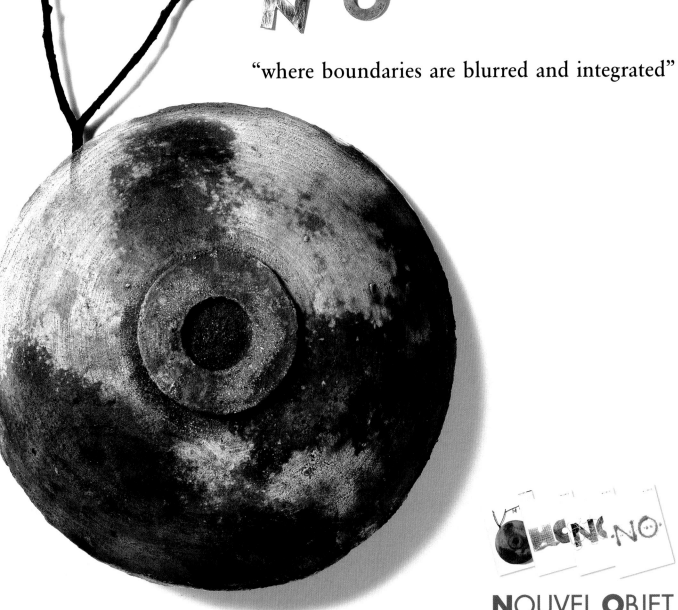

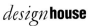

Paradise Bldg.,186-210
Jangchung-dong 2-ga,
Jung-gu, Seoul 100-392, Korea
Tel.(+82 2)2275-6151
Fax.(+82 2)2275-7885
dgn01@design.co.kr
North America correspondent
Tel/Fax (+1 215)735-6466
nvobjet@aol.com

"where boundaries are blurred and integrated"

NOUVEL OBJET
the new mook in the world of objet art

S O F A

THE INTERNATIONAL

EXPOSITIONS OF SCULPTURE, OBJECTS & FUNCTIONAL ART

PRESENTED BY ART GALLERIES AND DEALERS

SOFA NYC 2000

JUNE 1 – 4

SEVENTH REGIMENT ARMORY

SOFA CHICAGO 2000

NOVEMBER 3 – 5

NAVY PIER